FASHION'S FRONT LINE

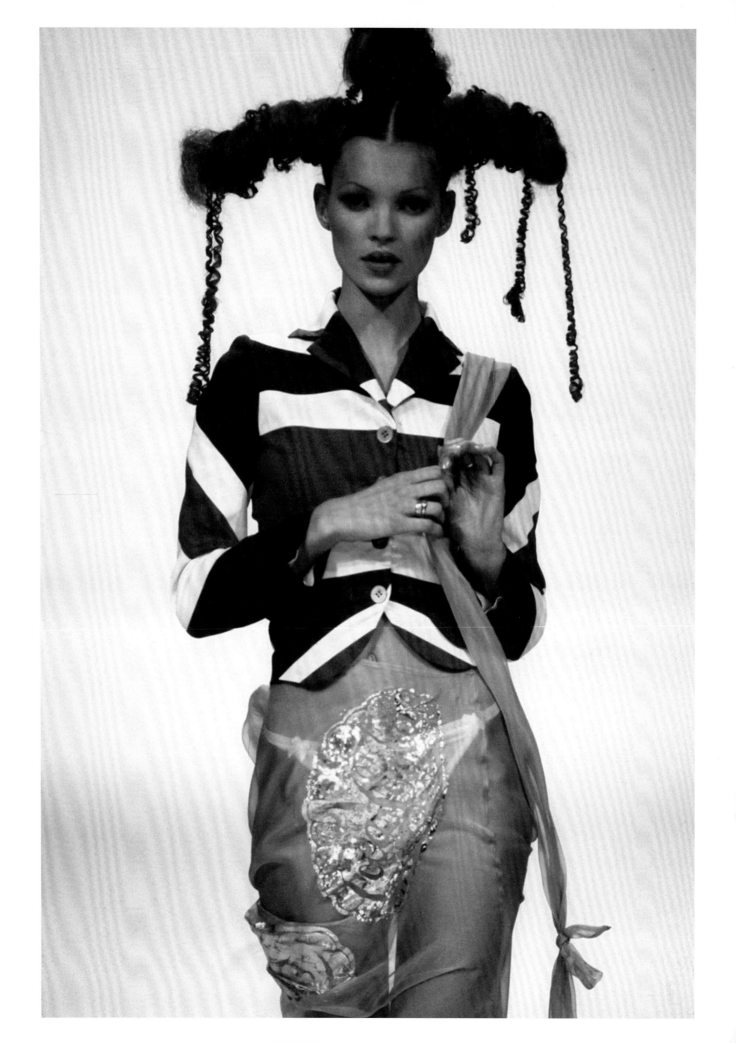

FASHION'S FRONT LINE

FASHION SHOW PHOTOGRAPHY FROM THE RUNWAY TO BACKSTAGE

Photographs by Niall McInerney

Written by Nilgin Yusuf

Art Direction by Clive Crook

Bloomsbury Visual Arts
An imprint of Bloomsbury Publishing Plc

B L O O M S B U R Y
LONDON · NEW DELHI · NEW YORK · SYDNEY

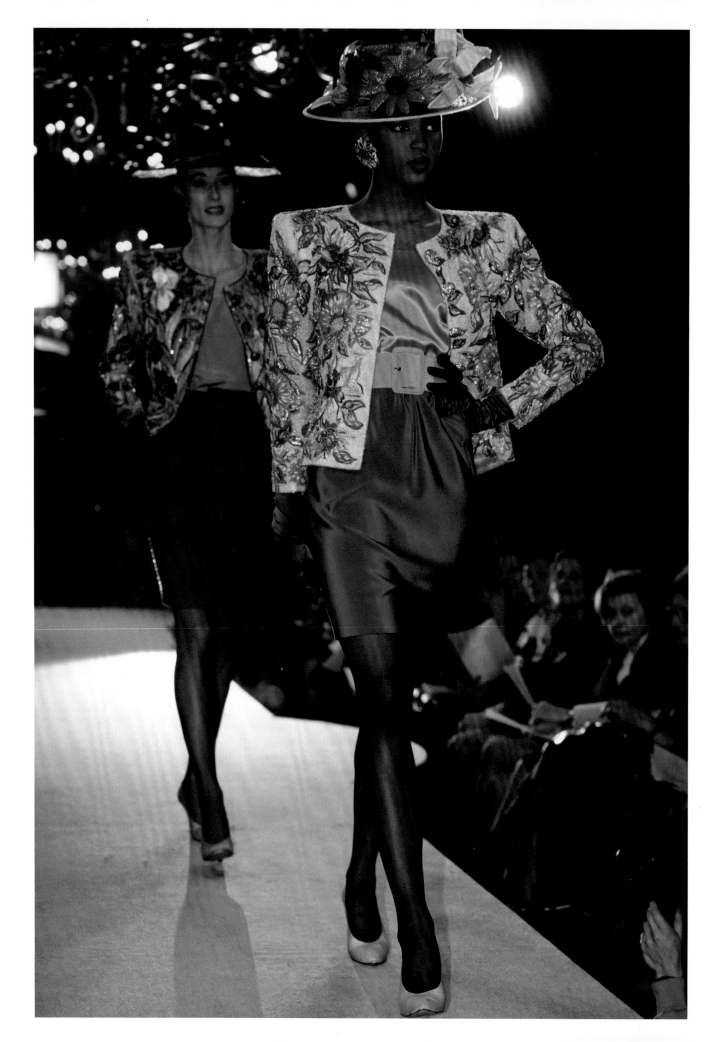

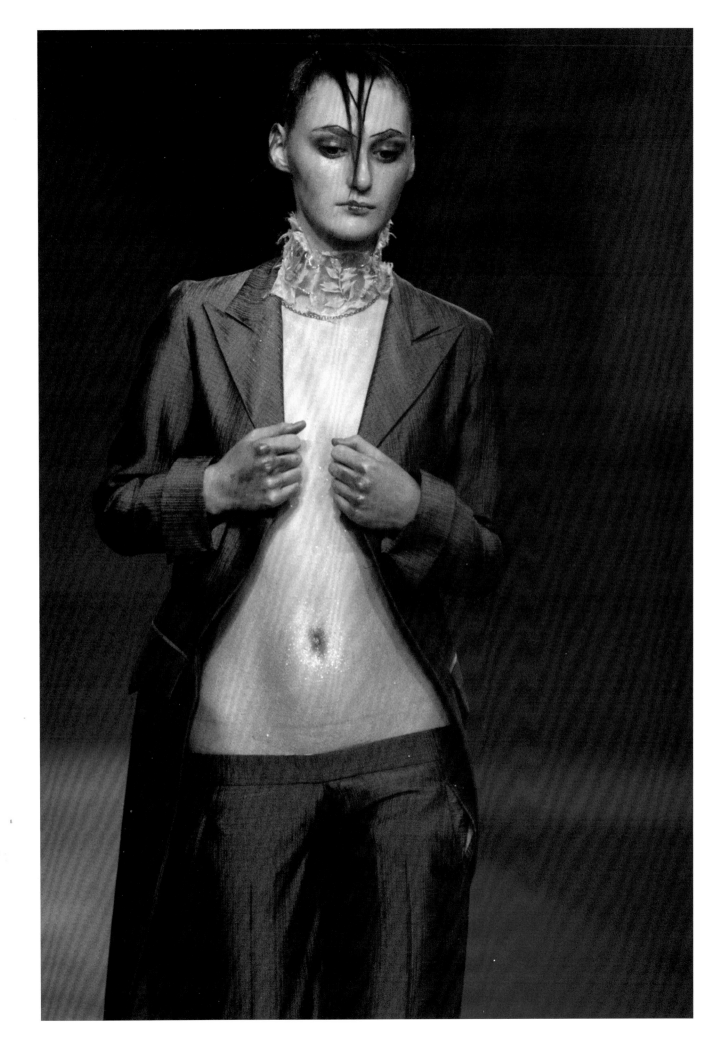

Bloomsbury Visual Arts

An imprint of Bloomsbury Publishing Plc
Imprint previously known as A&C Black Visual Arts
50 Bedford Square, London, WC1B 3DP, UK
1385 Broadway, New York, NY 10018, USA

www.bloomsbury.com

BLOOMSBURY and the Diana logo are trademarks of Bloomsbury Publishing Plc

British Library Cataloguing-in-Publication Data

A catalogue record for this book is available from the British Library.
ISBN: HB: 978-1-4725-9659-8
ePDF: 978-1-4725-9660-4
ePub: 978-1-4725-9661-1

Library of Congress Cataloging-in-Publication Data

McInerney, Niall, 1941-
Fashion's front line : fashion show photography from the runway to backstage / photographs by Niall McInerney ; written by Nilgin Yusuf.
pages cm
Includes bibliographical references and index.

ISBN 978-1-4725-9659-8 (hardback)
1. Fashion photography. I. Yusuf, Nilgin. II. Title.
TR679.M435 2015
778.9'974692--dc23

2015005707

Typeset by Lachina
Printed and bound in China

Images: Unless otherwise credited, all images in this book were taken by photographer Niall McInerney (© Bloomsbury Publishing Plc).

These photographs were taken during a period of pre-digital camera technology and have been digitized from original 35mm slides. Images therefore have naturally textured quality.

Cover: Alexander McQueen's S/S 1999 show No 13 where Shalom Harlow's dress was spray painted by robots.

Title page: Kate Moss in John Galliano Union Jack jacket for his "Filibusters" exhibition in S/S 1993.

Runway shapeshifting: left, Naomi Campbell in YSL Couture, S/S 1988. **Right,** Alexander McQueen's low-rise "buster" tailoring and bruised knuckles, S/S 1994.

Page 8, baroque luxury from Christian Lacroix, F/W 1988-89.

Abbreviations used throughout the text. International fashion collections classified by seasons.
S/S Spring/Summer collections
F/W Fall/Winter collections

Contents

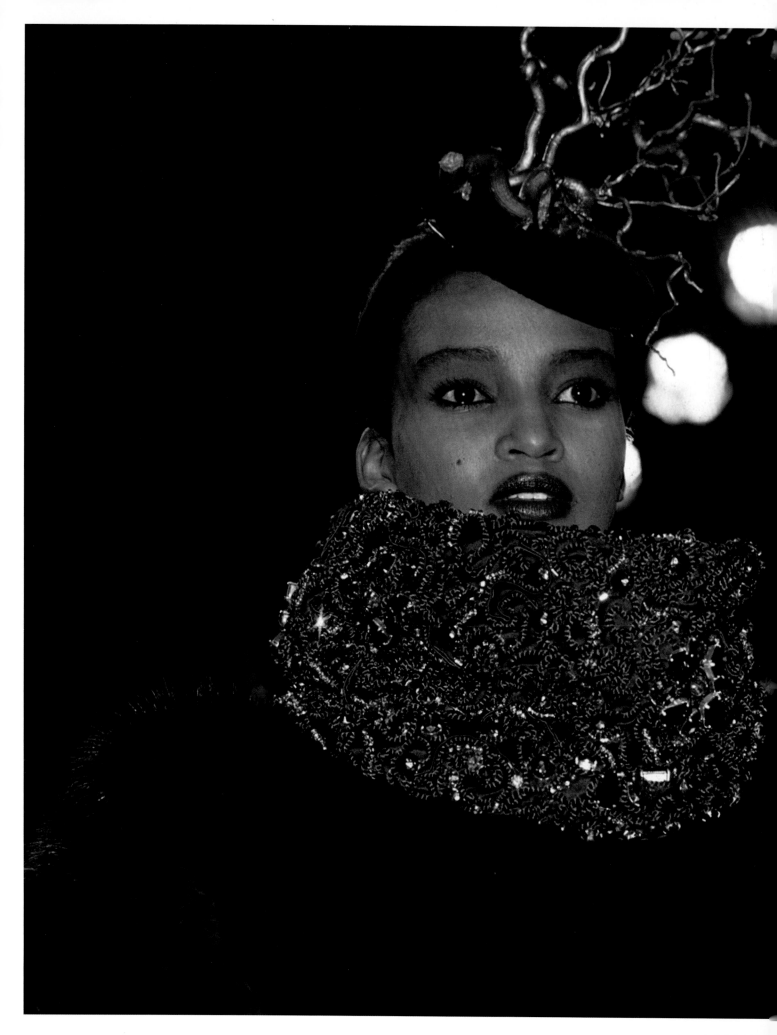

ACKNOWLEDGEMENTS

Many people have been involved in bringing *Fashion's Front Line* to fruition, not least runway photographer Niall McInerney, who has visually chronicled this fast-paced, frenetic world for almost four decades. Niall's experiences, stories, and anecdotes brought the runway circuit to life replete with humanity, spontaneity, and humor – it has been a pleasure to work with him. It has also been great to work with Clive Crook once more, my former Art Director at British *Elle* magazine. Clive worked closely with Niall to select images from the hundreds of thousands he took in his lifetime, and which are now part of Bloomsbury's Fashion Photography Archive (launching online in 2016). Sincere thanks are also due to Clive Arrowsmith and Lucian Perkins, who kindly granted permission to use their images in the book, and to the anonymous peer reviewers who reviewed the draft manuscript.

Insider insights into the world of fashion would not have been possible without the generosity of the top industry professionals who gave their time to be interviewed. Thank you to Antony Price, Sarah Doukas, Lynne Franks, Sam McKnight, Simon Chaudoir, Caryn Franklin, Debbie Mason, Kathryn Samuel, Elizabeth Walker, Iain R. Webb, Brenda Polan, Andrew Lamb, Niall McInerney, Chris Moore, Henry Bourne, Anthea Simms, Mitchell Sams, Simon Costin, Mikel Rosen, John Walford, Sarah Mower, and Jonathan Chippindale. Their perspectives all shed light on this complex, multi-layered world and show how much has changed in a relatively short space of time.

Thank you to Anna Wright, Emily Ardizzone, and Ariadne Godwin, who worked tirelessly behind the scenes at Bloomsbury and to the London College of Fashion, who gave me the time to write and research it. When we look at images of fashion runway, we rarely consider who made them or what it took to get them. I hope that *Fashion's Front Line* goes some way to addressing that.

—N.Y.

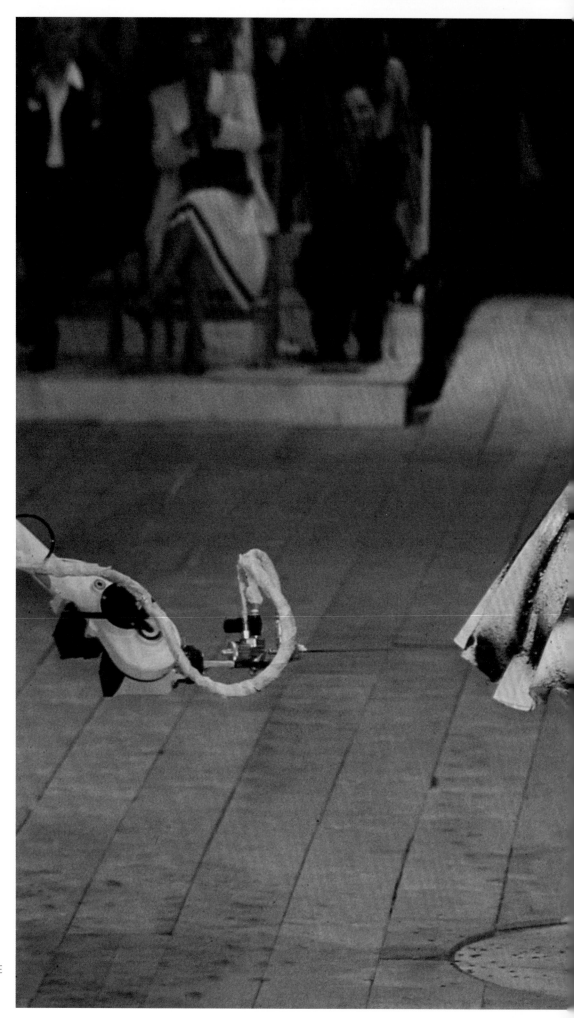

Fashion as art installation and performance in Alexander McQueen's S/S 1999 show.

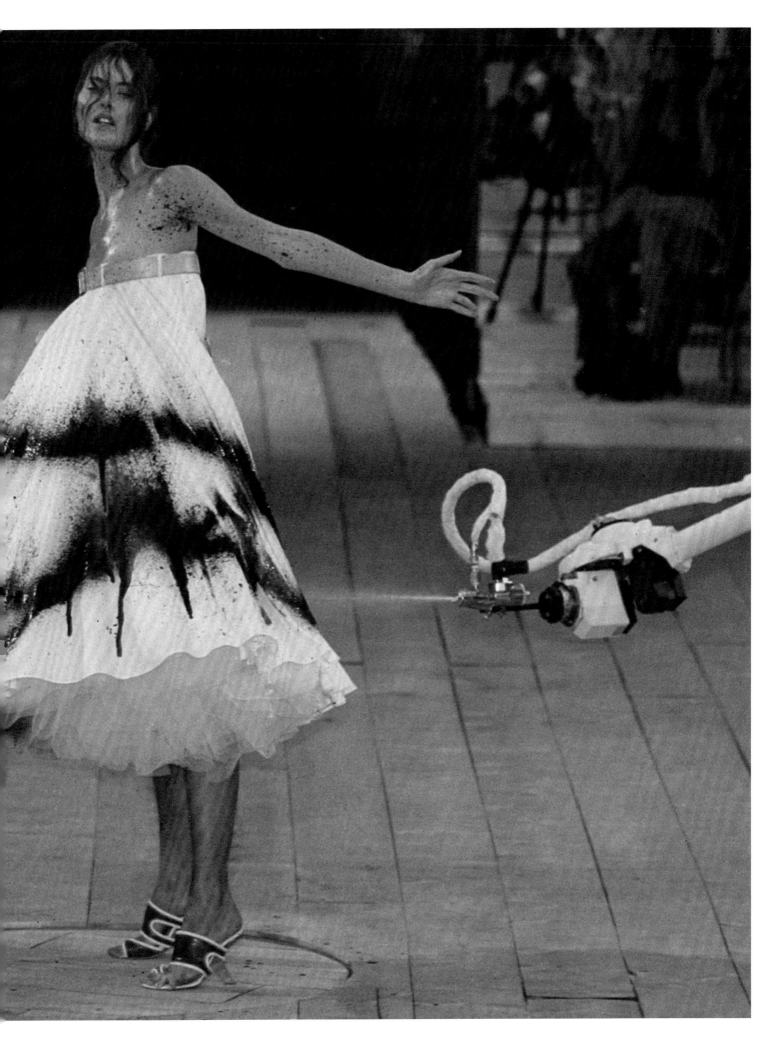

FASHION'S FRONT LINE
THE CULTURE OF RUNWAY

Parallel universe: no one ever forgets their first fashion show. **Left,** a pregnant Debbi Mason, former British *Elle* Fashion Director modeling for Comme des Garçons, S/S 1992. **Right,** Vivienne Westwood, Hobos collection modeled by Sara Stockbridge, S/S 1983.

You never forget your first big runway show.

For me, it was 1983, Paris, Vivienne Westwood. I was a fresh fashion student, seventeen, triumphant at having dodged security guards to claim a precious space in the tent. I was *here*. I was *in*. I did it again with Montana where I actually managed to occupy a seat, and later, with more restrained fervor (and considerably fewer kudos), I waltzed into Jean-Charles de Castlebajac. Although I remember very little about the clothes, this was a rite of passage. I recall the physical, emotional, sensation-rich experience of finding myself in the middle of this parallel universe, not unlike my first visit to a nightclub. Pounding with music and strident with style, this was totally intoxicating. I was *in*. Not just physically in the tents of Paris's Louvre courtyard but *in fashion*, right on the front line, where it was all happening.

In years to come as a fashion writer and editor (*Elle, Daily Telegraph, Sunday Times*), I legitimately and professionally frequented this world. As a member of the press, I had my own handwritten invitations and a seat with a good view. I was able to collect my free bottles of perfume and linger over the running order, double-checking fabrics and precise shades of brown. One senior member of the press had a standard question with which she tested all newcomers. "Is that faggoting?" she asked me, eyes narrowed, as some elaborate lacework sauntered down the runway. "Definitely," I replied with no idea what she was talking about.

Every runway regular has his or her own archive of runway hits. It might be a collection that resonated personally and aesthetically. For British *Elle's* former fashion director, Debbi Mason, it was Romeo Gigli. She was told by contemporary Hamish Bowles that "being at a Gigli show is like being inside your head." Suzy Menkes had a candid adoration of Christian Lacroix and wore his statement jewelry pieces on her collars. Alongside personal favorites, a show might also make a top five list for its memorable production attributes. Whether low-fi and gritty like

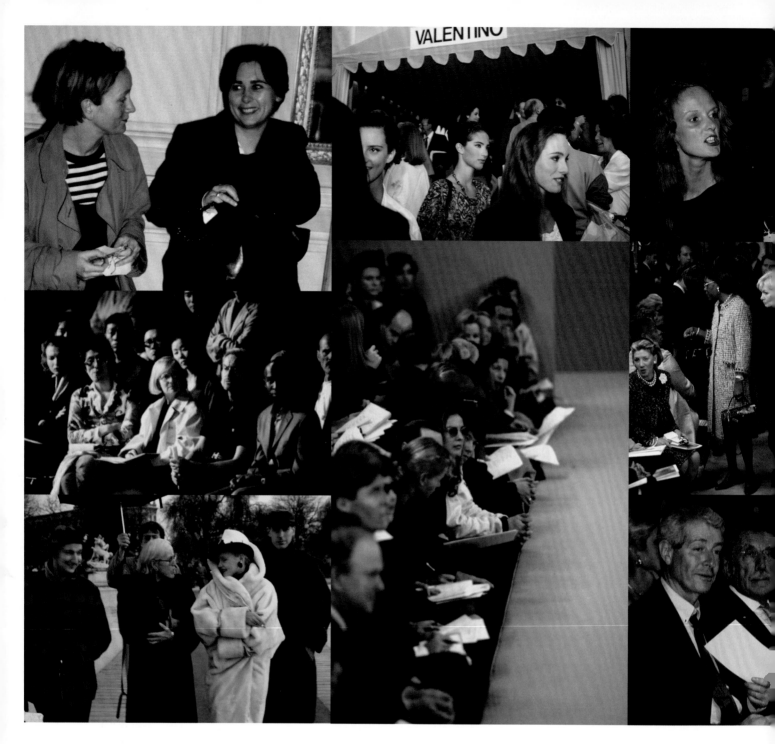

Martin Margiela's dour presentation in a dark, disused post office in Paris's outskirts or the glossy extravaganzas of Versace or Chanel, some shows are simply unforgettable.

But perhaps, the mother of all fashion moments are those when a fashion editor can almost feel the crackle of change in the air, hear the creak of the pendulum as fashion starts to shift. Former *Daily Telegraph* fashion editor Kathryn Samuel recalls sitting in the dilapidated Bluebird Garage on the Kings Road surveying, with some bewilderment,

models wearing "cling film nappies" by a then unknown designer named Alexander McQueen. "Why are you here?" she asked Constance White, an American journalist sitting next to her. "I want to be here when the next John Galliano is discovered" was the response.

This book celebrates three decades of runway shows through the photographic record of Niall McInerney, who covered this rich and colorful field in London, Paris, Milan, and New York. It's a book that tells the story not

Another day at the office: the planning of fashion editorial, networking with colleagues, and hunting out the new is the business behind the glamour. Fashion editors, photographers, and stylists take their seats in Paris, Milan, London, and New York alongside dignitaries, obsessives, and celebrities.

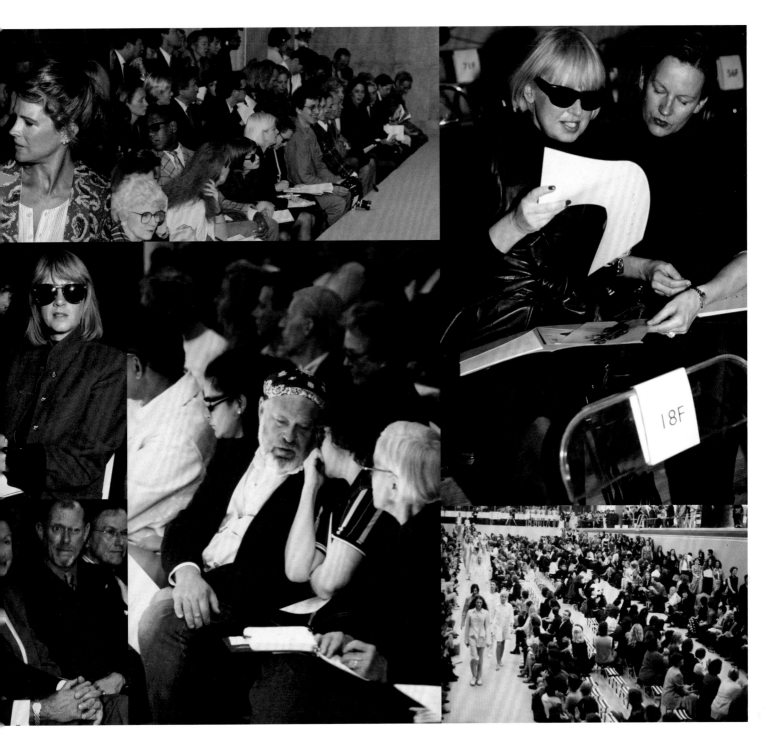

Top left to right,
Alexandra Shulman and
Lucinda Chambers; Grace
Coddington; Andre Leon
Talley, Anna Wintour, Liz
Tilberis. **Center,** Kathryn
Samuel in blue jacket.
Center right, Bruce Weber.
Bottom left, Stephen Jones
and Polly Mellen. **Bottom
center,** Denise Dubois and
the Chambre Syndicale.

of changing hemlines and proportions—that tale has been told countless times before—but of the runway as a culture and construct. It examines the perspectives and eyewitness accounts of those who have encountered it firsthand. Fashion is change, and that change is reflected not only in the evolution of seasonally paraded cut, color, and cloth but also in the way these garments are packaged, presented, and recorded.

In the thirty years Niall McInerney spent inveigling his way into shows, clamoring

over runways, or standing in one position for hours at a time, he has witnessed enormous change. He has seen changes in the scale of the production and certain players, be they capital cities or individual designers, public relations firms, or press organizations. When he started, London was just hatching; by the time he finished, British superstars were being transplanted into the leading French houses of Dior and Givenchy where, eventually, McQueen and Galliano imploded under the pressures of *le machine*.

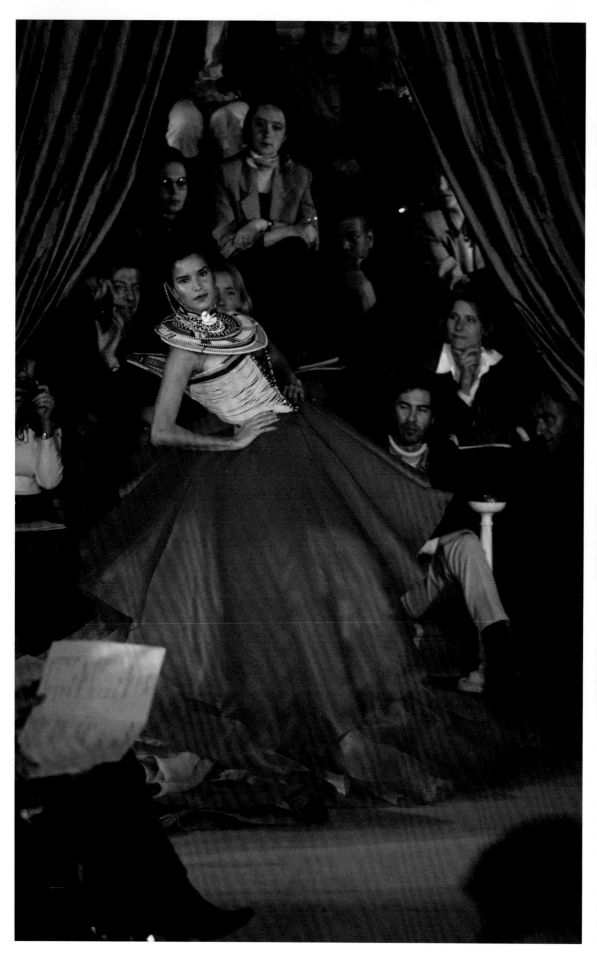

Creating a spectacle: John Galliano's first Christian Dior collection in S/S 1997 combined African tribal corsetry with a Belle Époque silhouette. McInerney was a fan of the wide shot, **right,** which was able to convey the occasion, theater, and ritual of the fashion show.

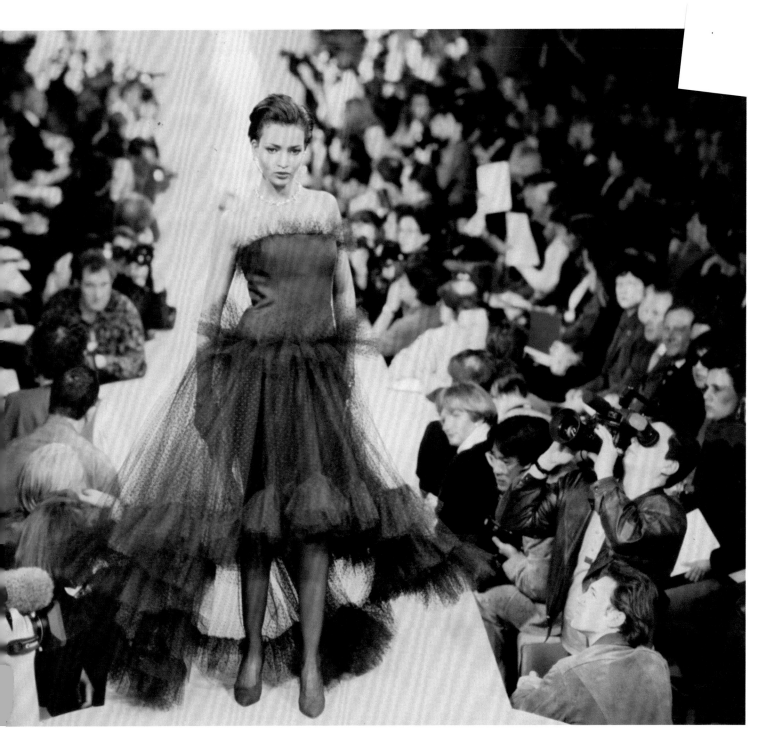

Changes in technology have seen the world move from analogue to digital, which has had an impact on how fashion is produced, disseminated, and consumed. As we move forward, the reverberations of this revolution continue to shape and inform how fashion shows evolve. When McInerney started, everything was on film and had to be sent off for processing. Eventually fashion became increasingly connected to the Internet and social networking. Instant, seamless, and infinite, this development

Being there, overleaf: defining collections through the decades captured by McInerney. **Left,** Naomi Campbell shimmers in powder pink Chanel, F/W 1990-91. **Right,** the energy and dynamism of early Vivienne Westwood in the F/W 1993-96 Witches collection.

brought both positive and negative change to its mediators.

There have been changes in perceptions of beauty. In the not so distant past, runway models did not do editorial so appeared only on runways, not in magazines or commercials. They were attractive, elegant women who could walk the walk. That was before the big fashion explosion of the late 1980s when the supermodels raised the beauty bar by several feet and their earning power by millions. Celebrities in their own right, they eventually

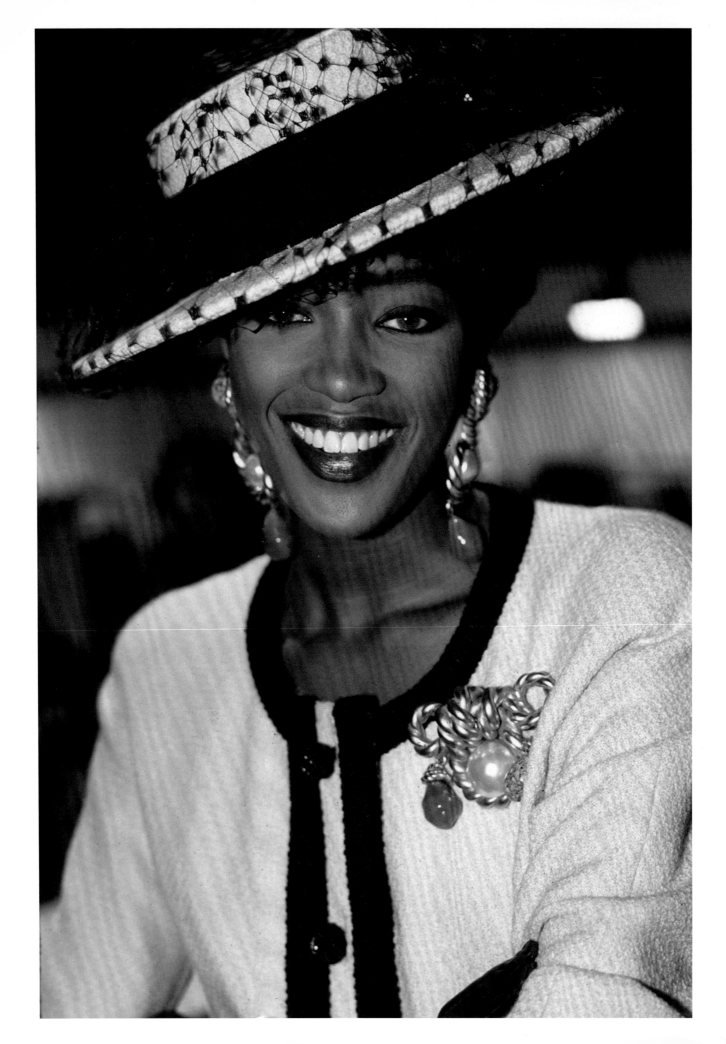

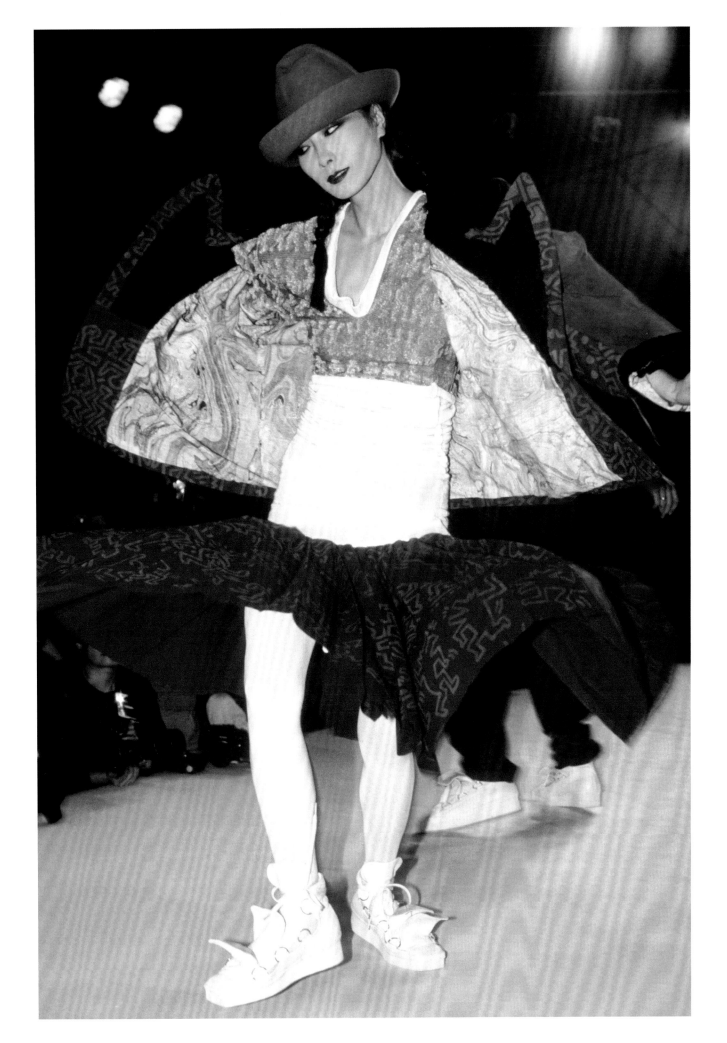

attracted into the shows the paparazzi who realized the runway was as sexy, exciting, and profitable as Hollywood.

Our understanding of what a fashion show is has changed. The classic interpretation of runway, where one model in one outfit walked up and then down the runway, accompanied by a woman whose sonorous voice, which sounds a bit like that of a posh bingo caller, called the numbers—"numero trois"—gave way to the fashion show as entertainment where singers, dancers, trapeze artists, unconventional models, animals, celebrities, and nudity provided a Fellini-esque, baroque bellyful. These shows commonly took place outside of the standard fashion locations in ice rinks, supermarkets, metros, and, fittingly, a circus tent. As image became increasingly important in this media-led frenzy, stylists became vital in fashioning the runway vision. Women like Amanda Harlech (Karl Lagerfeld and Chanel), Carine Rotfield (Tom Ford and Gucci), and Katie Grand (Alexander McQueen) infused collections with credibility and desirability, propelling images of female strength and style onto the runway.

People watching:
above, fashion designer Alexander McQueen with his stylist, Katie Grand, **left,** and his friend and fashion muse Amanda Harlech. **Right,** Suzy Menkes, grande dame of fashion journalism is captured on the move in Milan, F/W 1993–98 wearing her trademark statement jewelry.
Below, an unexpected arrival of Buddhists attracts McInerney's lens.

The high-concept shows of the 1990s championed by Gareth Pugh and Alexander McQueen were closely related to the fine art of installation or performance. Rather than making you laugh or feel happy, these shows, if they didn't alienate you entirely, made you feel clever and somehow managed to raise fashion's cultural capital. With designs that bordered on sculpture, these creations were fit for a gallery with prices to match. In the 1990s, many fashion labels became arms of the luxury goods industry, and branding and big business became the focus of public attention. We saw the glitter of a well-oiled machine that could and continues to generate millions of dollars for its shareholders, and this too changed many things in many ways. Some will say that this emphasis on big business has changed the atmosphere of fashion shows. Greater professionalism and proficiency by organizers combined with the dead hand of health and safety regulations has given a less spontaneous, more sanitized feel to the presentation of runway collections. "Everyone used to be crammed in the tents,

smoking like chimneys. Sometimes, it felt like this was a death trap," recalls fashion commentator Iain R. Webb.

Whatever the changes, fashion continues to retain a tremendous power. It is something that is aspired to, dreamt of, and desired by people all over the world who become starry-eyed about it. Wrapped up as it is in notions of status, beauty, power, esteem, and social acceptance, fashion's imagery and its hype sell magazines, newspapers, careers, clothes, perfumes, and handbags. People still fight, beg, plead, wrestle, connive, and cajole their way into this arena, as though their lives depended on it. "I've met runway photographers that have covered war zones in places like Croatia and they've said this is worse. They can't believe the hunger, the pushiness; people behaving as though their life depended on getting into a runway show— and that's from someone who has been in real life and death situations," relays runway photographer Anthea Simms. This is not a new observation. In April 1978, photographer Don McCullin, renowned for his photography in Vietnam and other battle zones, was sent to Paris to photograph the collections for The *Sunday Times* newspaper by fashion editor Michael Roberts. Chris Moore, who stood next to him at the Dior show, recalls his saying this was worse than a war.

If a fashion show can be compared to a war, then the runway photographers are its foot soldiers. They have arguably the toughest and

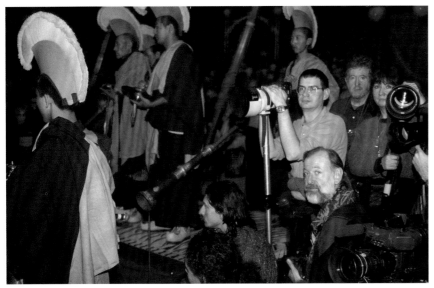

most physical of front line jobs and the fewest perks. Fashion designers are at the center of all this action, and every group from editors to stylists, hairdressers, and bloggers have had their moment of glory in the spotlight; runway photographers have served invisibly for the last fifty years. They are seen almost in abstraction: a pyramid of cameras, corralled at the top of the runway, not at the sides where they once were. With a few notable exceptions, runway photographers are rarely known by name or for a distinctive style or interpretation. Their task is one of technical documentation rather than subjective translation. Yet, they are the all-seeing eye that, in a blink, captures, chronicles, and

conserves what we call fashion. They do not have glamorous titles or fancy outfits. They do not have the allure or seduction of fashion photographers, the ones that do "sessions" or editorial shoots for the glossy magazines.

Yet, before anyone else can snap a picture, the official photographers step in as the sole custodians of the runway image. It is they who have documented what happens on the runway and, as time passed, what happens *around* the runway, *behind* the runway, and *beyond* the runway. Their work, carefully edited by a fashion editor or reporter, appears in newspapers and magazines or online to illustrate the look of the season. Journalists eulogize, idealize, and contextualize; the runway photographers show us how it is.

Runway kings:

top, McInerney with Dan Lecca, Chris Moore, and Thomas Wiedenhofer (photographer unknown). **Below,** runway veteran Chris Moore photographed with Donatella Versace, sister of designer Gianni Versace. **Right,** Alexander McQueen's F/W 1996–97 collection features a print from a Don McCullin Vietnam War photograph. **Far right,** a beautiful cast of thousands at Dries Van Noten, F/W 1997–98 grand finale.

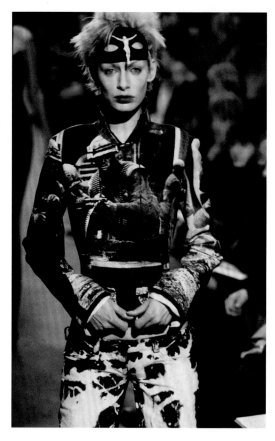

Although a great deal has changed in this arena, as the pictures in this book will illustrate, what hasn't changed is the front line's premier position as the nexus of the fashion industry. If fashion is your business, profession, or addiction, then this is where you must be, every season, without fail. From fashion generals to cannon fodder, everyone who goes leaves behind their loved ones and the comforts of home for three to four weeks at a time. Living in hotels or bed and breakfasts, moving from city to city, tent to tent, chair to chair, they tirelessly seek out the new look because that's what fashion is all about. It's a hell of a show and you need to have been there to understand, but in case you weren't, Niall McInerney was. We salute him.

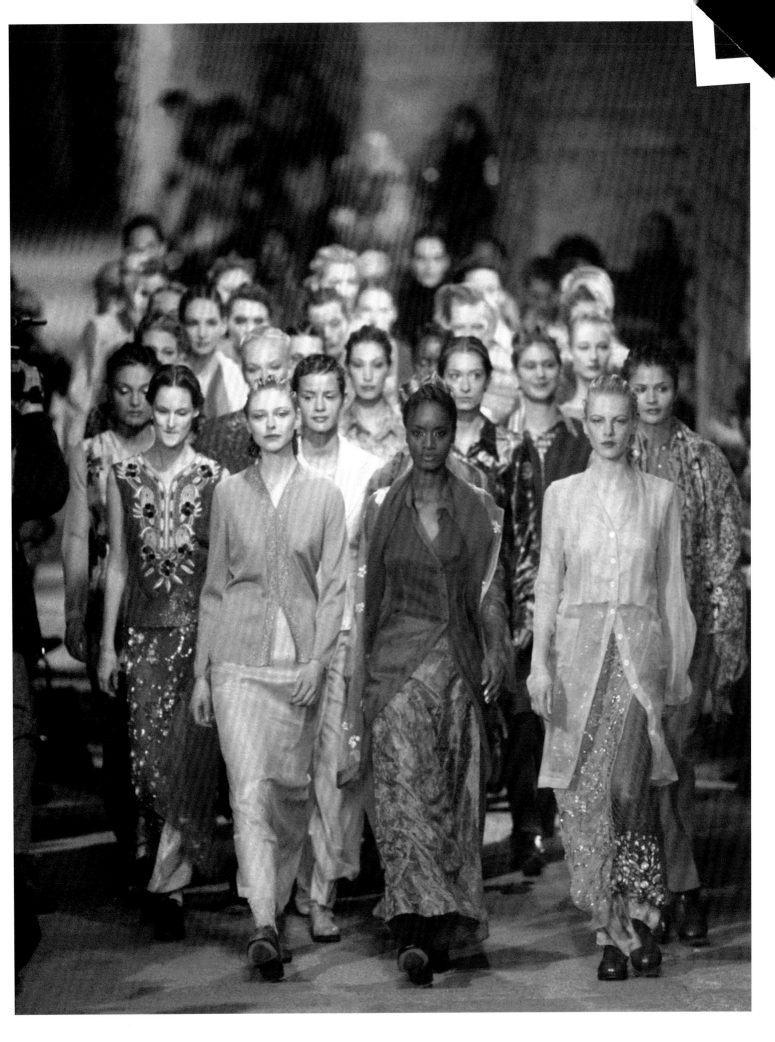

Left, riotous pattern and color at Kenzo in F/W 1982–83, who brought a multi-cultural, eclectic aesthetic to Paris's well-behaved runways.

Overleaf, Polly Mellen, Diana Vreeland's protégé with former collaborator and photographer, Richard Avedon in May 1986, keeping their fingers crossed for a good show.

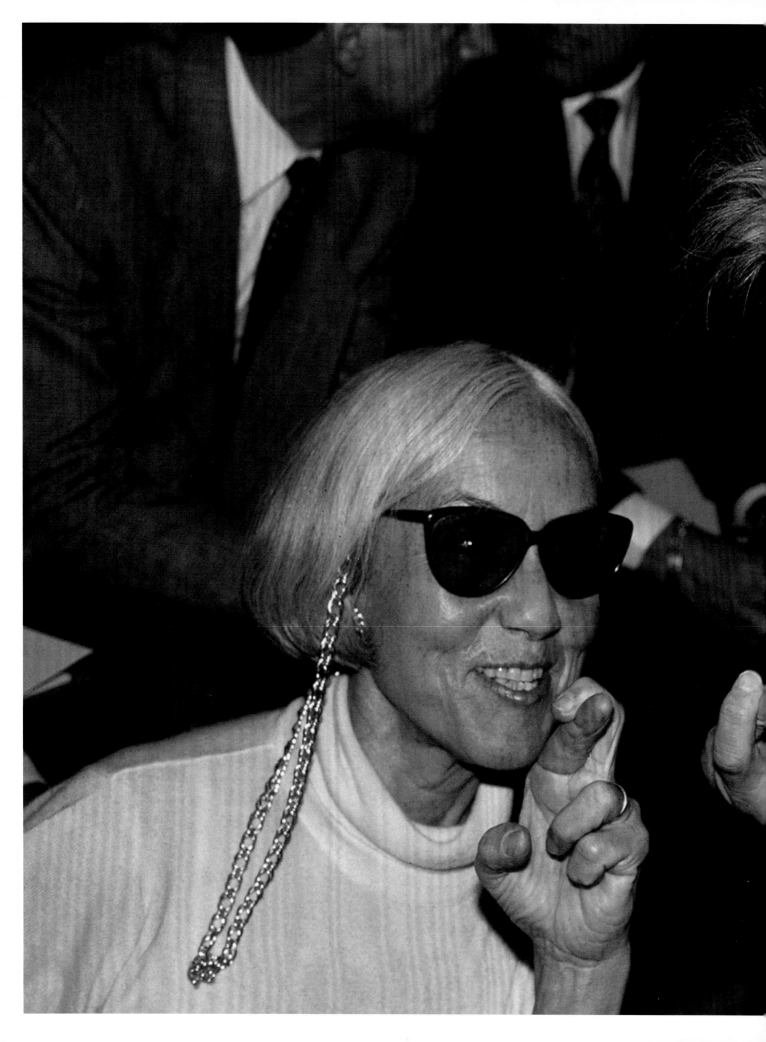

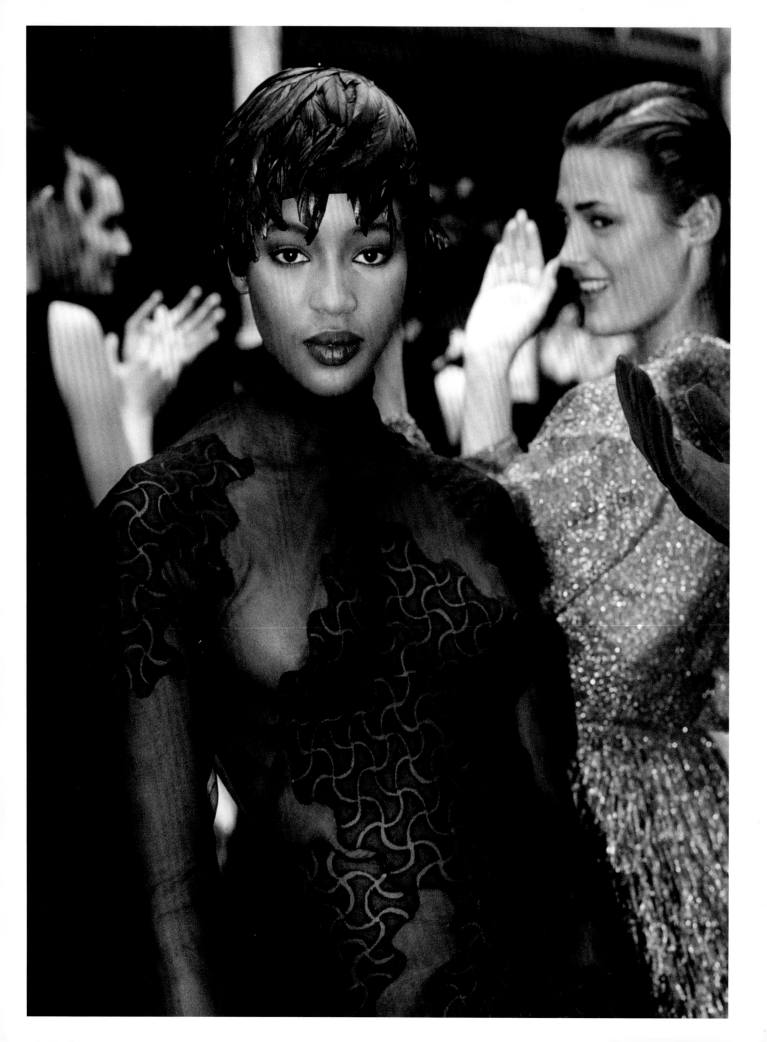

CHAPTER 2

PREPARING FOR BATTLE

BECOMING A RUNWAY PHOTOGRAPHER

From the early 1980s onwards, if you were involved in fashion, you would have seen a recurring figure at all the key shows. A wiry, sharp-featured individual with elbows to match, Niall McInerney commonly wore a blue shirt and jeans and was constantly loading, preparing, or pointing his Nikon FM2 at something interesting. His fellow runway photographer Chris Moore recalls Niall McInerney's blue shirts with some exasperation. "He was often shooting in front of me and I would look back at the pictures and say: There's another one of bloody Niall in his blue shirt."

If there was a fashion show, McInerney was there, like a human extension of the runway. In the early years, he was at the sides, leaning in to take the picture and then leaning out when it passed. Later, he stood on his metal box, an indestructible piece of hardware made by a military supplier in the hinterlands of Heathrow Airport. At only 5 foot 7, he set it upright to give himself more height. If another photographer was blocking his view, he would rapidly construct a makeshift platform for his box from a series of interlocking plywood slats

Life through a lens: previous page, over a lifetime of visual inspiration can be seen in Niall McInerney's pinboard, a site of memories and moments spanning over half a century.

In the frame: left, Naomi Campbell at Azzedine Alaïa, F/W 1988–89 with Yasmin Le Bon in the background. **Right,** McInerney with Anna Piaggi, fashion editor, style icon, and muse (photographer unknown).

that he designed and always carried in his case. Because of his improvised contraption (known by his peers as the "Orgasmatron"), the other photographers gave him the moniker "The Master Builder." McInerney's contraption, which he called "my secret weapon," was both a source of amusement and irritation. He recalls

"they would all shout 'Sit down! Sit down!' but I wouldn't sit down because you wouldn't get the picture if you sat down."

"Niall would get so close that models would almost be falling over him," remembers British *Vogue* runway photographer Mitchell Sams. "He would always be determined to build something to get a better view and use whatever was around him: tables, crates, sound equipment. He could probably build something from a pile of old coats and a bunch of twigs." Niall's reputation for squirreling himself into the best photographic positions at the very front of the runway "for a clean shot" meant he would sometimes obstruct the view of others. "My boss at the time, Michel Arnaud, would be almost bursting a blood vessel because Niall would be in the way. At the end of the show, Niall would assume this innocent, slightly furtive face because he knew that half the photographers wanted to kill him," continues Sams.

Described by a former fashion editor as "tenacious like a terrier," McInerney, slightly built at 140 pounds, was nimble on his feet with fast movements and reflexes. He was also renowned for his ability to get into shows whether or not he had been invited. "Throughout my career, there was not a single show that I didn't get into," he said with evident self-satisfaction. When he was an unknown photographer and before he had acquired prestigious clients such as *Newsweek* and *Harpers & Queen*, cunning and stealth were required to penetrate the fortresses of security guards who would refuse entry without a ticket.

Backstage banter: the photographer backstage with Kate Moss early in her modeling career. A sense of humor and winning personality has always helped to warm subjects to McInerney and his camera (photographer unknown).

"Within your peer group, your status is defined by whether you can get into the big shows. Some photographers were devious and sneaky about getting into shows. Niall was just ingenious; funny and charming. He was able to gauge very quickly who he was dealing with and use it to his advantage," notes Anthea Simms.

"Once, we photographers were standing in the rain waiting to be let in by security. Andre Leon Talley of American *Vogue* turned up and Niall, quick as a flash opened his umbrella for him and they were both let in," recalls Chris Moore. Another time, Terence Donovan, a burly photographer who did judo, simply lifted Niall over the barrier. "The Cravat Rouge [Parisian security] weren't happy about it," grins McInerney, "but I was in." Then there was the time he was invited to take the service elevator by the Calvin Klein security guard who looked suspiciously at his camera trolley (all the other photographers had shoulder bags) and told him: "That will have to go in the service elevator." Niall took the tradesman lift that opened up directly onto Klein's showroom where he was able to secure a prime shooting position. McInerney adds, "You always had to do a bit of research before the show to work out where the models would come from and where they would be walking. Would they appear at the sides and walk down the middle? If they came from the sides and your space was in the middle, you would get a clean shot. If you were at the sides, you would get lots of arms and legs. If you got into a show early, you might see a rehearsal. If you got in late, you did what you could."

Whether it was his unstoppable Gaelic chutzpah or an insatiable sense of curiosity, McInerney always felt that there were more pictures to be had beyond the runway. Even though the majority of his time was spent securing the right aspect for documenting the designer outfits, McInerney believed that "there's a single moment, the garment is flowing beautifully not sitting awkwardly, the model is looking up, she is in graceful motion." He was keenly aware of the dynamic environment around him, and for the trained eye, it was one rich in photo opportunities. Whether he was framing the power players of the front row or the colorful cast of characters that circle fashion's orbit,

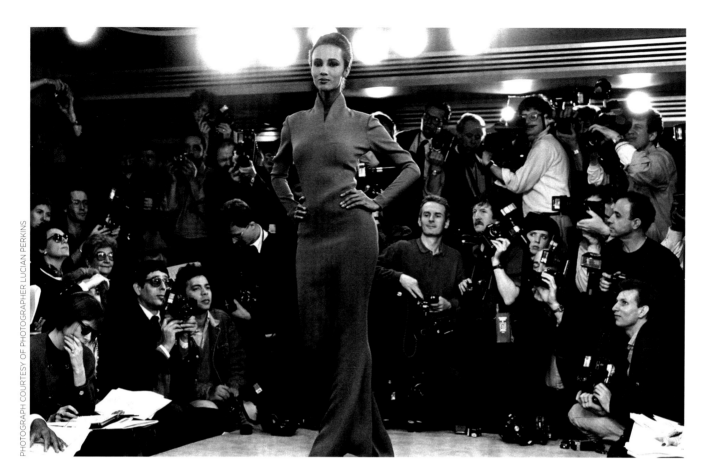

McInerney was just as, if not more, intrigued by the "beautiful people" off the runway.

When the show was over and the other photographers packed away their cameras, Niall would head off to see what he could find backstage. He understood instinctively that these images had relevance and value long before the idea of "backstage" became a standard element, even a cliché, of print and digital editorial. McInerney was always ready for front line duty: "I always kept a camera, a roll of film and flash with me at all times." Now, there are three or four photographers to a team, each assigned different photographic beats: one for runway, one for capturing the colorful cast of street style characters, unknown but visually distinctive, and one to snap the front row's lauded players: editors, style ambassadors, opinion formers, celebrities. This reflects the fact there is now a greater hunger for this type of "upstaged" incidental material, probably due to the Internet's greater exposure of fashion. In fact, recording backstage has become its own mini-industry with filmmakers, beauty journalists, photographers, and video bloggers all cramming into increasingly tight spaces.

Low-key luxury: above, Calvin Klein's collection in New York, S/S 1987 saw McInerney first through the door and able to secure the prime shooting position, seen centre front just behind Iman. He told the model that the runway photographers had voted her "Rear of the Year" (© Lucian Perkins, reproduced with kind permission).

Although some photographers see runway as a stepping-stone, a grubby interlude before sculpting their careers into more cultured callings, others make it their life's vocation. Niall McInerney, born in Limerick, Ireland, in 1941, is one of the latter. The youngest of five, his father was an engineer, and his mother looked after the home and family. He went to Crescent School, a strict Jesuit school (whose alumni include actor Richard Harris and TV entertainer Terry Wogan) where the boys were sometimes beaten for their misdemeanors. McInerney, although bright, was a rapscallion. When his friends dared him to climb out of a fifth floor window, he did so. "An elderly lady was passing and ran into the school saying: 'A boy is trying to kill himself!' I was made to write an essay on the Disadvantages of Suicide, but, after that, I was in the bad books," says McInerney. At sixteen and a half, he left Ireland for London, not knowing a soul, with twenty pounds in his pocket. He had no idea what the future held, but he knew there were plenty of jobs and something would turn up. Even though he was not trained in photography

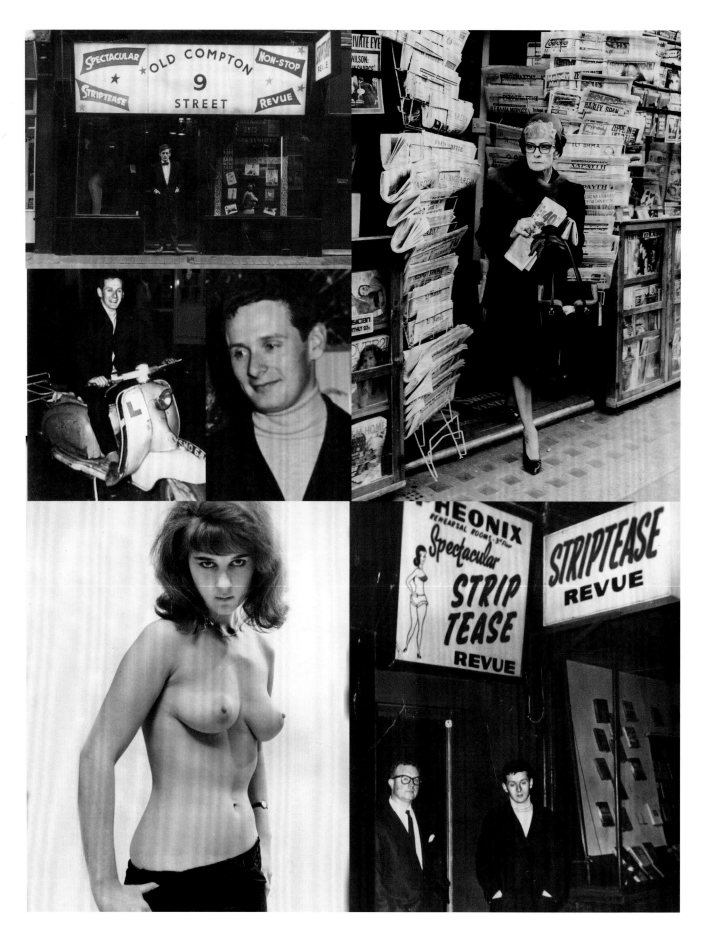

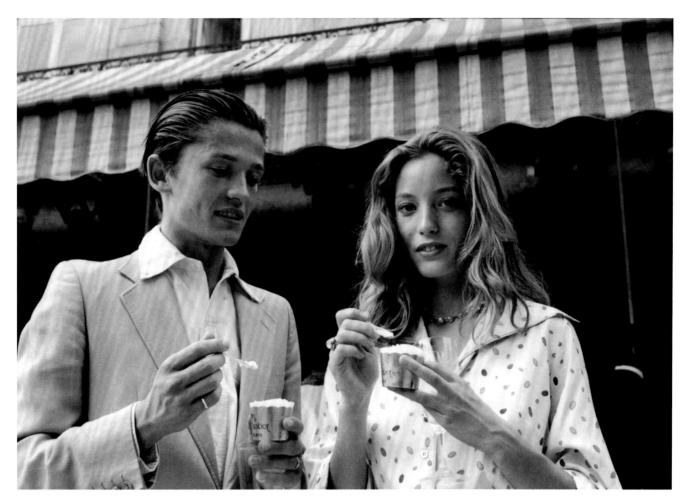

in any formal sense of the word, it is likely that his early years in London, in a series of random, unskilled jobs, steeled and prepared him for a life in runway in a way that no photography degree ever could have. In the Walls ice cream factory in North Acton, he worked at a conveyor belt keeping an eye on gliding lollies and ice cream blocks as they were wrapped by machine. This relentless ice cream sequence is arguably comparable to certain runways that could politely be described as vanilla. In the future, he would have to endure many dreary runways, in between the occasional heart-stopping, visually brilliant one.

For a while, he was a British Rail porter at Paddington Station. He recalls that "there were three shifts. I would wake at 5:30, push a trolley and wear a hat. I did 'quilling,' which involved pushing the hand trolley from the taxi rank to the station platform transporting people's luggage. You made some good tips." He couldn't have known

The Soho years: left, McInerney's first assignment was taking promotional shots in the 1960s of strippers in Soho's Pheonix Club in Old Compton Street, which he managed. His first photographs are in the window. Fledgling street style from Niall McInerney; one of the strippers at the Pheonix; a portrait of a young Niall and sat astride his Lambretta scooter in 1967 (images of McInerney: photographer unknown).
Beautiful people: above, Daniel and Lucie de la Falaise during a reception at the British Embassy in Paris, July 1989.

then that a trolley was to become a lifelong companion, loaded up with photographic equipment and pushed around the most glamorous cities in the world. As a cinema usher at the Swiss Cottage Odeon, he took the tickets and led punters to their space; in years to come, finding the space would be the repeat story of his professional life.

But it was in 1962 when Niall was given his first photographic assignment. At the time, he was twenty-one and working in Soho at a strip club called the Pheonix. "I started as the projectionist and eventually became the stage manager," remembers McInerney. The late, great photographer Lewis Morley—who was known for his portraits of celebrities and most famous for his photograph of a naked Christine Keeler astride a Panton chair—had his studio just around the corner in Greek Street above the Establishment Club, and Niall struck up a friendship with him recalling that "he would always walk past our club in a cloud of smoke, holding a cigarette."

London Fashion Week
— designers, buyers,
copyists . . . and the
Fashion Pack. What the
Pack sees today, you'll
be wearing tomorrow ▷

Aces in the Pack

REPORT BY JO EARLEY
PICTURES BY CLIVE ARROWSMITH

When the owner of the club, Billy Gardner, asked if Niall would take promotional shots of the twelve strippers, Niall turned to Lewis Morley for guidance and advice. McInerney remembers him with clear fondness: "He was fabulous to me, a real mentor. He invited me to his studio, lent me equipment; Tungsten lights, a Rolleiflex camera and background paper. He showed me how to load and unload a camera and how to measure light. I owe a lot to him; he got me going and introduced me to real photography." The black and white photograph of "Carol," whom Niall affectionately called Miss Whiplash because of her specialty act, is tacked to the door in Niall's studio. She smolders for the camera, black bangs flicked at the sides and topless: "The girls were dancers; they knew exactly how to stand and used to practice their poses. I didn't need to tell them how to be in front of the camera but I did talk to them to make them feel at ease. I wanted them to enjoy it," says McInerney. Chandra Chanel, another of the Pheonix's star acts, was a stunning transsexual who draped herself over

Tipped for the top: the runway photographer was featured in a You Magazine feature photographed by Clive Arrowsmith in in the early 1980s as one of fashion's rising stars. **Back row, left to right,** Caryn Franklin, Iain R. Webb, Niall McInerney, Michel Arnaud. **Front row, left to right,** Linda McLean, Mikel Rosen, Sally Brampton, Debbi Mason, Janine du Plessis, Ray Allington, Stephen Linard, Marysia Woroniecka, John Flett, Stephen Jones, Dylan Jones (© Clive Arrowsmith, reproduced with kind permission).

Billy Graham's car when he arrived one day, inviting Soho's sinners to repent.

Shots of strippers might not be the most salubrious start to a career in fashion photography, but it was at least a start. When the owner of the Pheonix was found dead, face down in his own swimming pool, Niall decided it was time to rethink his professional trajectory and set up as a freelance tourist photographer. Although not uncommon in the 1960s, it was not a choice for the faint-hearted. You had to be physically fit, able to think quickly, and respond accordingly. It required an eye for an opportunity, a winning way with strangers, and the ability to compose a shot in seconds. It required strategic planning, creative enterprise, technical know-how, and financial preparation. It required everything that was needed to succeed as a runway photographer, and this was to be Niall McInerney's boot camp where his skills and expertise were tested in preparation for the battlegrounds of Paris, Milan, New York, and London that lay ahead.

Operating under the name Piccadilly Press, McInerney hung around with his camera at the

top end of Lambeth Bridge in London waiting for coach loads of foreign visitors to be dispatched. As they descended from their coach, Niall photographed them in groups in front of Big Ben and the Houses of Parliament. When he slipped the coach driver some money, the driver would disclose the address of where the party was staying. On the last day of their trip, Niall would reappear with the souvenir prints, which the tourists were happy to pay for. On the wall of his studio is a black and white print of a group of Hare Krishna, including their founder, in Parliament Square, all smiling beatifically at their photographer. Decades later, he would get similarly positive responses from designers and their friends or supermodels.

Niall found himself in fashion when he met and started to date Melanie Haberfield, one of the founding designers of Swanky Modes (a desirable London label of the mid 1970s that specialized in body-conscious stretch jersey). Haberfield asked if he would take pictures of the collection, and Niall obliged. This led to Niall taking pictures at the Swanky Modes fashion show, and one runway led to another.

Fashion calling:
Niall McInerney photographed the degree show of Willie Walters, which would become Swanky Modes, modeled by Helen Scott Lidgett at Battersea Funfair in 1978.

Following pages,
scarlet silk dress and pea green leather gauntlets at Thierry Mugler, S/S 1980.

McInerney recalls that his "first one was at Saint Paul's Churchyard and was organized by Lynne Franks." A precursor to London Fashion Week, this was an event promoting young British designers including Paul Howie (Franks' husband at the time) and Wendy Dagworthy.

After this, McInerney started to cover the unfolding London fashion scene that was in a period of growth and media interest including events related to *The Clothes Show*—a long-running TV program that reported on the fashion industry and various designer collections. In 1979 "on a wing and prayer," he decided to try Paris, at that time the undisputed center of the world's fashion scene. He had never experienced anything like it. McInerney says, "I was knocked out by the whole thing. The sound system was fantastic, the girls were incredible. The first one I really remember was Montana; the sound track was cawing crows in a churchyard. Have you ever heard crows before? I remember them in Ireland. They make a tremendous racket all flying around telling each other, 'this is my space this is my space'—a bit like catwalk photographers."

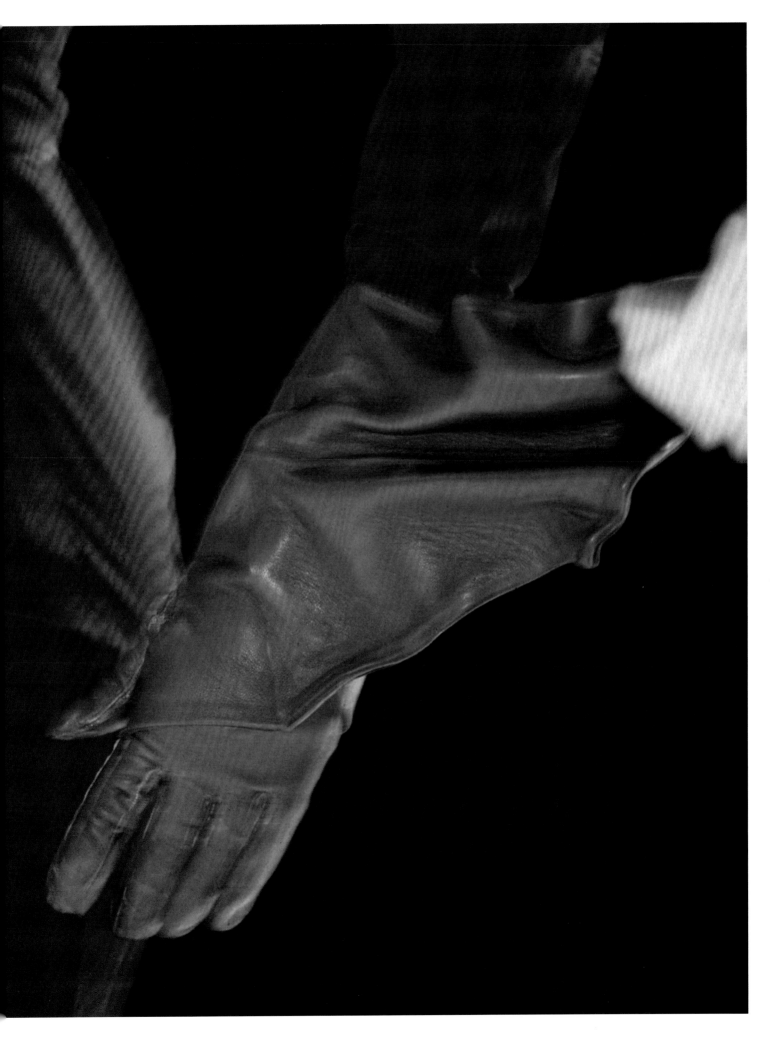

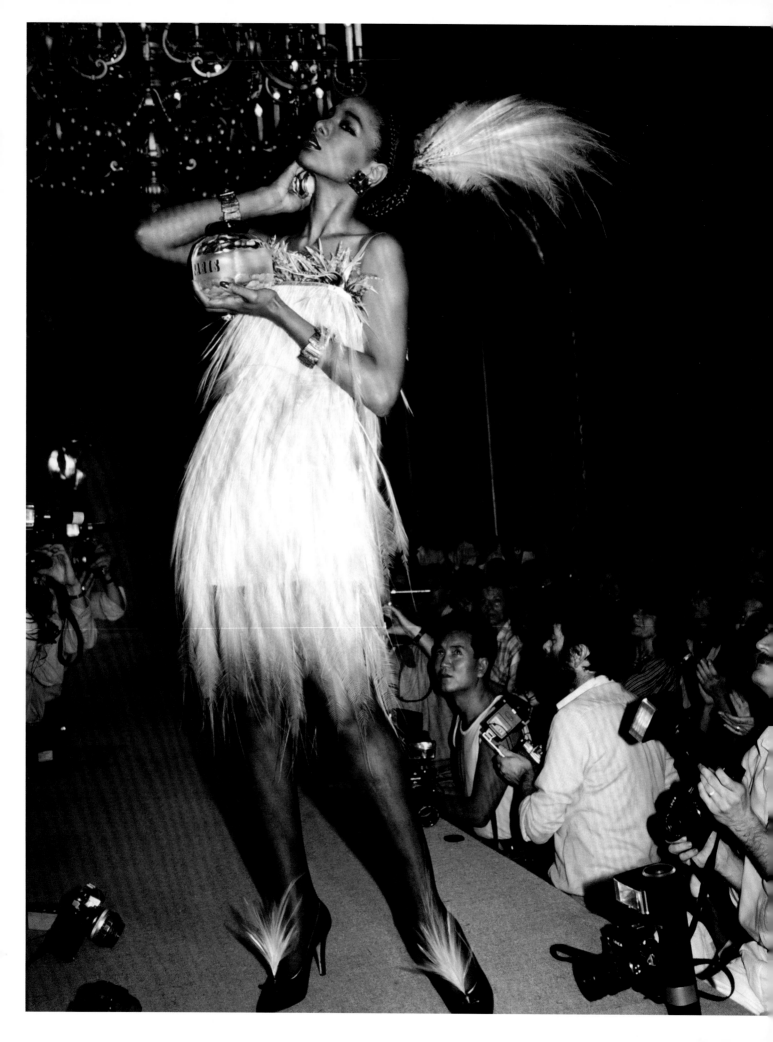

CHAPTER 3
CAPTURING THE RUNWAY

THE SKILLS AND SCRUMS OF RUNWAY PHOTOGRAPHY

The architecture of the runway environment is, at first glance, all about the viewing of outfits. A runway, or walkway along which models present the latest looks, is sometimes a raised platform, sometimes set at floor level. Traditionally, the international press has been seated on one side and the buyers of the world's designer stores on the other. The runway photographers stand at the end of the runway, facing the runway as the models emerge.

However, anyone who has been to a runway show understands quickly that its structure and space is not just about clothes but about power. The further back an individual is seated by the public relation representatives and organizers of the show, the less is considered his or her sphere of influence. For visitors, this is a seating plan that can cut deep, believing as most do that the position of their seat is a reflection of professional regard.

This is an arena where reputation within the business is laid bare, a pecking order

Passport to another world: left, the launch of Yves Saint Laurent's Paris fragrance at the Hotel Intercontinental, Paris at the F/W 1983-84 collections, a time when runway photographers could all be clustered around the runway. **Above,** the calm before the storm, awaiting programs and chairs at Anna Molinari for Blumarine.

made public. "People would take it so seriously," remembers Debbi Mason. "They had probably been on a diet for weeks leading up to the show, had arrived in all of their finery and then to be placed in the third row? It was an insult!" At different points, it is possible to plot shifting perceptions of power. In 2008, Dolce & Gabbana invited influential bloggers into their front row seats, which sent traditional print journalists into paroxysms of indignation.

However, the runway photographers perhaps best illustrate this visible display of status. They stand; they don't sit, often interminably in an ever-decreasing space. "We are held back like cattle," commented one photographer, who noted that there is no union for runway photographers and that their working conditions leave a lot to be desired. "We are seen as no different to security," rued another photographer, who felt that their status has become increasingly diminished in the face of more powerful, digital, online competition. Niall McInerney, now retired, is unequivocal about their status: "Catwalk photographers were low in the pecking order

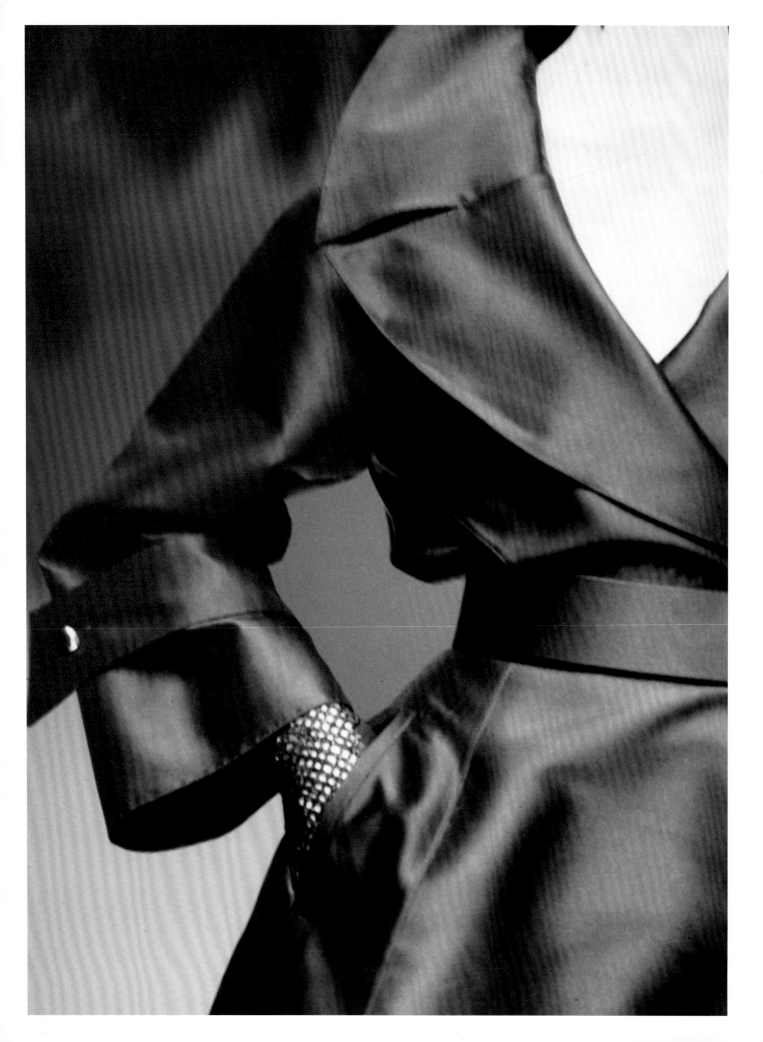

of fashion, abused from one end to the other, standing forever in the rain it seemed. But I must say I was lucky to work with some very good editors, Liz Walker, Kathryn Samuel, Jennet Conant [of Newsweek], to name a few, who always made time for a dinner with me, in New York, Milan, or Paris." Even veteran runway photographer Chris Moore, recently given a lifetime achievement award by the British Fashion Council, chooses a prosaic metaphor to describe his profession: "It's like being a potato picker. You find the best potatoes and travel from field to field."

When you look at runway photography from the 1970s and 1980s, you will be struck by the many variants of framing and composition. The fashion model filled the frame in a multiplicity of ways. Sometimes, there would be leg close-ups and detail shots, striking back and fetching side views. There would be abstract as well as figurative shots; atmospheric blur as well as informative clarity. Now there is a runway image template. "Everyone wants the same thing. It has become very formulaic. The model in a rectangle full frame, looking straight into the camera with one leg raised," notes Andrew Lamb, former *Vogue* runway photographer. By contrast, McInerney was fond of landscape shots that would take sweeping vistas of the whole spectacle and production of runway shows: models, photographers, audience. That, he says, "was more of a picture."

This change in runway photography—the diverse multiview to the potato print mono view (to extend Moore's metaphor)—is a reflection partly on the fact that runway photographers were once pitched along the sides of the runway and were then moved along to the end of the runway. Arguably, when they were all crouched and squatting in the trench around the runway, they were technically the front row. The photographers themselves became a visible part of the production process and a visual spectacle as they fought for their spaces, fiddled with equipment, and stripped off their layers in the heat. "You could watch all the argy bargy and that was part of the atmosphere," recalls Iain R. Webb, author of *Postcards from the Edge of the Runway*.

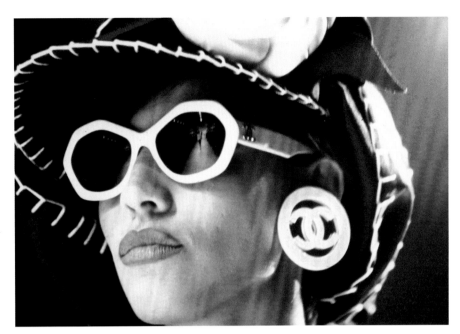

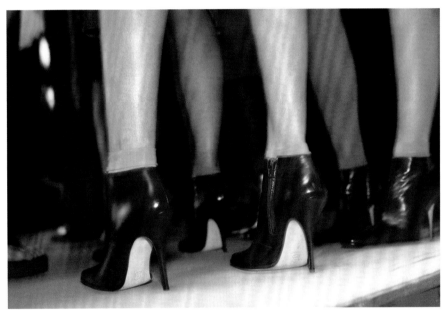

Up close and personal: when runway photographers were placed around the runway, there were more opportunities for a diversity of viewpoints.
Left, a dramatic cut collar and cuff are beautifully framed at the Montana S/S 1993 show.

Above, the focus is all on the detail including Chanel insignia sunglasses, S/S 1990, reflecting the runway, and a chic gathering of brown leather heels captured at close range.

Although photographers were there to get the pictures, this was not the same as seeing the story. This was the fashion editor's skill or intuition, which Niall describes with bitter experience as the "blue hat moment." "Fashion editors always wanted the look. You would go and see them after the show with 300 pictures and they would say 'but Niall, you forgot the blue hat.' I once came out of a Vivienne Westwood show and said: 'What a load of cobblers. Who would wear that?' I remember Kathryn Samuel saying to me: 'But Niall, that was the most important show of the season.'"

For Iain R. Webb, former fashion editor of the *Times* and *Blitz* magazine, capturing the fashion atmosphere in a runway photograph was just as important as the detail. He mourns the days when the framing of the fashion moment was just as valued as the precise documentation of collars and cuffs. Webb notes that "once, the photographers were able to offer their own artistic interpretation of an outfit. They weren't just pointing a camera; they were making a conscious composition, framing what they saw. There was a certain point when runway photography became characterized by a certain uniformity and sterility." In those days, photographers would work with two manual cameras, one loaded with 35mm black and white film; the other, with color. There would be a constant process of evaluating a shot, leaning in for the best position, framing, focusing, and capturing. There would be the frenetic switching between cameras and then a rapid reloading when a reel of film was finished. McInerney explains:

"I used two 35mm Nikons. They were very good, motorized cameras and are still working. I had two separate lenses that were pre-focused, which saved all the fiddling and faffing around. I would have one pre-set for a three quarter length and another for full length and would wait for the girl to walk into frame. It was a cleaner, more disciplined way of working."

Cut above the rest: red and white lace-side dresses from Azzedine Alaïa, S/S 1986. **Overleaf, left,** coat by Kelly & Clare, 1975, photographed in the snow. **Right,** a model in Norma Kamali alongside a yellow New York cab, F/W 1985–86.

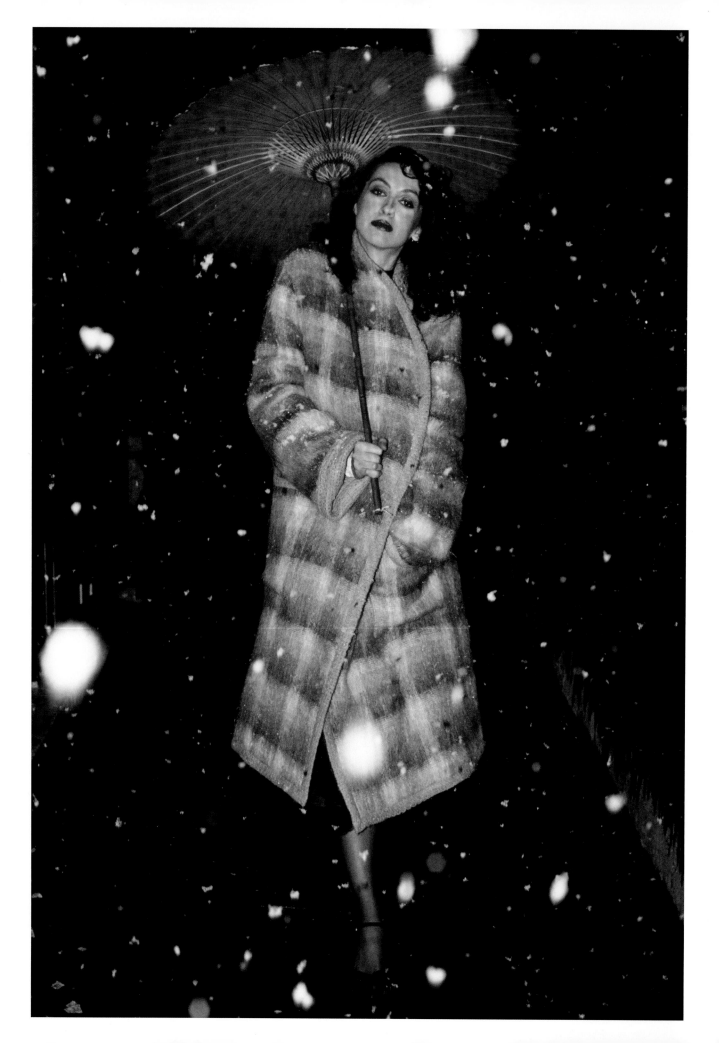

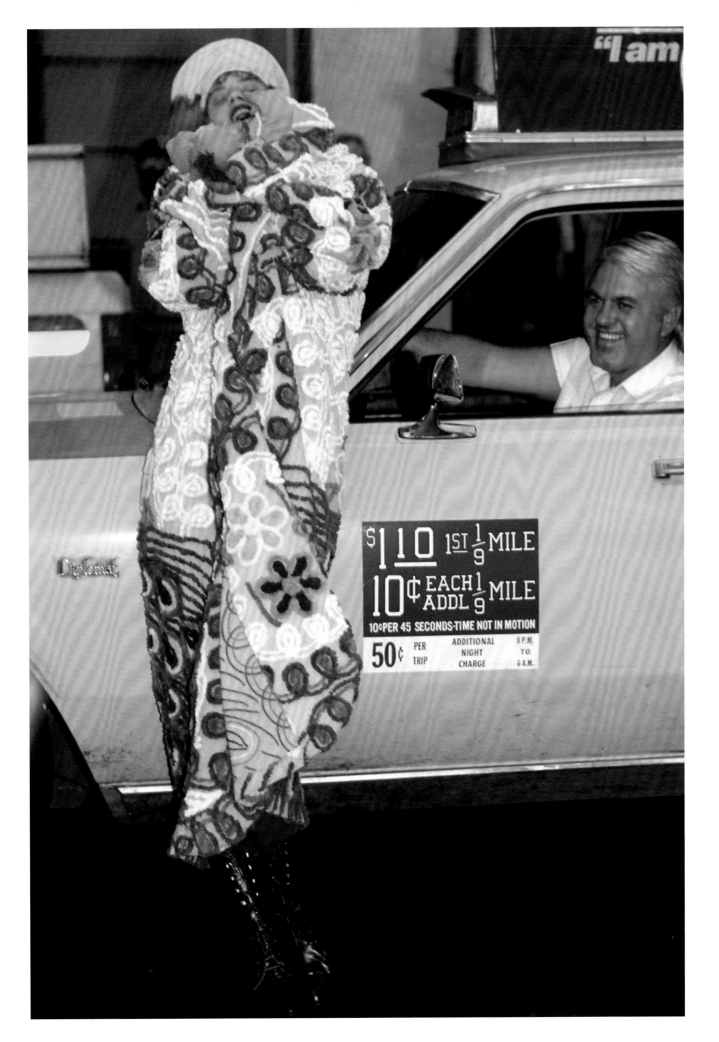

Depending on whom you ask, the gradual migration from the sides of the runway to the back happened for a variety of reasons. For some, it was due to the express wishes of certain clients who wanted full-length shots for their pages. For others, it was down to the demands of influential front row individuals who felt their view was obscured. Chris Moore tells the story of one leading Italian designer who once marched down the runway before a show started and kicked every single camera off the stage. "I've never heard a sound like it before or since. The moan that went up from the photographers was like a pack of wounded animals."

Whether the choice to reposition the photographers at the back of the room was professional, aesthetic, or hierarchal, the full-scale exodus couldn't have happened without the necessary technology. Manual cameras would have made it technically challenging to obtain any degree of photographic consistency from the back of the room; however, the ascent of the auto-focus camera changed everything. "At the end of 89/90, the Canon EOS1 was the first professional level auto-focus

Runway camaraderie: above, left to right, Anthea Simms, Corinna Lecca, Dan Lecca, Charli Gerli, journalist, Michael Gross, and Maria Valentino.
Right, the united nations of runway photographers including Antonio D'Avila (Brazil), Kazuo Oishi (Japan), Paul Van Riel (Holland), Graziano Ferrari (Italy), Vladimir Sichov (Russia), Chris Moore (England), Terence Donovan (England), Pierro Biason (Italy), Dan Lecca (USA), Michel Arnaud (France).

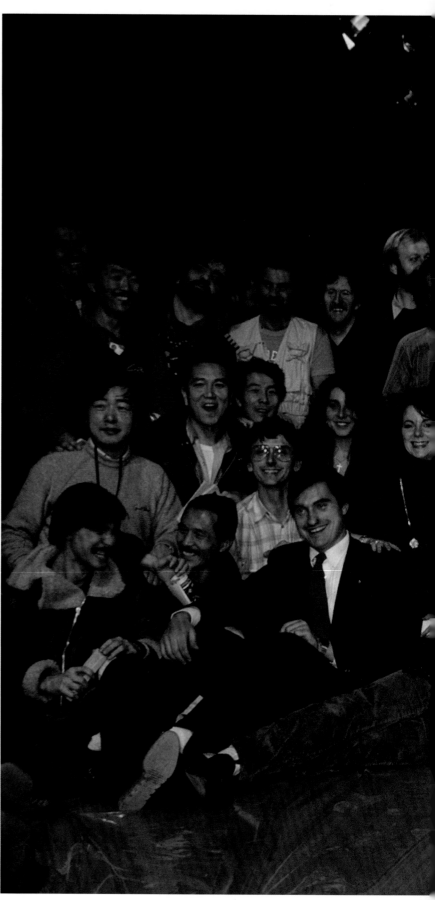

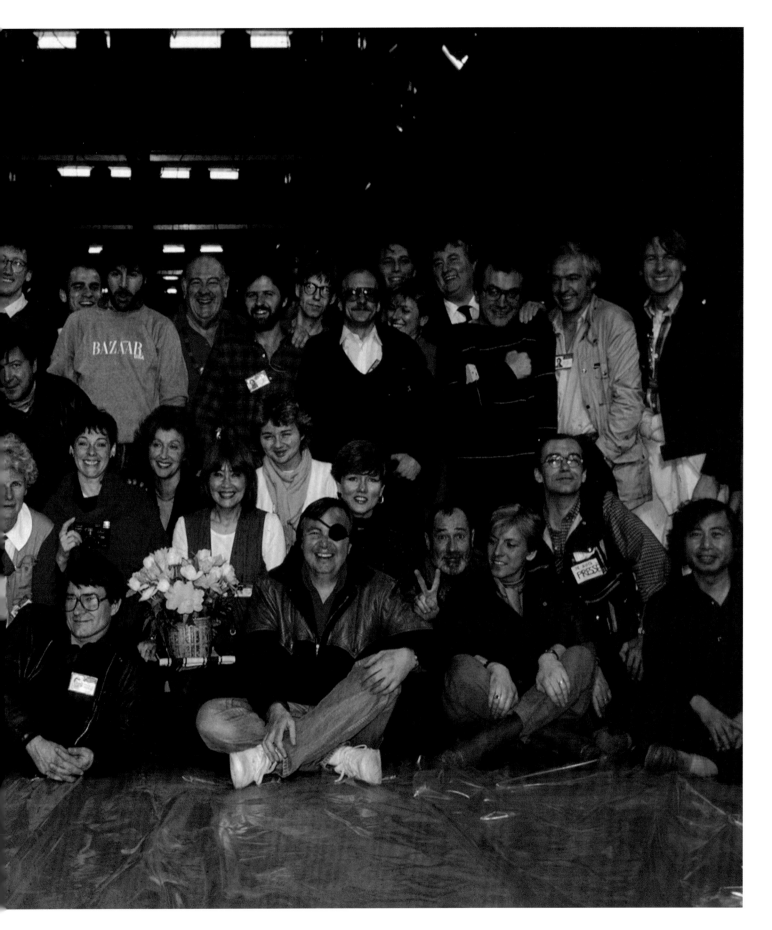

camera, which was a complete game-changer in catwalk photography," explains Andrew Lamb. It meant that all runway photographers had to upgrade their equipment from traditional manual to auto-focus lenses with cameras, which represented a considerable investment. These cameras cost between two and a half and three thousand pounds ($3,862–$4,634) each. By 2002, nearly all of the runway photographers had gone digital.

In predigital days, the processing of film also had to be factored into a day's schedule. Bundles of film were constantly being driven to airports to be flown off for processing; digital photography had effectively eliminated this additional layer of production, saving a great deal of expense for photographers and wiping out many processing laboratories in what turned into a digital culling. Photographers were no longer limited to 36 pictures per roll and could capture everything without the stress of juggling camera bodies and films. Even though being at the back gave photographers a totally different perspective and the digital imaging looked dynamic through the viewfinder, McInerney and many other runway photographers missed the old atmosphere: "It was like being in a shooting gallery; you were literally nailed to the spot and couldn't move. Even though the view was exciting, the ingenuity had gone," observes McInerney. Digital cameras were able to deal with low levels of light, so pictures were consistently of a higher technical quality.

The organizers had managed to visually tidy away the photographers onto the perimeter of the runway picture; however, as a community, they were still very present and brought with them an irrepressible energy and personality that enlivened the whole space. They might not have been seen in the same way, but they could

Landmark moments: left, Vivienne Westwood's Buffallo collection, F/W 1982–83 at the Pillar Hall in London. A slow shutter speed gives a feeling of movement while the flash gives sharp definition to the clothes.
Previous pages, this shot of Thierry Mugler ballgowns from 1984 has a painterly quality and is one of McInerney's favorite runway shots.

certainly be heard at times hollering, yelling, whistling, singing, laughing, or bantering. I remember being entertained by the various farmyard noises that emanate from the photographers including the "baa baa" of sheep. I had assumed the photographers were making a comment about the conformity of fashion people or perhaps a comment on fashion itself: "They were just venting their animal frustrations," translates Chris Moore. "It's because we were penned in like animals," agrees Andrew Lamb.

Drawing together representatives from all over the world, this was like the United Nations of runway photographers. All were joined by their common purpose, and both friendships and rivalries sprang up. "Catwalk photographers hunt in packs and keep each others' spaces," reflects Elizabeth Walker, former fashion director at *Marie Claire* and *Harpers & Queen*. "Whenever you looked up from your seat in whatever city you were in, you would see the same photographer in the same place." Some looked out for each other, guarding spaces and supporting each other when it came to getting specific shots for editors, but there were also tensions that were tribalistic, testosterone-fueled, and exhaustion-exacerbated. When speaking to runway photographers, it becomes apparent that a structure exists that is not dissimilar to that of the press. McInerney compared them to "a group of apes in the Congo. There were the Alpha apes and some very aggressive apes who liked to bully the others. Some played up to them, and others didn't give a damn."

An international territory, it also lent itself to cultural stereotypes, which McInerney takes great pleasure in relaying: "The Italians would always turn up late in leather trousers. The Germans would be there hours before anyone. The Japanese were incredibly polite and well behaved." However, despite any differences that existed among them, there could also be a strong solidarity that would emerge when it was felt a fashion designer had overstepped the mark or a model wasn't playing ball. There would, for instance, be lots of caterwauling if the lights were set too low or if the models walked too fast or didn't look up.

There were even a few occasions when runway photographers boycotted certain shows and refused to photograph them. This happened once at a Prada show in Milan when the photographers were asked to leave their bags and equipment in a separate room. Camera theft was a recurring issue, and photographers were not prepared to take the risk. It also happened at a Donna Karan show in New York when the photographers walked away because so few of them were being let in. These boycotts didn't mean a complete coverage blackout (every designer always had its own house photographer), but it did mean that the atmosphere of the show was significantly curtailed.

Even though there could be unity in the face of adversity, there were also tensions. Stealing a fellow photographer's clients was akin to adultery. The fear of losing clients and the times when one runway photographer was rejected in favor of another caused rivalries to surface and created a volatile atmosphere. In the boom years of runway photography, there could be as many as 300 snappers in position attempting to get their shots. There used to be lots of coveting of each other's spaces, arguments, and subterfuge. Lamb recalls "the minute edging of boxes into someone else's space in between frames and the deliberate kicking or nudging of boxes." This territorial tittle-tattle eventually led to the chalking up of

Cast of characters:
Graziano Ferrari with his trumpet would keep audiences entertained when waiting became dull, surrounded by Marcio Madeira, Buster Dean and Rudi Faccin.

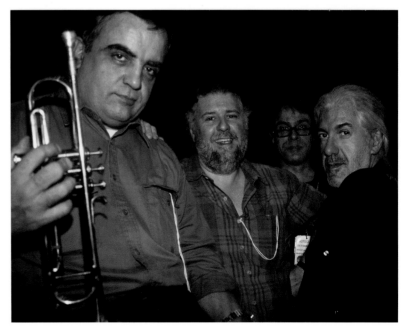

space and then the use of gaffer tape to mark out specific spaces. However, chalk could be rubbed out, and gaffer tape could be ripped off. "So, then photographers would use a Stanley knife to slash the gaffer tape so that if anyone tried to take it up, it would leave a line," continues Lamb. Now, there are hired markers whose sole function is to secure spaces for their photographers with a sign that says "HERE ALL SEASON" if they are not physically occupying and guarding the space themselves.

To the outsider, fashion photography may seem like a glamorous profession. Taking photographs of the world's most beautiful women in a series of stunning capital cities sounds appealing, but anyone who has ever been involved in capturing the runway will confirm that it is a tough business. The hours are long; it is physically demanding and professionally stressful. Andrew Lamb recounts a nightmare that he would have before the collections were just about to start: "My assistant had found a space behind a brick wall. I wouldn't be able to see a thing. I would be able to hear the cameras all around me, and my heart would be racing."

"It's a sometimes physically impossible job. You have to be fast all the time. You are constantly clamoring over people, jumping into your spot. We don't have the Star Trek

Runway photographers of the world unite:
above, Kazuo Oishi, Japan's leading runway photographer with model at a Kenzo anniversary bash.
Below, Russian runway photographer Vladimir Sichov and his daughter Dounia became the subject of McInerney's impromptu street photography.

gene yet that allows us to be in two places at once, but sometimes the expectation is that we can," explains Mitchell Sams. "One minute you will be taking photographs in a room that looks like something from Versailles, the next you are balancing on a platform the size of a coffee table." A punishing and relentless schedule requires endless standing around inside venues or outside in all weathers. The need to cover the terrain often means that regular meals and decent sleep are sacrificed.

"Some people have the impression that covering catwalk shows means that you go to parties. You couldn't party and be out at 7 a.m. Unless you were having a heart transplant, you had to be there," emphasizes McInerney. "You had to be fit to be a catwalk photographer, and if you weren't, the job would make you fit. You would go from one side of the city to the other carrying heavy equipment." The digital revolution has not meant that runway photographers have any less to carry. Even though the cameras may be lighter, they now have to have a computer with them so that the photographers can look at the photographs with their editor. The physical demands carried occupational hazards of spinal and muscular injuries. "There have even been some fatalities.

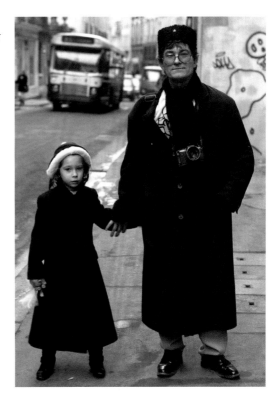

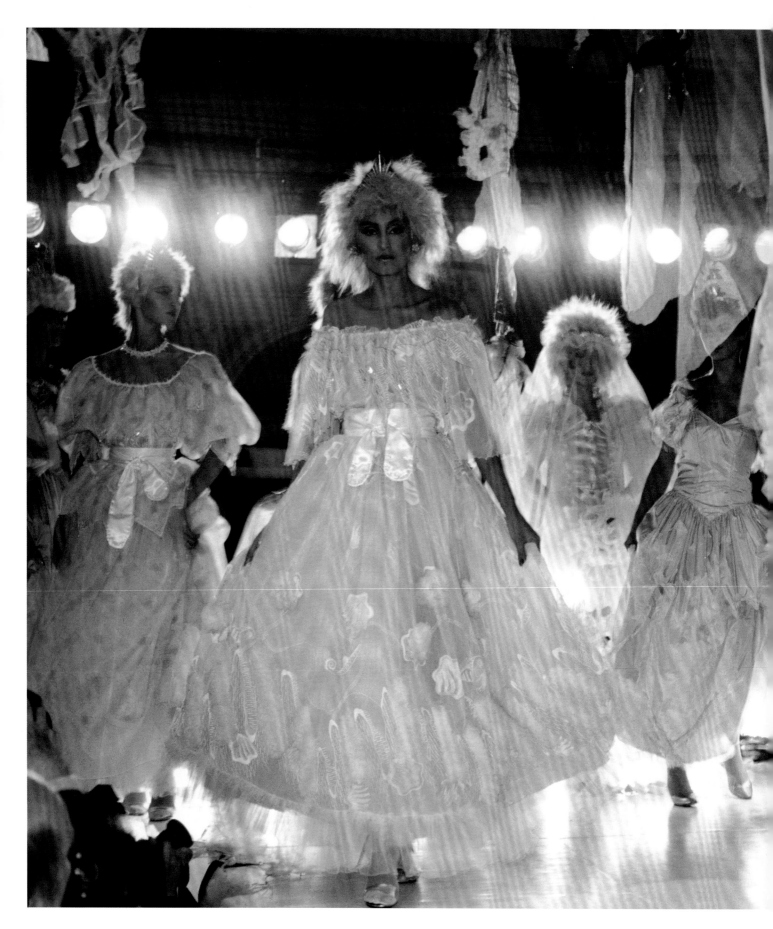

One runway photographer died in a taxi, another by riding his bike into a brick wall. Both were said to be under intense levels of professional stress," says Anthea Simms. "The quality of life is questionable, but that is part of the challenge. You get by on very little sleep for three months a year. I've cried through being so tired and frustrated by the experience."

To alleviate the stress and tedium between shows, there would be banter, jokes, and sometimes fun. "Graziano, an Italian photographer, would bring a trumpet with him which he would sometimes take out and play," recalls McInerney. The American photographer Buster Dean of the *Houston Chronicle* had a whistle that he would blow when a show was taking too long to start. Sometimes, the runway photographers would, en masse, spontaneously break into a verse of "Volare" or a chorus from Aida. If a show was dragging on too long, they would shout: "*la mariée!*" which was a plea for the bridal dress that signified the end of a show. More recently, if a female celebrity is strategically and cynically paraded for the delectation of photographers, you will hear the cry: "It's a man!" even if she is the most gorgeous creature on the planet, perhaps a reminder to the hosts that runway photographers can only be played so far.

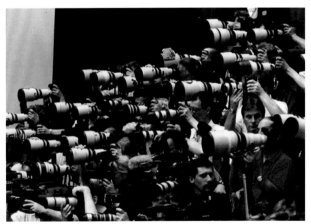

Runway dream catchers: left, Zandra Rhodes S/S 1982 collection at the Pillar Hall, was lit from behind causing the collection to be bathed in a magical glow. **Above,** a sea of long lens cameras waiting for the decisive moment.

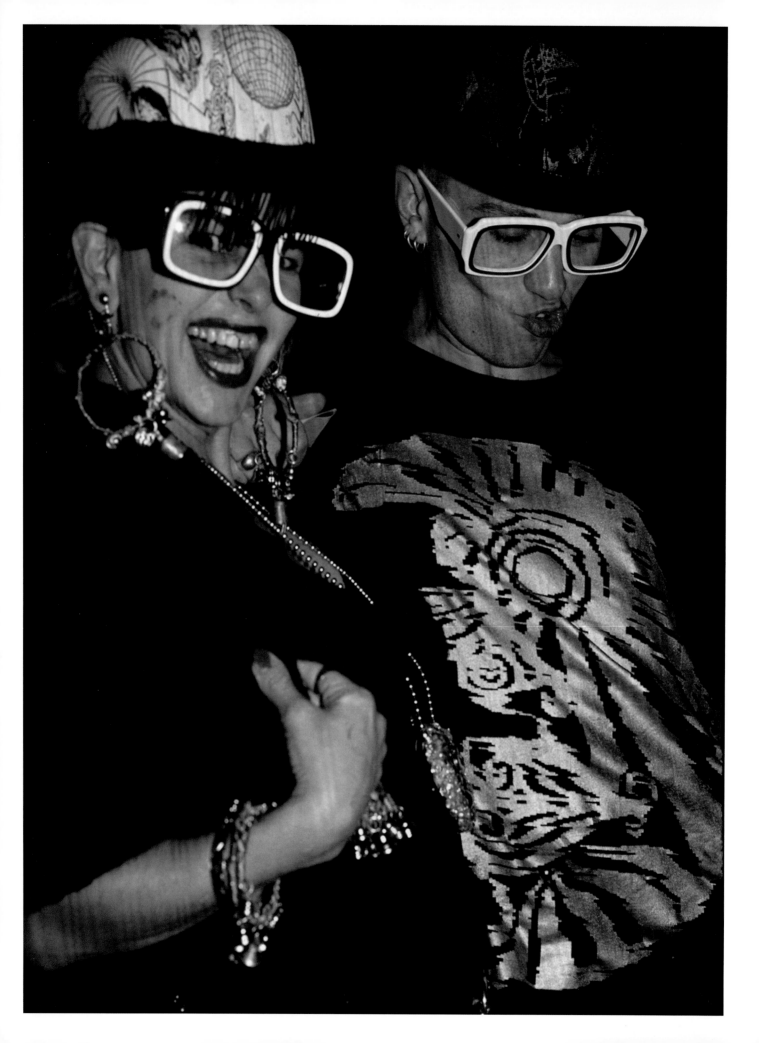

CHAPTER 4
RUNWAY COUPS
GAME-CHANGING COLLECTIONS

The International Designer Collections are the nerve center, brainpower, and spinal cord of the fashion industry. They are where fashion shifts, slowly, sometimes imperceptibly, year on year, season after season. An upside-down world from the onset, the S/S collections are presented in October, whereas the F/W shows appear in February and March. Organized by august institutions such as the Chambre Syndicale in Paris (set up by Charles Worth in 1868) or more recent players such as the British Fashion Council in London (established in 1984), the fashion schedule provides the working framework to which the fashion industry seasonally gravitates. Like a huge flock of black-clad homing pigeons, they descend, ready to feed.

This is where fashion, sometimes described as a social barometer or mirror of change, is sold. Although Fashion Week has more glitz and glamor than your average trade show, this is where fashion houses and big brands sell their core values, reputation, and goods. It's where ideas are promoted and

Clubland meets runway: left, designers Stevie Stewart and David Holah of the cult London label, Bodymap photographed in 1986.

Their energetic, individual collections brought elements of clubland and streetwear to the runway, seen **above.**

exchanged, deals are done, and the future is mapped out. It's where buyers come to place their orders for the following season and where fashion editors, reporters, and correspondents come to feel the sartorial pulse and stock up on story ideas for the next six months. A vital source of information and inspiration for anyone involved in fashion media or retail, the shows have been described as a circus, a camp, a school, and a freak show.

When Niall McInerney started to regularly photograph designer collections, he couldn't have known that he was on the cusp of a fashion boom, the waves of which would

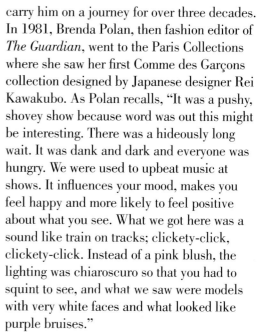

Radical interpretations:
Rei Kawakubo of Comme des Garçons introduced a new aesthetic: architectural, sculptural, textual, and artistic, her vision liberated the female form from stereotypes of sexuality and traditional notions of taste (**below,** early 1980s; **opposite page,** F/W 1986-87).

carry him on a journey for over three decades. In 1981, Brenda Polan, then fashion editor of *The Guardian*, went to the Paris Collections where she saw her first Comme des Garçons collection designed by Japanese designer Rei Kawakubo. As Polan recalls, "It was a pushy, shovey show because word was out this might be interesting. There was a hideously long wait. It was dank and dark and everyone was hungry. We were used to upbeat music at shows. It influences your mood, makes you feel happy and more likely to feel positive about what you see. What we got here was a sound like train on tracks; clickety-click, clickety-click. Instead of a pink blush, the lighting was chiaroscuro so that you had to squint to see, and what we saw were models with very white faces and what looked like purple bruises."

The collection, sensationally branded "Hiroshima chic" by the press at the time, comprised simple clothes in a neutral palette of black, gray, and darkest purple. Deceptively basic shapes had skewed armholes and off-kilter sleeves that caused the garments to fall into unexpected folds and sculptural shapes. The collection agitated some of the audience (one left the show muttering "ridiculous" and a then doyenne of Fleet Street declared that she would henceforth be leaving the profession), but Polan recognized this was something culturally relevant and significant. "At that time, most of Paris's designers were presenting clichéd stereotypes of ooh! la! la! sexiness but this was something with a different attitude to the body and beauty, from a part of the world where dress could be considered an intellectual activity and creative art form. It was a watershed show," maintains Polan.

Fashion is change. This is the truism on which an entire industry has been based. The designer collections must sell clothes but also reflect fashion's restless image. It is this change, the essence of fashion, that propels us to consume more clothing and update our wardrobes. This change is mirrored every day, week, and month by the fashion media and the shop windows through which we peer, be they physical or digital.

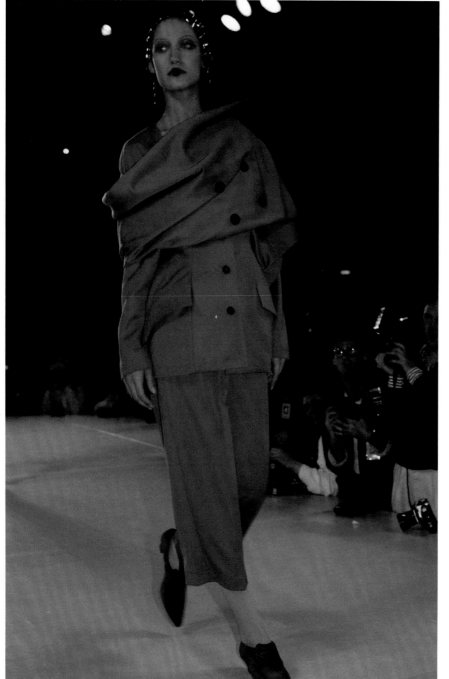

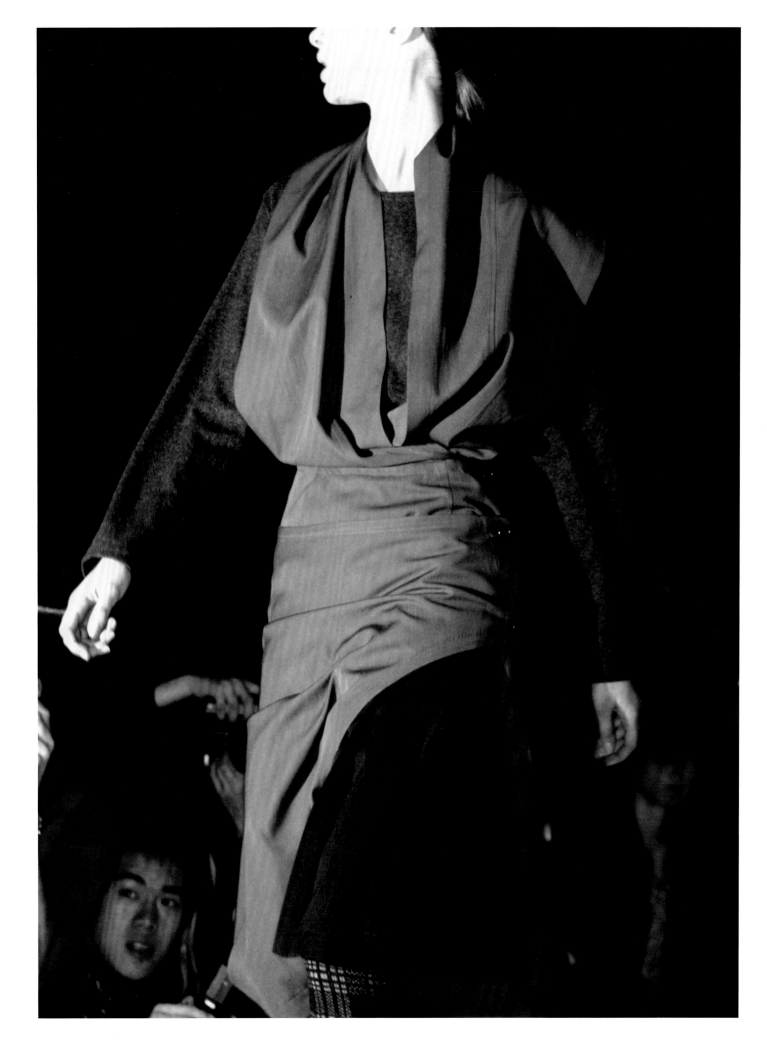

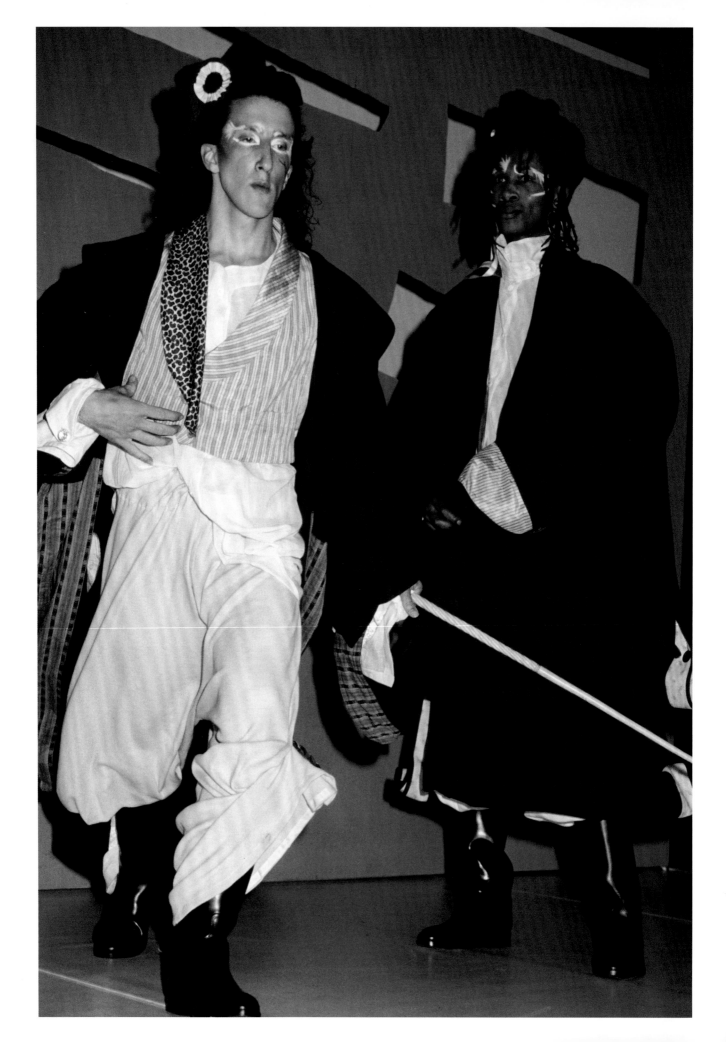

Most fashion change is evolutionary: proportions shift, balance realigns, and the silhouette is redrawn. The F/W color and fabric palettes are translated into something lighter and easier for S/S. The kind of radical and revolutionary change witnessed by Polan in 1981 is unusual and rare. It also takes highly attuned, clear-headed individuals to recognize change when they see it and not dismiss it as absurd or unrealistic because it contradicts the status quo. Polan remembers that then "fashion then was from cartoons, movies, and fairytales. Mugler was heaven, but the women I was writing for wouldn't have been seen dead in his clothes. These were clothes for women who were their own property. What it wasn't was about sex or clichés. There wasn't the emphasis on the body that you get in the West. The shirt that we were looking at with the unusual button came from a deep cultural place with more complexity. Anyone who took fashion seriously respected the Japanese designers enormously. Kenzo had already challenged Western ideas of proportion in the 1970s, but the impact of Comme and Yohji was that their clothes initially looked ugly, deliberately disfiguring and gender denying."

Being able to separate show production from the substance of a designer's collection also takes a measured approach, one that can strip away the background noise, look into a collection with laser-like vision, and see its potential. The influence of Kawakubo's early work—and that of her peers Yohji Yamamoto and Issey Miyake—can be seen on many levels today from creative pattern cutting to conceptual show production and the preeminence of black as a clever fashion color. Kathryn Samuel adds, "I remember a French man, a member of the public who looked at this crowd all in black and asked: 'Qui est mort?' I explained no one was dead. This was fashion. Even though I found the Japanese designers baffling, they were responsible for putting us all in black for years."

I first heard about Comme des Garçons and the Japanese designers when Polan's report was not only pinned up in the corridor but also photocopied and handed to us fashion

New kid on the block:
left, McInerney was there to capture John Galliano's degree show, Les Incroyables at Saint Martins School of Art, now Central St. Martins (CSM) in 1984.
Below, John Galliano, F/W 1985–86.

students as essential reading. This is relevant because media and fashion go hand in hand. Without the platform and visibility that media gives fashion, it ceases to exist and loses its relevance. The idea of the *fashion moment*, which has become quite popular, is something staged and constructed in the media. Fashion comes alive in the spotlight and can perish in obscurity.

Christian Dior's New Look is the one most commonly cited as a great fashion moment. When in 1947 the designer reintroduced the femininity of full skirts to the female wardrobe after a decade of rationing and war, his ideas caused riots on the street and a moral outcry. How much Dior's pole position as fashion game changer has to do with the fact that he was the first designer to allow photographers into his show is worth reflecting on. There are arguably other more germane arbiters of change that were premedia (such as America's Claire McCardell), but they remain largely unknown to international audiences.

In the early 1980s, fashion media had started to expand with greater visibility in the national press. It was a time that also saw the

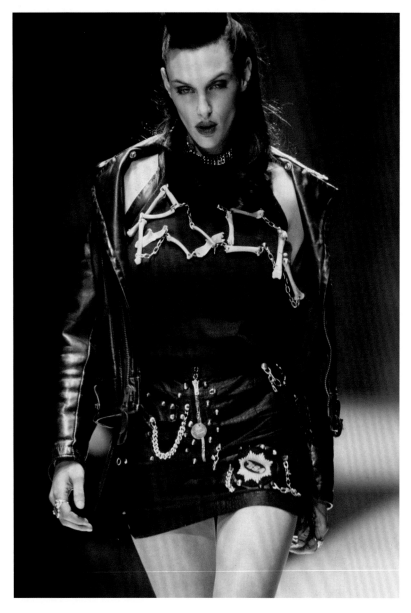

brought a fresh and distinctive voice to the fashion scene. "In the 1980s, we really believed that we could do anything and that fashion could change things," Iain R. Webb recalls. "The Stephen Linard menswear show in 1981 was entirely street cast using the designer's clubbing pals. Dylan Jones, now editor of *GQ*, modeled in it, and it was a hugely influential show in terms of model agencies changing the sorts of models they had into boys that had character." John Galliano's Les Incroyables graduation show is recalled by anyone who was there as the moment when a tremendous talent was unleashed on the world. "I selected a John Galliano dress for Bath Museum's Dress of the Year. His style of presentation and attention to detail is second to none. He is a visionary and utter perfectionist," endorses Debbi Mason.

The early shows of Vivienne Westwood from this period (Buffalo and Punkature) are also distinguished for their originality and bravura. Some of Niall McInerney's personal favorites, he describes them as "magical." Westwood's fascination with historical dress has enabled her to revise and rewrite expected design narratives, offering fresh and exciting alternatives to contemporary dress, ideas that have often been years ahead of their time but have slowly soaked into fashion consciousness changing the way we dress. "Westwood used to go the Victoria & Albert Museum and look at trousers cut in the Napoleonic era and then reproduce them. The insistence of researched fashion is one of the things that changed the game, alongside how fashion is taught in British art schools," opines Polan. Both Westwood and Galliano brought us fashions that—through deep research, skillful cutting, and visualization—were able to transport their audiences into different worlds both ancient and modern. They were able to shake off entrenched ideals of bourgeois femininity and draw us into the possibility of different identities. Westwood and Galliano were the inspiration and catalysts for the generation of designers that came after, the likes of Alexander McQueen, Hussein Chalayan, and Gareth Pugh, who with their conceptual and original approaches dazzled the world.

birth of the style press with publications such as *New Sounds, New Styles*; *Blitz*; *The Face*; and *i-D*. These publications—built around youth culture (fashion, music, the street, and clubland)—were able to give the oxygen of publicity to many newly formed fashion babies, some still in their incubation period. So while Brenda Polan was translating the idiosyncrasies of modern Japanese fashion for *The Guardian* readership, Iain R. Webb who would go on to be fashion editor of *Blitz*, was experiencing something thrilling in London. The anarchic and energetic collections of Bodymap—designed by Stevie Stewart and David Holah—and the graduation collections of Stephen Linard and John Galliano each

Spirit of punk: above, Vivienne Westwood's fearless Seditionaries collection, presented in Bordeaux, France, where the designer was invited to present her work.

Right, Vivienne Westwood, F/W 1994–95 takes classic Highland plaids to new heights of elegant eccentricity.

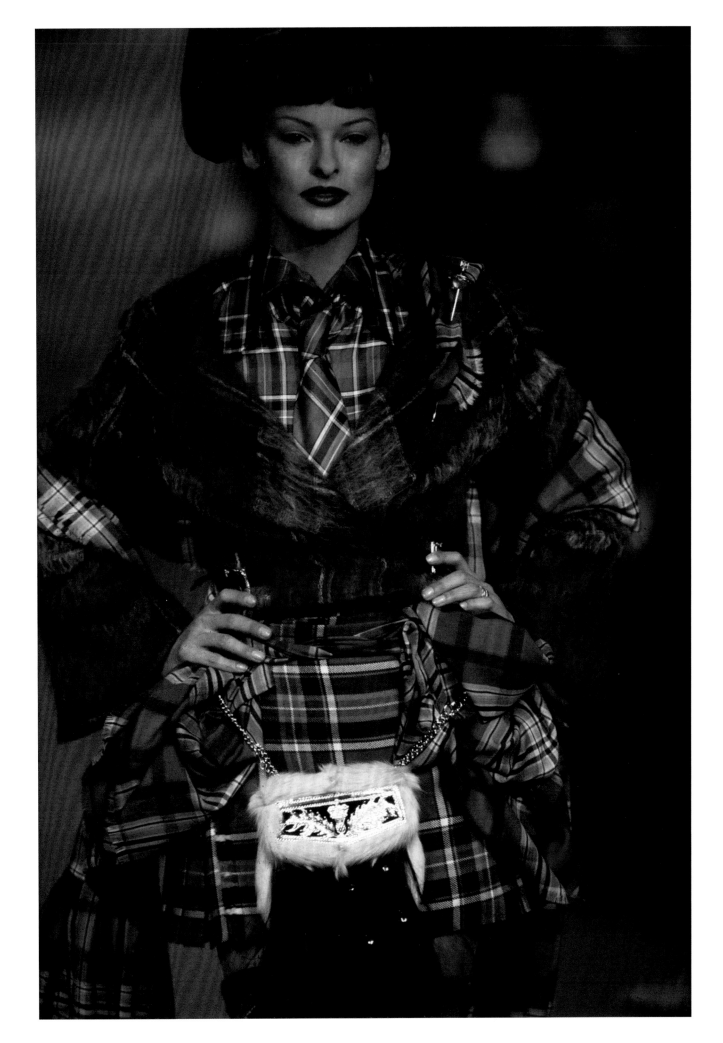

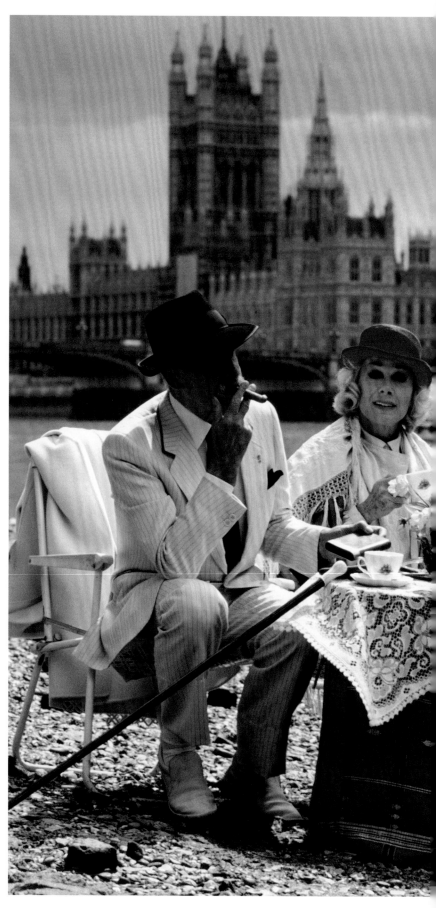

London unleashed: a sense of anarchy and new possibility was felt in London in the early 1980s with labels such as John Flett photographed with model in 1985 **above** and Mark and Syrie, **below** photographed in the same year. This joyful Thames side scene, **main picture,** features Herbert Sidon and former actress, June Havoc, enjoying tea while Mark and Syrie frolic in their designer swimwear.

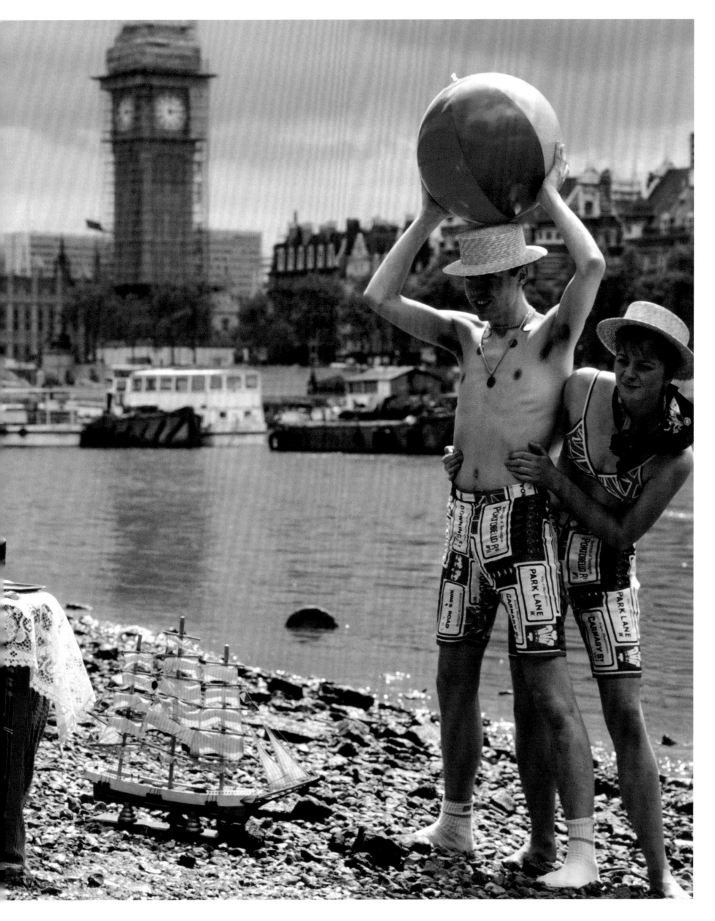

Yves and his girls:
One of the most exciting moments for Niall McInerney was backstage at Yves Saint Laurent, seen here during the Couture S/S 1984 collections at the Hotel Intercontinental in Paris. "I understood that he was a genius, an artist."

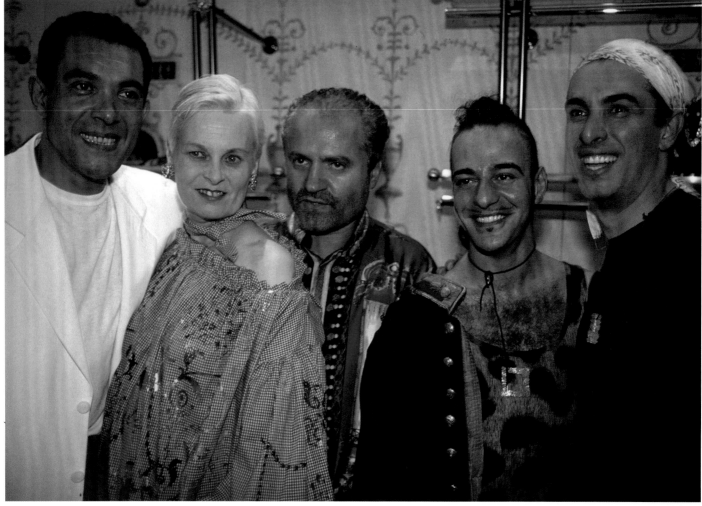

CHAPTER 5
FASHION FACTIONS
DESIGNER BATTLE LINES

Everyone wants to be a star in fashion but not everyone is. No one wants to be forgotten in fashion, but lots of people are. These are hard truths. There are many history books that offer us roll calls of fashion's relevant designers, and each will be selected, selective, and subjective. Someone will always be left out; someone will always be made unhappy. As in everything, there are fashions that are remembered, although forgetting seems to be perennial. A designer of the past might be rehabilitated by being referenced by a stylist or photographer, by launching a retrospective exhibition or documentary, or by being the recipient of homage paid by a new designer who graciously credits his or her work as being inspirational and influential.

If we strip away the glitz and the glamor, the brilliant lighting effects, and the seven-foot tall models of the runway, we will see an individual with an idea, a pair of shears, a bolt of cloth, and a mannequin. The tools might change as might the scale of production: 3D imaging on a computer screen is just as likely as modeling the garment on a stand. Rather than a solitary individual waiting for the

The designers: opposite page, above, Issey Miyake and Grace Jones, 1984. **Below, left to right,** Bruce Oldfield, Vivienne Westwood, Gianni Versace, John Galliano, and Rifat Ozbek at the opening of the Bond Street Versace store, 1982. **Above,** Dolce and Gabbana, March 1987.

lighting flash, there is likely to be a sizable team of designers and researchers who help to conceive a collection. But what governs unforgettable designers is a die-hard philosophy and set of values that guide their aesthetic decisions. Through their powers of cut, cloth, and color, they present to the world unforgettable fashion with a unique perspective, a distinctive voice, an opinion. The following pages include the work of some of these sartorial iconoclasts, many of whom continue to influence the way we dress today.

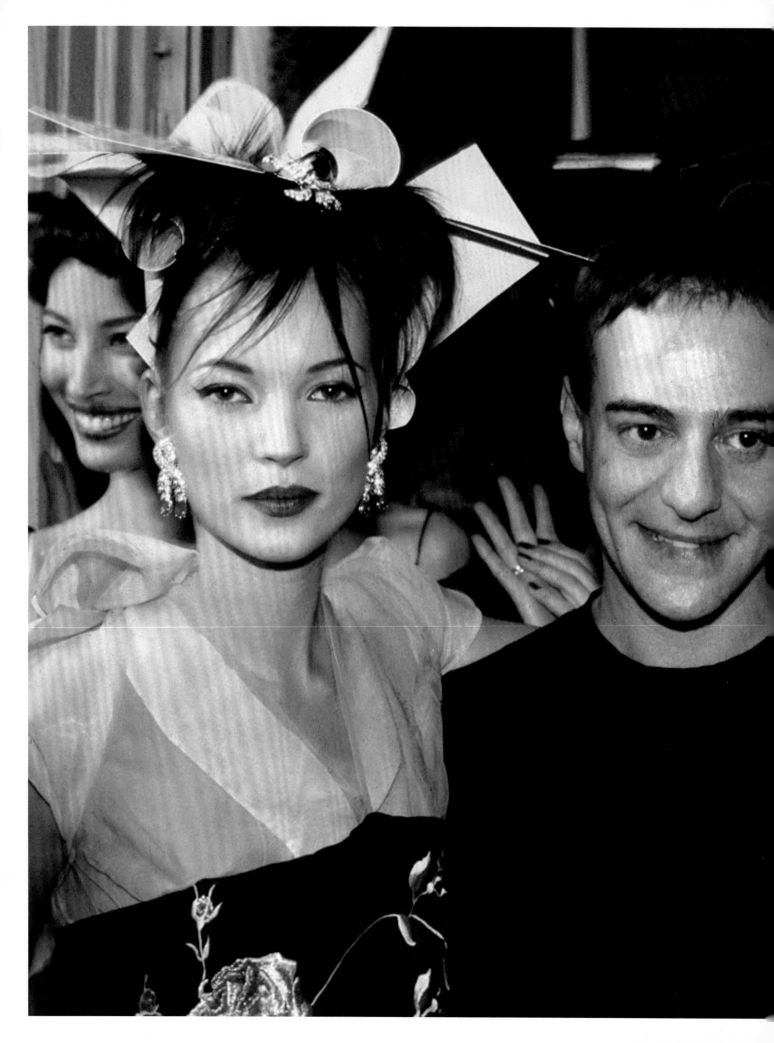

Star turn: John Galliano with his friend and supporter Kate Moss, with Christy Turlington in the background. The critically acclaimed Japanese-inspired collection (S/S 1994), which took place in Sao Schlumberger's 18th-century Paris mansion, was largely done on favours as Galliano sought a backer for his business.

EYEWITNESS

Antony Price
Fashion Designer

The function of a fashion show is to get yourself established. Primarily, it's a business promotion. You want to show the world and your peers what you are capable of. You provide an orgy of exhibitionism for the press. There is an atmosphere created by a show. It's the excitement of the unveiling. It's like watching a butterfly hatch. There is exclusivity to the fashion show that suits the snobbery of the audience.

Putting on a show was incredibly stressful and an awful expense. Even though I had Mick Jagger sitting in the front row, I had no sponsor. I did everything myself including at one show putting the lights up. I didn't have a stylist, although I did have someone come in and help me get shoes for the show. The sound system and lighting cost five grand although the clothes cost the most. The fabric for one dress might be a hundred pounds but the labor was three thousand. You dreaded a sick child because it meant you might lose a machinist and a whole outfit.

My show in Camden Palace in 1980 basically cost me my foot on the housing ladder. It was open to the public, a pay to see show. Bryan Ferry thought I was mad to do that. Fashion likes to be exclusive, not for the public. We booked it out for five nights. But because the press weren't prepared to buy tickets, we only managed to fill it for three nights. People like John Galliano and Alexander McQueen, who were students at the time, were there. They paid their nine quid.

Antony Price shows were highly influential, influencing designers such as Thierry Mugler. Apparently the French designers received financial support from the French Ministry of Culture, whereas the situation was different for British designers at that time.

Once you had committed to doing a catwalk show and were given a date by the organizers, you had to see it through. You couldn't just pull out, or you would be seen as a coward or failure. Doing a catwalk show

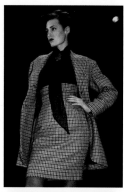

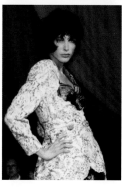

Original king of glamor: designer Antony Price was ahead of his time in many ways, understanding the media potential of fashion and its powerful connection to celebrity. **Above,** Yasmin Le Bon models tailoring by Antony Price, F/W 1988–89. **Below,** Price was known for his sleek glamour, S/S 1990. **Opposite, top left,** Naomi Campbell steps out in Price's sexy suiting, S/S 1990. **Top right,** a little black cocktail number from the same show. **Below,** Jerry Hall and Marie Helvin in the first Antony Price runway show, F/W 1979–80.

would mean working fifteen or sixteen hour days for about eight weeks before. Three nights before the show, you would have no sleep at all. By the time the show arrived, you would be exhausted, a complete zombie. After the show, all these people would turn up backstage and say, "Will you come and have a glass of champagne?" I would be so tired, I couldn't see straight or remember who any of them were. I was so exhausted; I didn't even know who *I* was let alone anyone else. Straight after the show, I had to load the clothes into the van. I was so paranoid about my collection being stolen that I sometimes slept with it.

Because Camden Palace was a mixture of fashion and music, we managed to sell it to a TV channel. It was put on after the football; Annie Nightingale was hosting and interviewing people like Steve Strange and Robert Palmer who were in the audience. Even though football was on, the audience figures didn't drop. I always did my shows late at night so it was a bit like being at a club. Footage of my shows often ended up in clubs like The Fridge and Heaven. My clothes are loved by scary women and queens.

While you were backstage, there was no technology to see what was happening on the catwalk in 1980. As the designer, you would have no idea how it looked out there. You would have just seen the models getting ready under a horrible strip light. And you couldn't rely on what the fashion press said when they came backstage afterwards. Fashion people lie. They will say "black is white" just to be polite. Video arrived in 1979, and it was like very low quality, like something from *Borat*. You had to wait 24 hours to see the video but *that* would be the moment you could see if it had been any good. It was after watching the video on the second night that I realized that the catwalk, which was black, was throwing up shadows on the models' faces. Fortunately, you could just flip it over and it was white on the other side so I managed to change it for the third night.

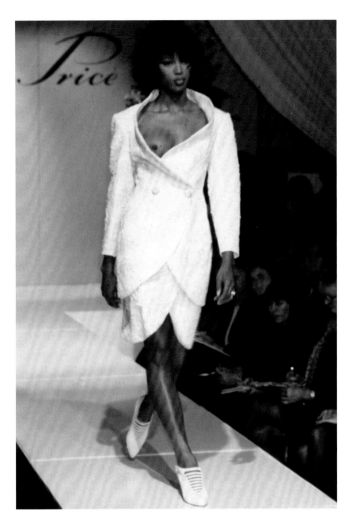

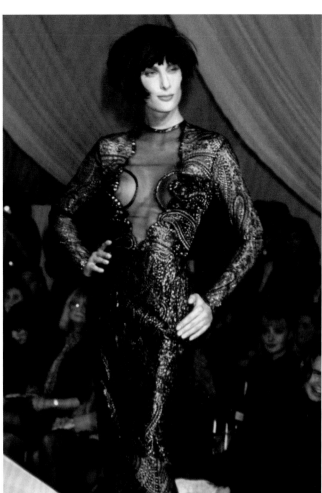

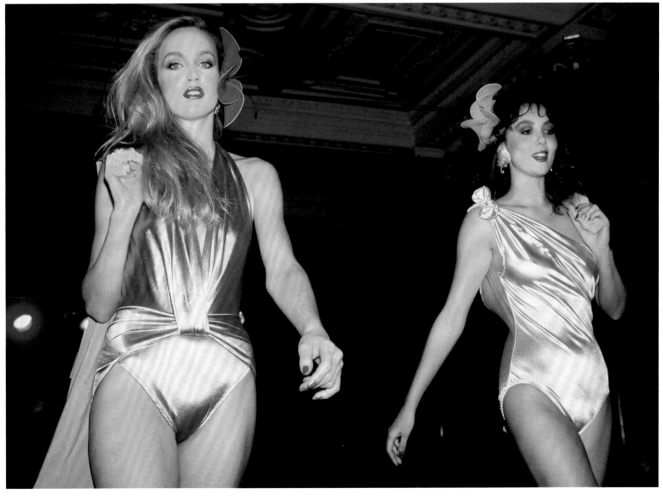

MAXIMALISM

Embellishment, ornamentation, and ostentation; the ones who say it loud and proud.

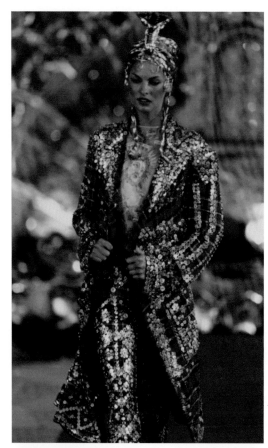

Christian Lacroix, main picture, combines an encrusted jacket and evening skirt for a confectionary treat, F/W 1988–90 Très Bon Bon.

John Galliano, top left, goes for gold, F/W 1997–98 collection.

Thierry Mugler, right, brought animated escapism to the runway.

Yves Saint Laurent, bottom left, layers animal prints and feathers for F/W 1990–91.

Gianni Versace does Warhol's Marilyn in audacious technicolor.

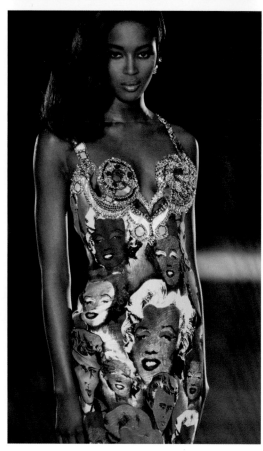

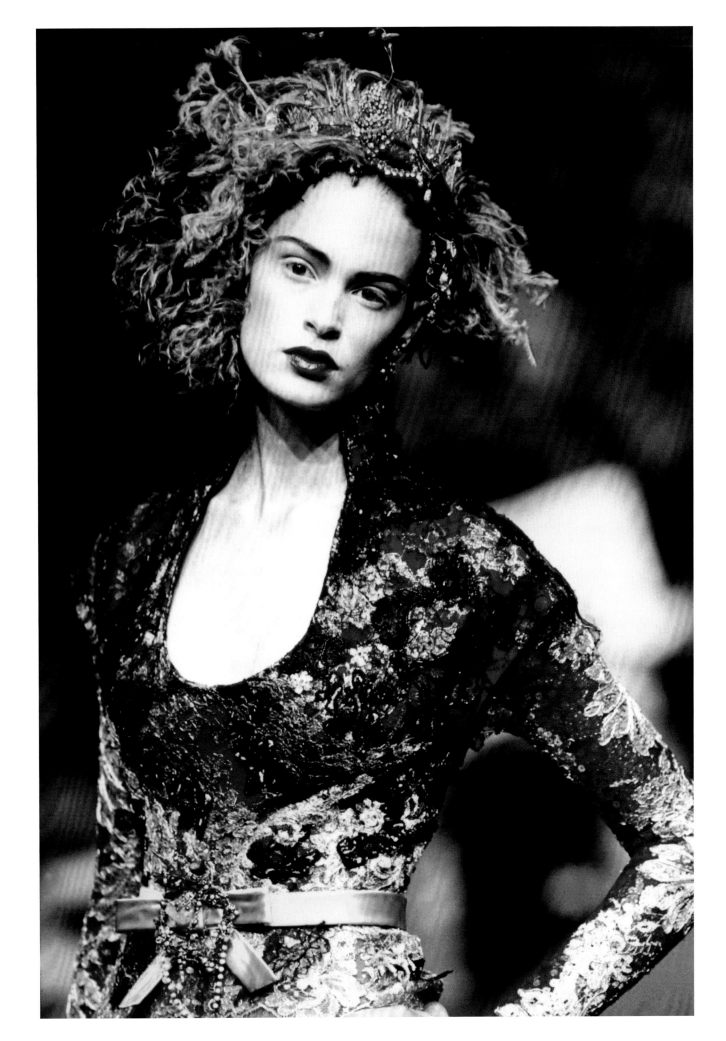

MINIMALISM

Designs distilled to their essence; where economy meets luxury.

Calvin Klein, main picture, left, parades timeless slip dresses.
Jil Sander, top left, gives us understated grey jersey, F/W 1993–94.
Giorgio Armani, top right, red suit from Milan's master, F/W 1996–97.
Helmut Lang, below left, injects modern tailoring with a scarlet flash, S/S 1997–98.
Prada, below right, shows less is more in S/S 1997.

ARCHITECTS OF STYLE

Where fashion is recast into wearable architecture.

Philip Treacy, main picture, black and white elliptical hat and starburst design, **inset,** both from the milliner's 1999 collection.
Above, the designer with Jerry Hall.

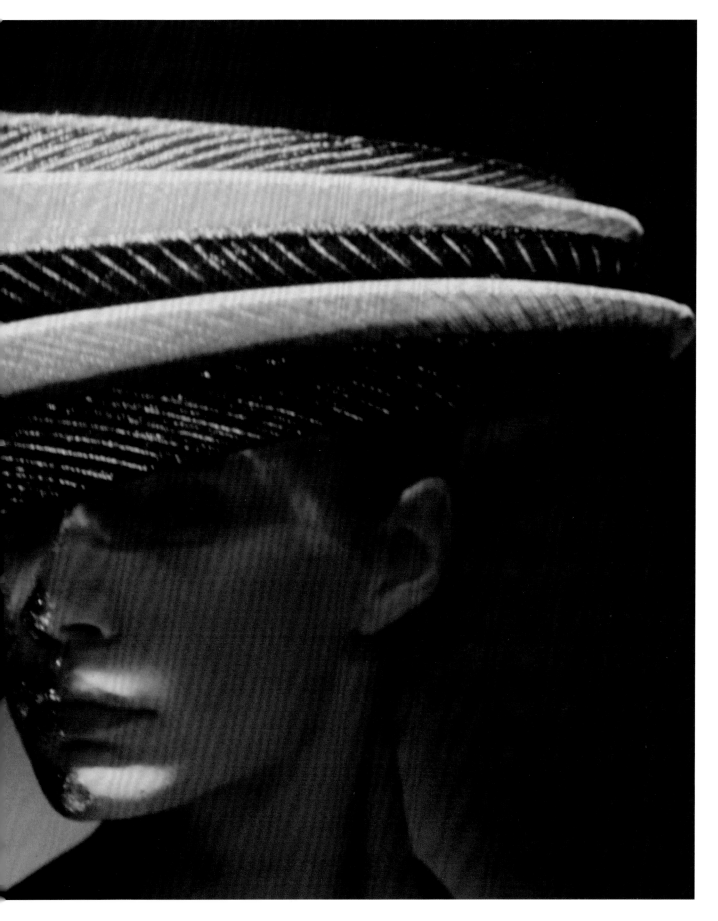

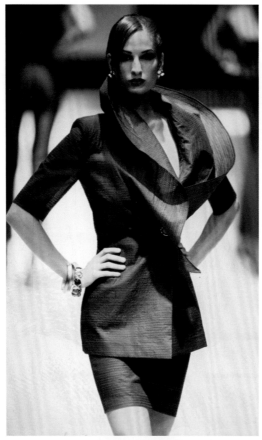

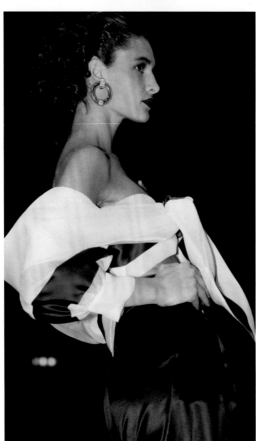
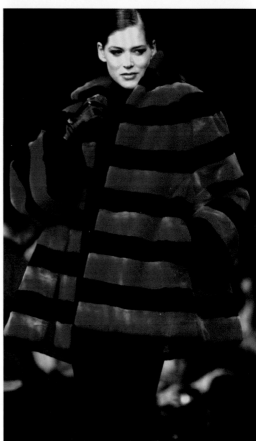

Gianfranco Ferre, top left, leaf green evening suit reveals the designer's original training as an architect, S/S 1992.
Gianfranco Ferre, top right, photographed at the end of his collection, S/S 2000.
Geoffrey Beene, below left, one of America's greatest designers was inspired by the architecture of flowers, S/S 1988.
Claude Montana, below right, red and black fur by the designer whose signature style featured a strong silhouette and graphic detail, F/W 1990–91.

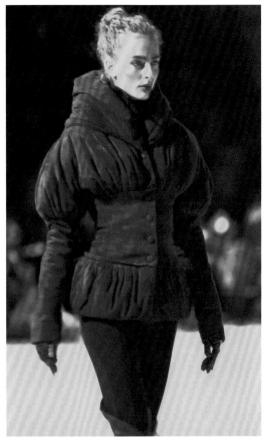

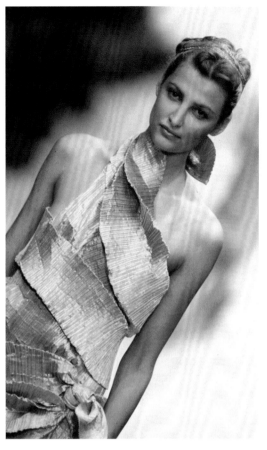

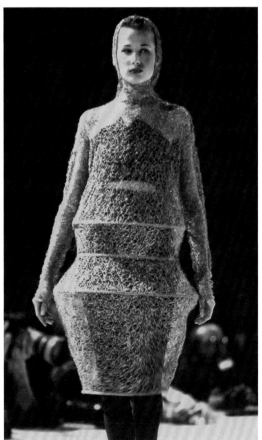

Romeo Gigli, top left, brought a new aesthetic to Milan's runways, seen here in deep purple velvet, F/W 1992–93.
Romeo Gigli, top right, gold evening dress, S/S 1994.
Romeo Gigli, below left, the simplicity of a Chinese lantern remodeled to the female form, F/W 1992–93.
Romeo Gigli, lower right, is photographed at the end of his runway show, S/S 1995. Architecture's loss was fashion's gain.

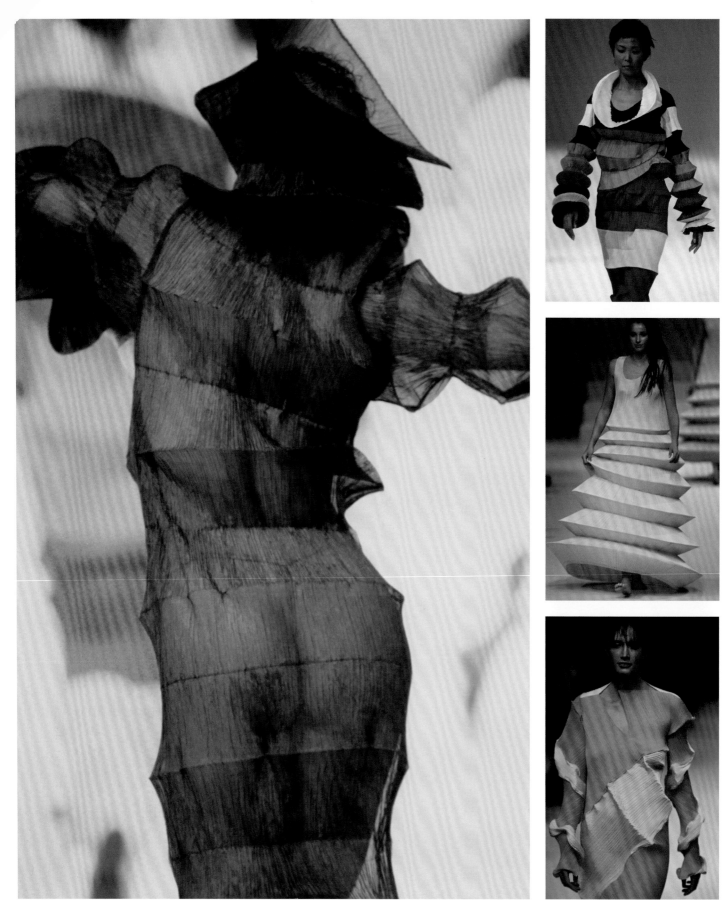

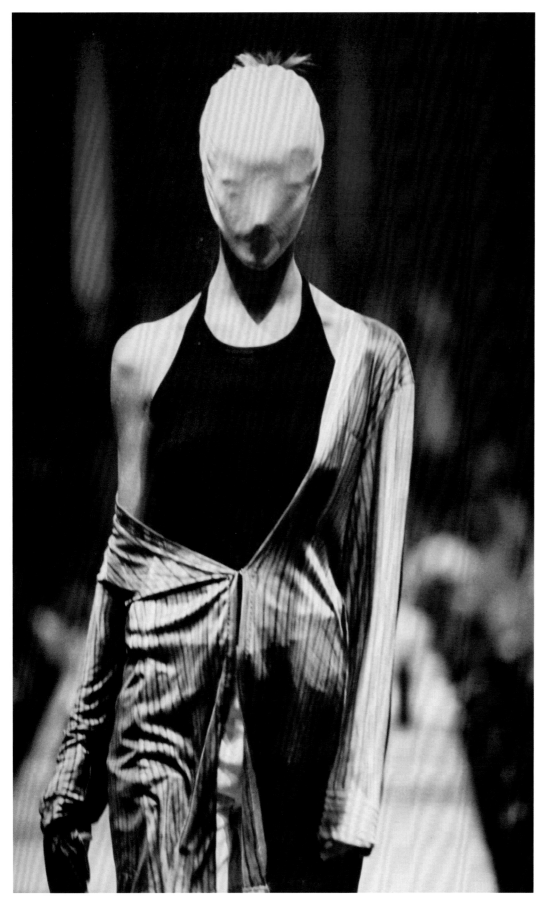

CONCEPTUALISTS

Rather than endlessly re-styling established templates, some designers rewrite the rules.

Main picture, left, Issey Miyake, created a modernistic classic out of his pleated pieces that featured a rainbow of colors and brought an approach both sculptural and engineered, S/S 1994. **Inset pictures,** S/S 1995. **Martin Margiela, right,** was originally part of the Antwerp Six, a new generation of Belgian designers who broke down established modes of dress. He went on to become the front-runner and one of the most influential desigers of the 1990s with his deconstructionist philosophy and uniquely urban aesthetic. S/S 1996.

Hussein Chalayan, main picture, left, and inset picture, blurs the boundaries between object and clothing, environment and dress to create multi-media performances that would not be out of place in a gallery, F/W 1998-99. **Right hand page,** one of **Hussein Chalayan**'s classic concept pieces; the coffee-table skirt, F/W 2000-01, captured in this photographic sequence in transition.

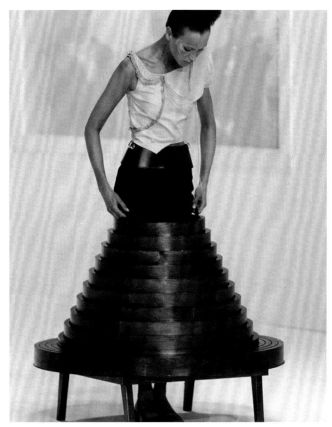
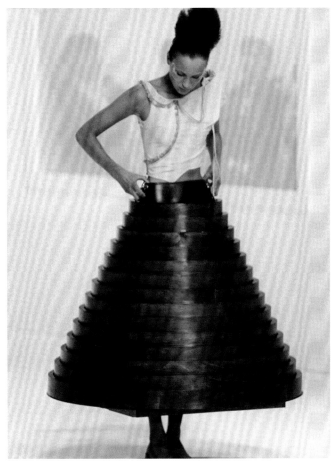
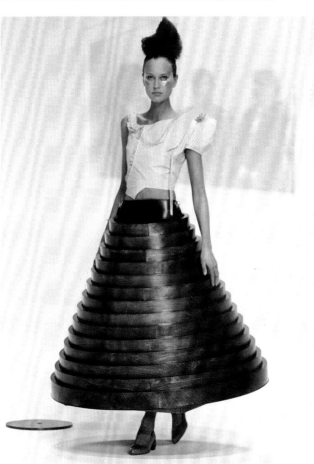

PLAYFUL POST MODERNISTS

With eclectic references and comic asides, these designers brought humorous respite to fashion audiences.

Jean Paul Gaultier, left, makes a statement in houndstooth with his all in one and matching mask, F/W 1991–92. Fashion's comic, **Moschino, right,** transforms childrens' teddy bears into the height of chic, F/W 1998–99.

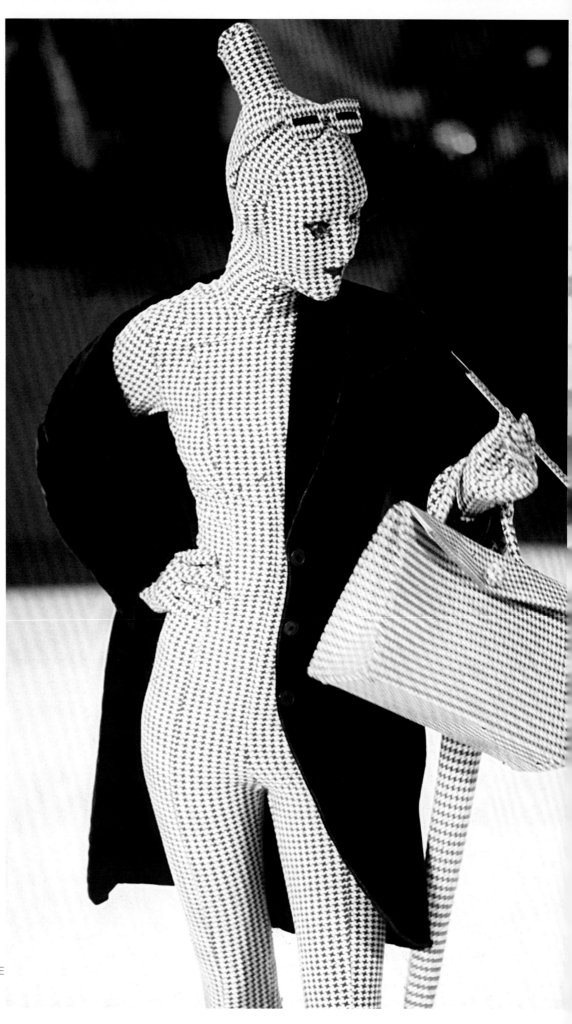

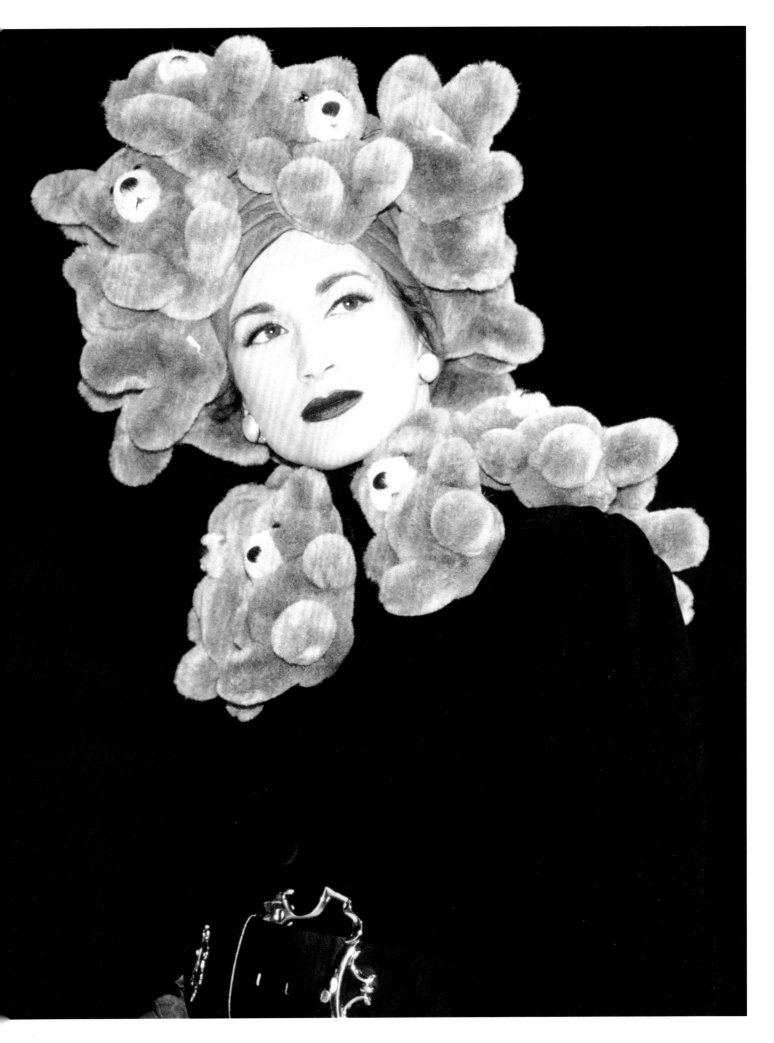

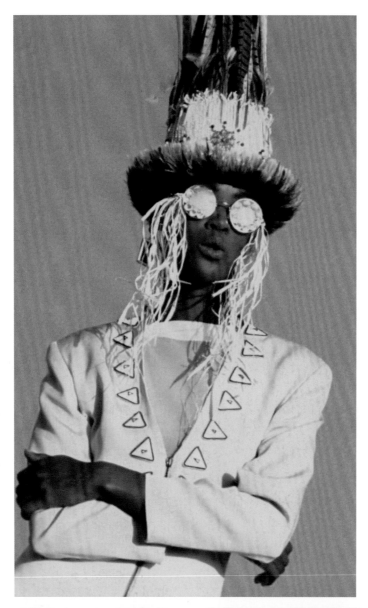

Clockwise, left to right, this page: Rifat Ozbek, S/S 1991; Indian headdress at **Moschino;** stars and stripes hat, rubber ring hat, and **center,** Plane Hat, F/W 1994–95, all by **Moschino.** **Clockwise, left to right, opposite:** exaggerated fez hat from **Rifat Ozbek,** F/W 1994–95; **main picture,** newsprint dress by **Moschino,** red rubber by **Thierry Mugler,** F/W 1992–93; Russian Constructivist collection by **Jean Paul Gaultier,** F/W 1986–87; sequinned surf-inspired collection by **Chanel,** S/S 1991; **Jean Paul Gaultier** menswear, S/S 1994; **Walter Van Beirendonck** for Wild and Lethal Trash, F/W 1995–96; **Koji Tatsuno,** F/W 1992–93; **Moschino's** Roman centurion.

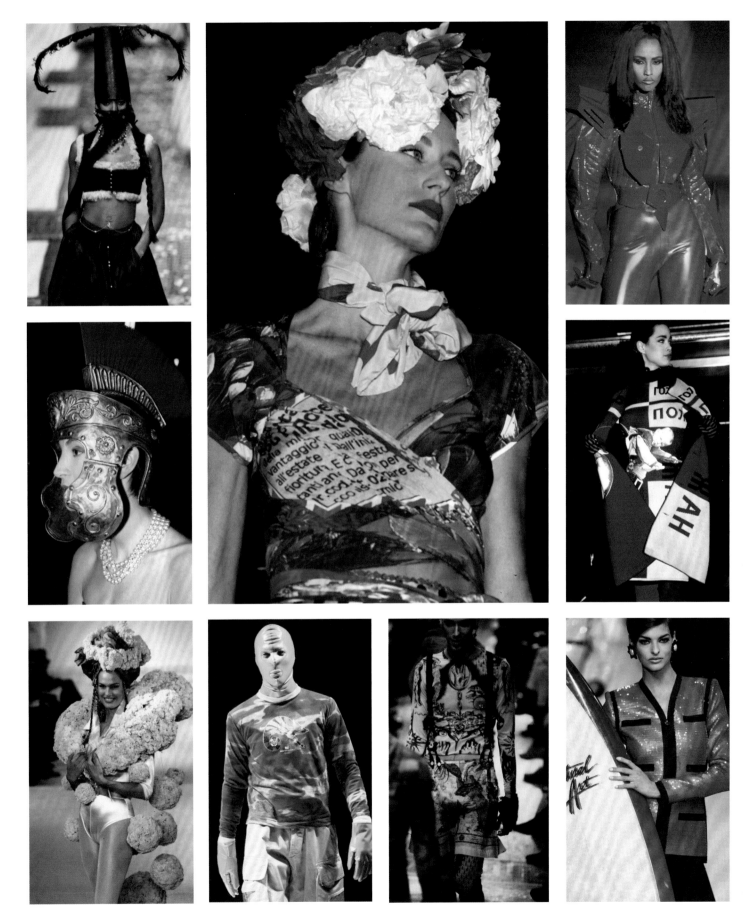

RADICALS AND RENEGADES

Iconoclastic and independent, fashion's free thinkers furrow their own paths rather than towing the hemline.

Vivienne Westwood, main picture, left, F/W 1994-95. **Inset,** Comme des Garçons, F/W 1995-96; **Opposite, clockwise, left to right,** masked model, **Alexander McQueen,** S/S 1996; demonic schoolgirl by **Alexander McQueen,** F/W 1999-2000; purple and sky blue shift dress, **Comme des Garçons,** S/S 1999; gold and chocolate brown chiffon worn by Stella Tennant at **Comme des Garçons.**

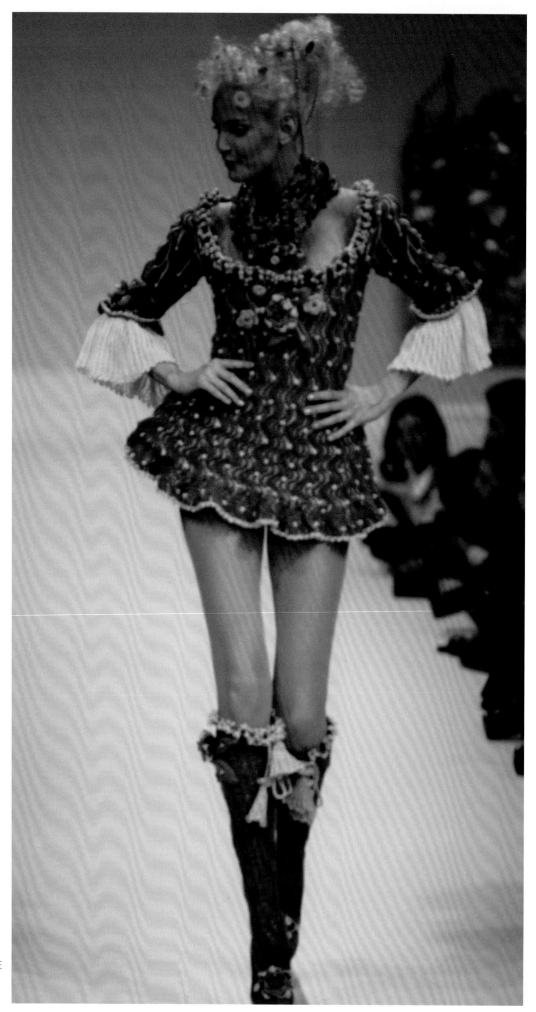

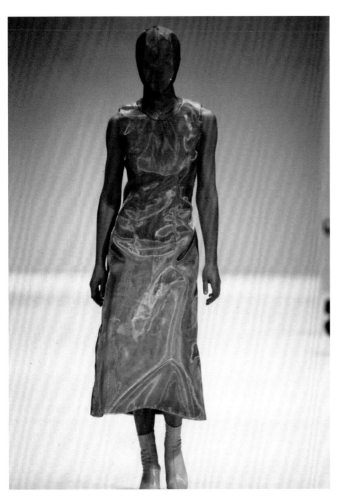
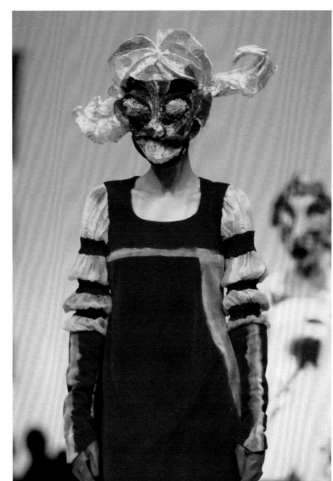
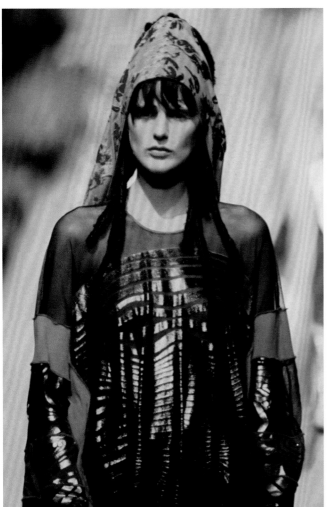
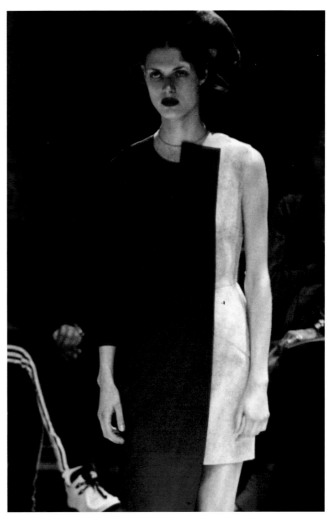

MODERN CLASSICISTS

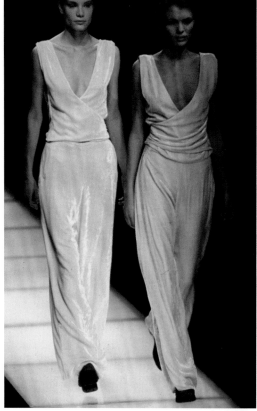

Resilient and hardy in their approach, these designs are created to go the distance, withstanding fashion's foibles.

Prada, above, offers contemporary elegance, F/W 1995–96; **Clockwise, left to right, Georgio Armani,** relaxed tailoring, F/W 1998–99; white dress by **Jean Muir,** queen of classics, S/S 1999; **Ralph Lauren** interprets mannish tailoring for women, F/W 1991–92; color blocked shift, **Calvin Klein,** S/S 1999.

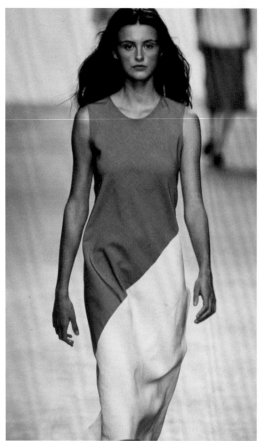

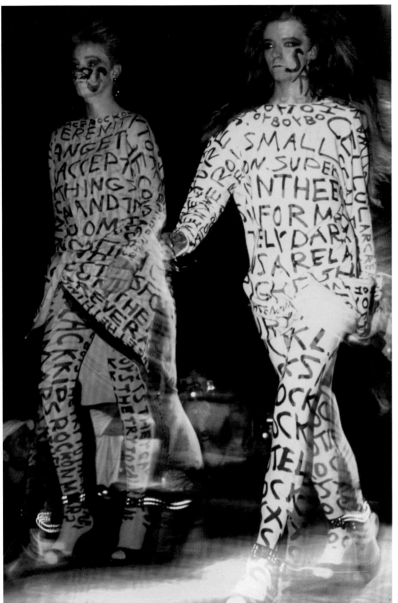

In a mono-chrome world, color has the power to pack a runway punch; it's any color except black.

Clockwise, Stephen Sprouse, New York's neon king, 1984; Kaleidoscopic ballgown, **Andrew Groves,** S/S 1999; Primary pizzazz **Emanuel Ungaro,** F/W 1989–90; peacock menswear by **Thierry Mugler**, S/S 1990.

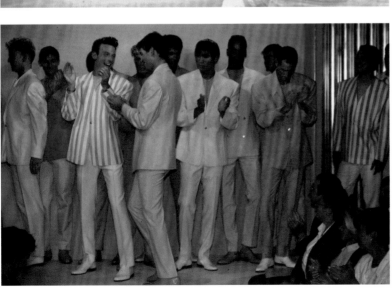

CONNOISSEURS OF CUT

Drawing with shears and redefining the body, these are precision engineers of the female form.

Comme des Garçons, main picture. Azzedinine Alaïa, above, with Tina Turner. **Opposite clockwise, Herve Leger** lace slip dress, S/S 1996; **Alexander McQueen's** mean collar for F/W 1996–97 Dante collection. The illusion of a longer body with his re-proportioned tailoring in S/S 1999, seen **bottom left,** deep green body conscious dress from **Azzedine Alaïa** (early 1990s); black and white top and organdy dirndl by **Geoffrey Beene,** S/S 1983.

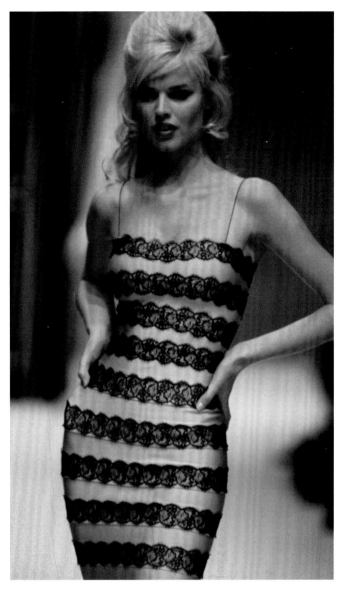

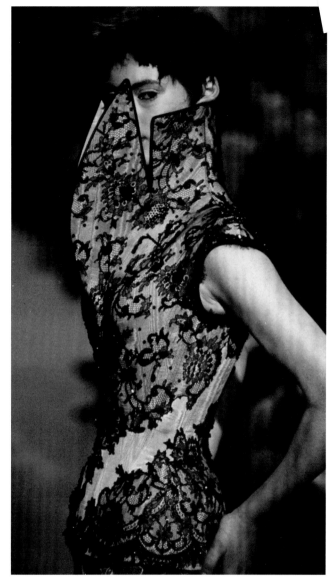

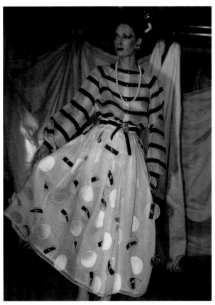

RUNWAY SHOW-STOPPERS

A collection
with great
visual impact
can deliver
global coverage;
the life blood
of a designer
business.

**Sizzling in Milano,
main picture,
Dolce & Gabbana.**
This memorable
collection from S/S 1992
saw the supermodels
stepping out en force in
black suspenders and
basques.
Top right, Rifat Ozbek
gave fashion his New
Age Collection for S/S
1990, striking for the
fact that it was present-
ed in one color only –
optimistic white and the
unusual casting of a
"New Age" family;
**Below, Katherine
Hamnett** utilized the
runway as a political
platform with her
agitator slogan T-shirts
in F/W 1984–85.

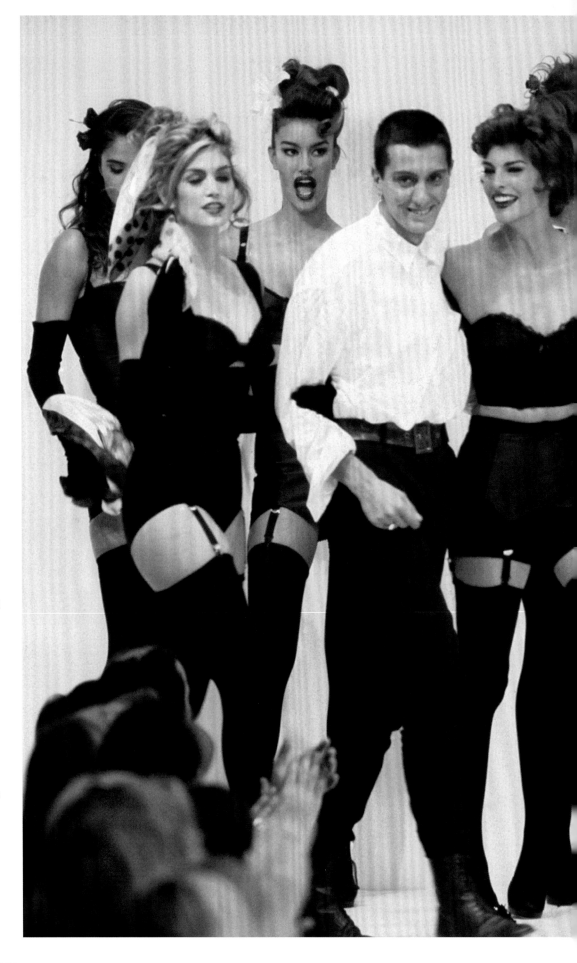

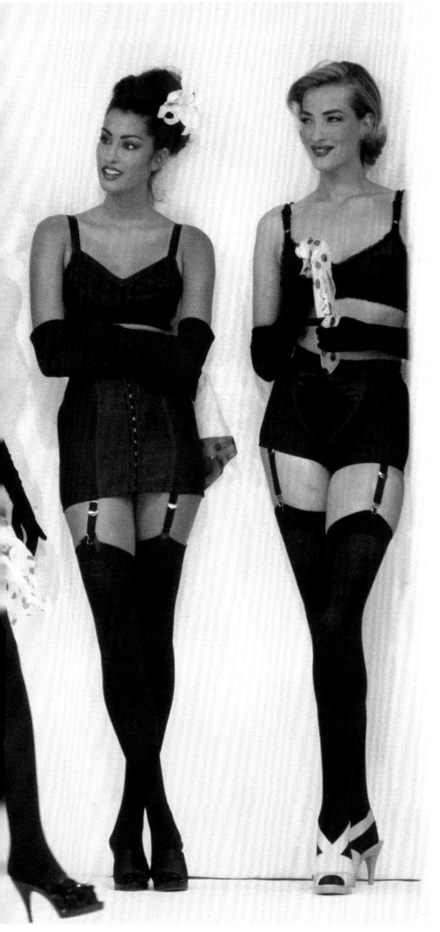

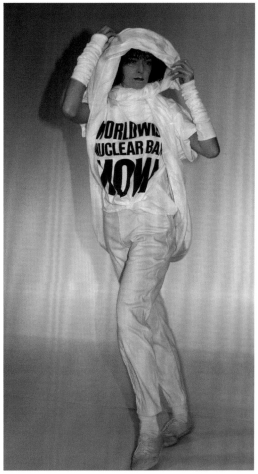

SHOW-STOPPERS

Clockwise, left to right, Yves Saint Laurent fuses fine art and design in his Picasso collection, S/S 1988; **Alexander McQueen's** Highland Rape collection, **top right,** was criticized for glamourising violence against women in F/W 1995-96; **Versace's** brash aesthetic was dignified by the supermodels seen here, with Linda Evangelista in F/W 1991-92; at Chanel, **Karl Lagerfeld** mixed the historically bourgeois label with street style, F/W 1991-92; **John Galliano, opposite page,** for Christian Dior, S/S 1995 collection.

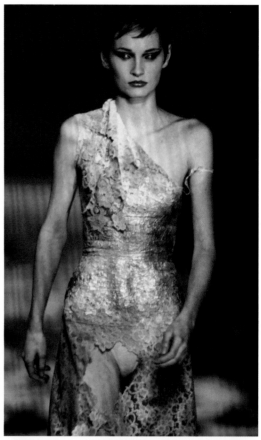

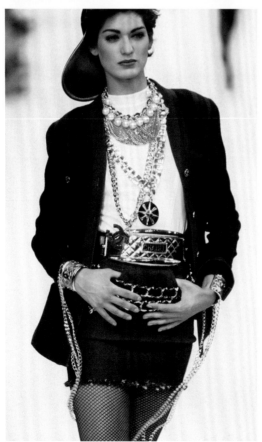

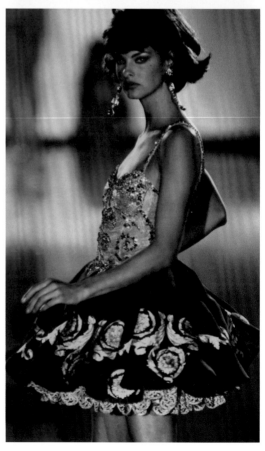

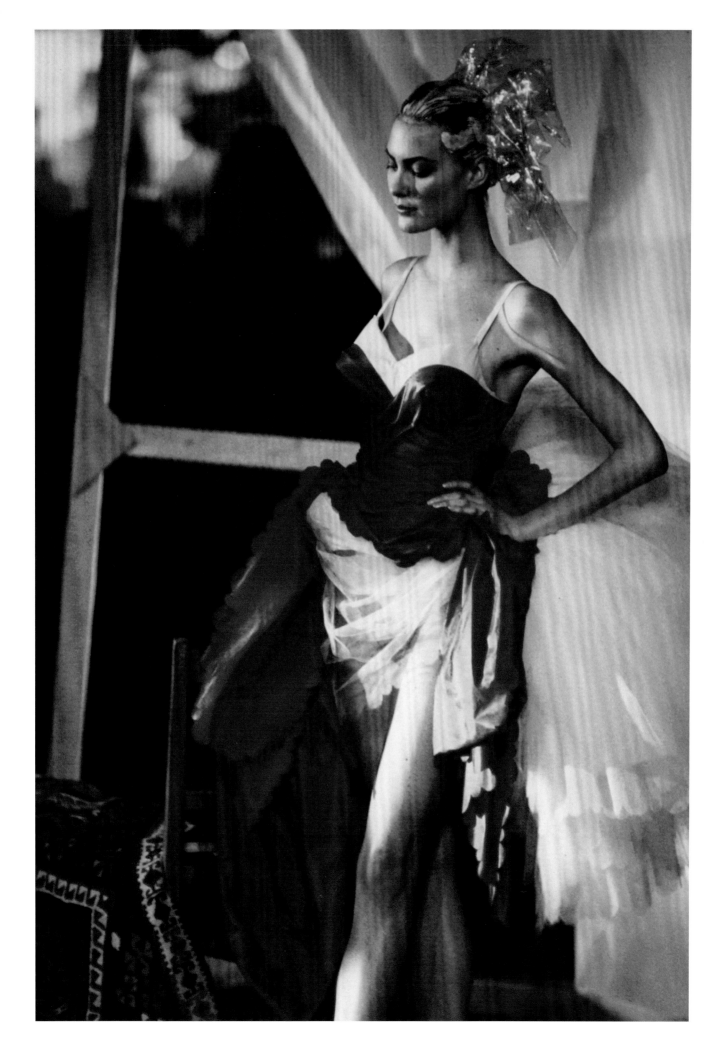

FULL-SCALE ASSAULT ON THE SENSES
SPECTACULAR SHOW PRODUCTIONS

*"You can never tell a show
from shake down until afterwards."*
KATHRYN SAMUEL

When fashion's long-term observers recall their favorite runway moments, what is most commonly recounted is the description of a show. Fashion editors are more likely to describe unusual locations, specific models, unexpected happenings, or how a show made them *feel*—thrilled, shocked, astounded, apprehensive—rather than picking out a specific season's collections.

Kathryn Samuel recollects, "It was always terribly exciting. You walk into the big tent that is half dark and full of people. It's very dramatic, the music, the build up. You can't not be excited. Versace shows always had fantastic music that you would want to find afterwards. It was a bit like going to the theatre, a musical or show but more so. It was an extravaganza."

Fashion commentator Caryn Franklin explains: "There's an energy that is bigger than the show. The brain responds when there is the sensation of a rich experience. It's to do with the physical effect of the music, the

Instant recall: fashion designers hope to create memorable experiences for their audience. Spectacular sets such as the epic Chanel bag. **Left,** F/W 1990–91 and multi-sensorial dimensions like McQueen's snowy roof top presentation. **Right,** F/W 1999–2000 are more likely to be retained in the memory of an audience who are saturated by runway images during collection time.

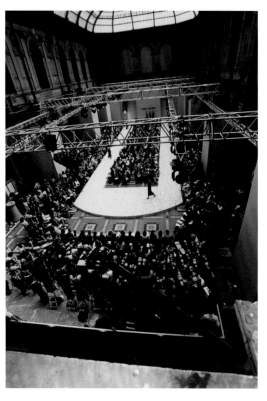

snatched conversations you hear around you, sitting in your seat as the model emerges. If you've sat at a show, it becomes more embedded, part of you, something you can't get just from watching it on a screen or video."

In fashion runway, the orchestration of location, music, models, choreography, lighting, multimedia, set design, and props coalesce for a production sometimes no less complex than the staging of a big Broadway show or music performance. Traditional couture shows would typically take place in a designer's salon; refined affairs characterized by elegant show women (not girls) and numbered outfits. The only sound might be the swish of gowns and gentle clapping. This is in direct contrast to the contemporary presentation of the runway, which started to evolve with the birth of ready-to-wear. In the 1960s, Mary Quant had her models dancing on the runway and, in doing so, sold an energetic and sexy ideal of youth as much as she did hot pants and minidresses.

Even though props or set designs do not end up selling in stores (although, increasingly, fashionable runway sound tracks do sell), these shows that frame the designer collections represent a significant investment on the part of the brand or designer (anything from £200,000 or $300,000 for a modest presentation to several million for a big budget show). This is an investment that must be recouped. One way to calculate whether a show has made its money is by evaluating the number of orders placed. Another way is to compare the publicity generated by the show to that of comparable advertising. To secure any space in a national newspaper or glossy magazine costs tens, sometimes hundreds of thousands of pounds (often as much as $400,000). Therefore, a show that generates good pictures and coverage (which these days extends to the number of tweets, blog mentions, and Instagram posts) represents better value than one that is ignored.

For the fashion professionals who may have sat through thousands of runway shows in their lives, a memorable presentation provides a hook, something to write about and talk about. John Walford, who produced Vivienne Westwood's shows for eight years, says: "I always try and open with something interesting like a flash of lightning, a great sound or theatrical backdrop. If you get the audience interested from the beginning, then you have their attention." Strong show production can keep a designer's name in the forefront of everyone's consciousness. And in fashion, like anywhere else, if you're not conscious, you're technically dead. Giving the old razzle-dazzle is not just about providing

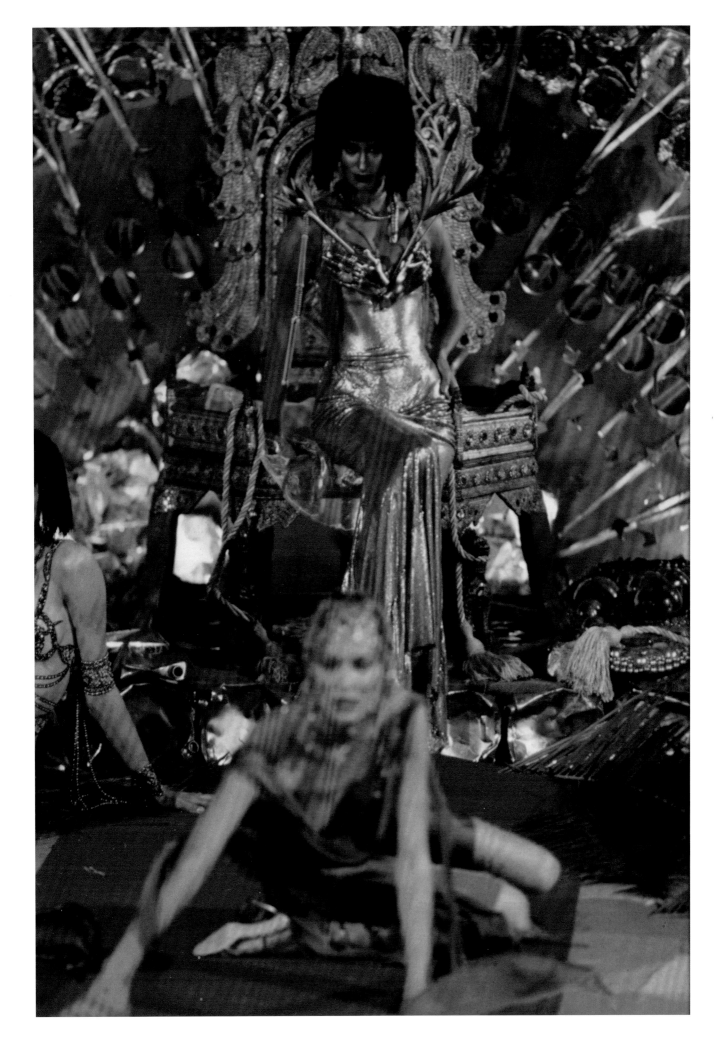

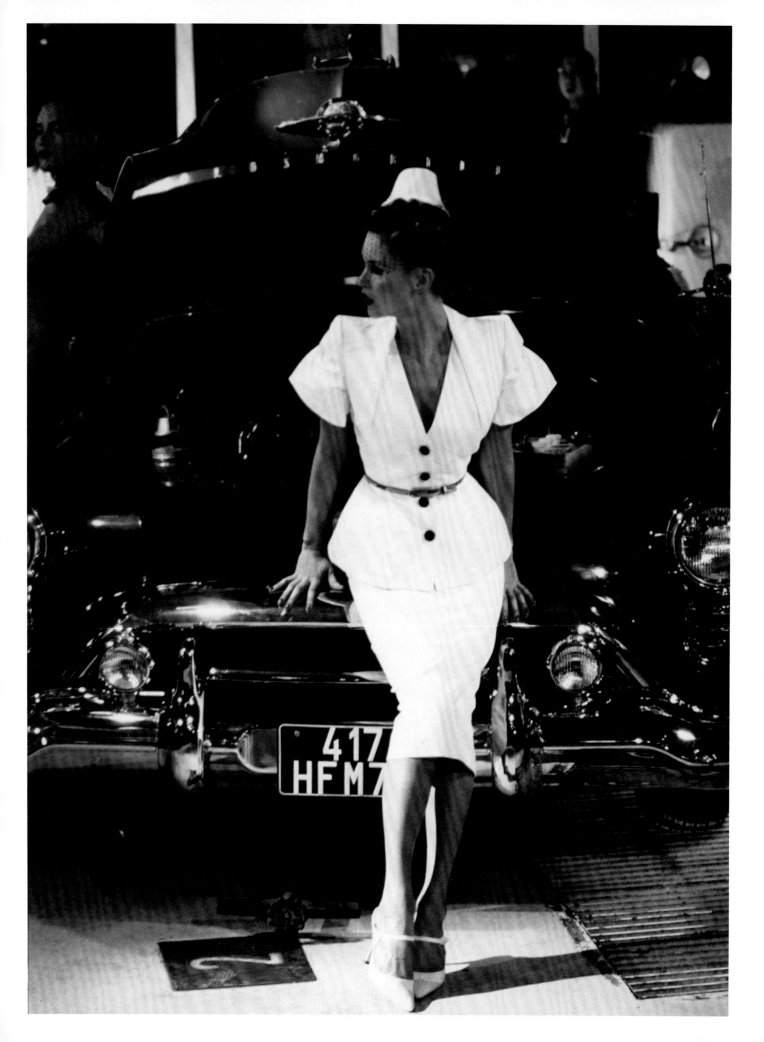

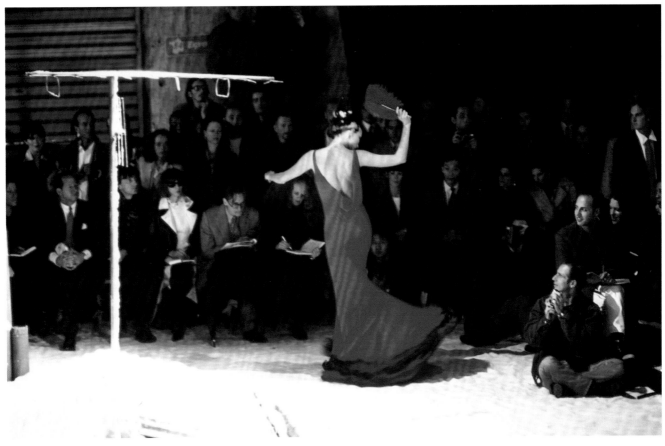

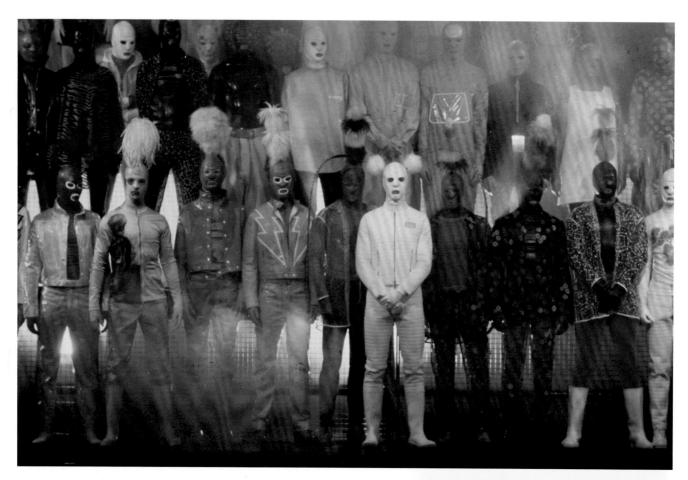

entertainment for battle-weary troops; it's a vitally important part of the publicity machine and necessary for a designer's survival.

The 1980s and 1990s could be described as a golden age of show production. There were a few memorable shows in the 1970s such as Kenzo's presentation in a circus tent erected in the Place des Victoires ("It was youthful and carefree at a time when many catwalk shows were quite middle aged and stuffy," recalls Kathryn Samuel), but it was in the 1980s when the scale of fashion started to expand and show producers started to push the possibilities. Even though London is a relative newcomer to the international designer showcase, some feel it was here that some of the most exciting approaches to show production were seeded.

Mikel Rosen's work with Bodymap presented work that was collaborative, open, and dynamic. Stephen Linard's graduation collection at Saint Martins was entirely street cast and inspired the use of unconventional "non-model" models on the runway. (The non-models became a hallmark of Jean Paul

Making a statement: above, Belgian menswear designer, Walter Van Beirendonck staged a rainbow of neon clubwear and tailoring for his label, Wild and Lethal Trash in F/W 1995-96, flooding the stage in rainbow brilliance.

Right, the runway itself has itself has often been the focus of attention for set designers, seen here painted with a neon strip to highlight Jean Paul Gaultier's F/W 1989-90 collection.

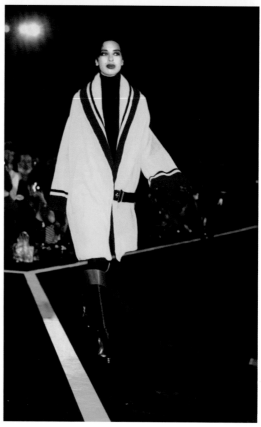

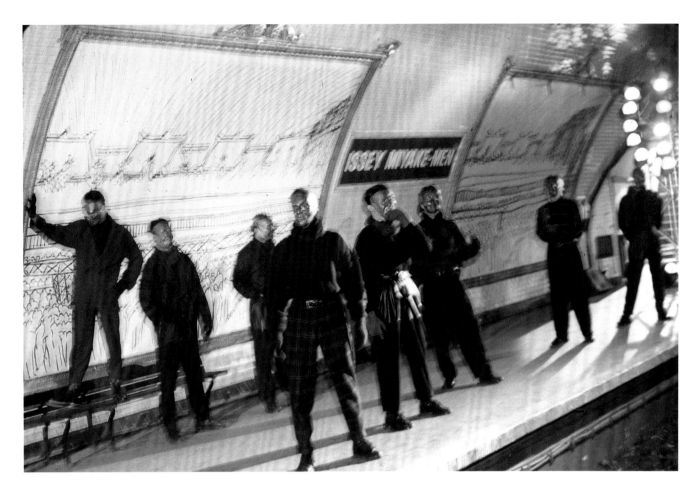

Gaultier's shows.) The exuberance of a Katherine Hamnett show—which always had fantastic, feel-good soundtracks and sexy modern collections (Caryn Franklin remembers the audience *dancing!*)—was in contrast to a John Galliano show where the designer's cutting-edge genius was translated into living storyboards and narratively rich, transportive experiences.

Across fashion's capitals, show production was as diverse as the designers themselves. From the baroque excesses of Versace and Mugler to the antiseptic and sterile presentations of Armani, whether it was the upbeat glamor of a Chanel show or the whimsical classicism of Ralph Lauren, the 1980s approach can perhaps be best summed up as broadly narrative. Runway shows presented themes and told stories.

As the decade started to draw to a close, there started to emerge a new feeling that was less about storytelling and more about ideas. This was perhaps kicked off by Rifat Ozbek's All White Collection in 1990 and Andrew

Grove's 1999 Cocaine Nights show, which saw liberal use of white powder and a row of razor blades on the runway. It was the show presentations of Martin Margiela, Alexander McQueen, and Hussein Chalayan that were the most innovatively, sometimes aggressively, conceptual. Sometimes more closely related to art gallery installations or a form of immersive theater, fashion shows in the 1990s had never been more intellectually stimulating or more challenging to their audiences. "We sometimes were speechless after a McQueen show," recalls Elizabeth Walker. "Every single one was staggering." Lanvin, Prada, and Comme des Garçons also produced imaginatively conceptual fashion shows.

In the desire to make a show publicity worthy, certain show tropes or clichés emerged. Putting celebrities or characters on the runway was one device, and it included the parading of fashion editors themselves. Animals, babies, and children were expected to extract emotion from the famously frosty audience, although it might not always be the

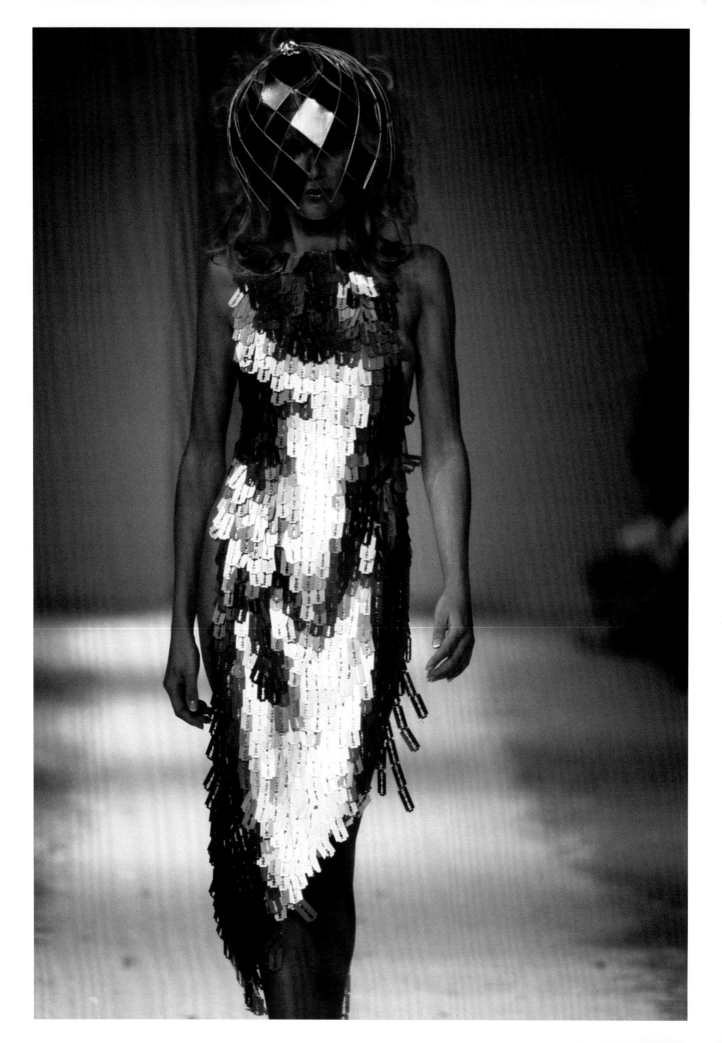

one hoped for. Various states of nudity, from the odd nipple or two to a flash of rippling buttock, would usually wake everyone up. Singers, dancers, musicians, and acrobats have all played their role in fashion productions. However hammy these ideas became, these antics are now considered fondly when set in the context of today's more formulaic presentations. With a few exceptions such as the fierce choreography of Rik Owens or the big numbers at Chanel, most shows are generally restrained and predictable in approach. For Mikel Rosen, "it's like watching donuts on a production line."

EYEWITNESS

Simon Costin, Set Designer for Alexander McQueen, 1994–1999

When the lights go up and the show starts, there is nothing more I can do. I'm normally in the control box with the lighting guys just sitting and watching the show. Production is a very collaborative thing; initially you sit round a table with the stylist and the designer and discuss how it might be. Everyone has their

Shock sensation:
Andrew Groves's 1999 Cocaine Nights collection, **left and above,** inspired by the JG Ballard novel *Cocaine Nights,* featured a gown made from razor blades and white powder trailed along the runway. **Below,** John Galliano's runway narratives are always carefully considered, seen here F/W 1997-98.

say. It has been months of work and it all happens in about fifteen minutes. It is such a small window of opportunity. And you can be sure that the sound won't be quite right, or a model will trip, or the lights will be slightly off. In a theatre piece, you would have had months of rehearsals building up to a show. For something like McQueen's Untitled, there was no rehearsal because of the rain effect.

McQueen was certainly amenable to me coming up with my own ideas. He knew with the Untitled Collection, that it would be black clothes on a white catwalk then white clothes on a black catwalk, it was quite Yin and Yang, but I came up with these illuminated plexi boxes filled with water and the idea of ink being pumped into them at some point. The Untitled Show was the first time that models exited the stage completely and there was six minutes of black ink pumping into the boxes, so that the catwalk became an installation in itself. Health and Safety would never have allowed it now: thousands of tons of water cascading across thousands of volts of electricity in a big crowd of people. It just wouldn't have happened.

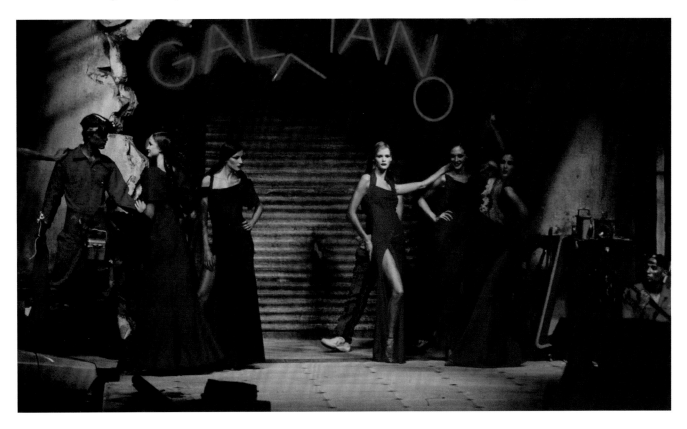

McQueen's It's a Jungle Out There had car wrecks on the stage. Some students had stormed the barricades that resulted in a burning can of oil spilling over the ground. The atmosphere of that show was very charged—it was quite extraordinary. It was to do with the location which was an open space and difficult to police in Borough Market; with the angst that was built into the designs of the clothes (the collection was based on the food chain and animals eating each other), and matters weren't helped by the dodgy security guards that had been hired in and were punching people; all topped off by the brilliant lighting by Simon Chaudoir, which cast the models in pools of light that they walked in and out of. This really upset the photographers who had already been slitting holes in the black out clothes swathing the market so they could see the collection. It all felt quite threatening and unpredictable. No one really knew what was happening or that this was a rare fashion moment or what McQueen would become.

In a theatre, the narrative is built around a play; at a catwalk show, your core text is the collection. I hope I bring additional meaning to the audience who may not pick up on all the nuances from the collection. I see myself as embroidering on the overall mood board. I hope I enrich the experience for the audience.

EYEWITNESS

Mikel Rosen, Fashion Consultant and Former Show Producer for Bodymap and Rifat Ozbek

A show is about entertainment, voyeurism, and variety. Ideally, show production is like art directing a live piece. You try to capture a designer's train of thought in 3D form with movement. How do you bring a rack of garments to life? It happens in the showing of them. There should be a balance. The show needs to portray the designer's handwriting but it should also be innovative too. Now it seems the emphasis is all about having the right girls in the lineup. I have this amount of clothes and this amount of models. Who will be the fifth girl out and the fifty-fourth girl out? It's more like the organization of a

The show must go on: opposite page, clockwise, top left to right: striking Big Brother backdrop at Kenzo menswear, S/S 1998; Bertie, a familiar character model at Westwood in F/W 1988–89; magical illusions at Jean Paul Gaultier, F/W 1991–92; choreographed menswear is taken outside by Comme des Garçons for S/S 1999; John Galliano's models encourage audience participation in F/W 1997–98; musicians and performers are sometimes drafted in to entertain the crowds, seen here at Jean Paul Gaultier, F/W 1992–93; Alexander McQueen's shows often blurred the boundaries between runway, performance, and art installation seen here in the La Poupeé collection with box, S/S 1997; Jean Paul Gaultier's collection inspired by burlesque took place in a railway carriage in S/S 1997–98.

production line: donuts or sausages going through a machine. If one stands out it's because the donut has some bright icing or eye shadow. Show producers are now more like casting agents than art directors.

We produced a mad show for Bodymap. The models came out in groups of fours and fives, from first one side then the other, all in different outfits. We had scratch music, and they zigzagged in beat rather than walking in a straight line. The designers (Stevie Stewart and David Holah) had no money but they wanted to put on a show. Their first collection was called Cat in a Hat Takes a Rumble with Techno Fish and was inspired by the Coppola film *Rumblefish*. Stevie's mum modeled, as did David's nephews and nieces. There were proper models too like Nick and Barry Kamen but all sorts: tall people, short people. Stevie found two black guys on the tube that used to tap dance and she invited them along to be in the show. John Maybury did the backdrop, Geoffrey Hinton the music. Originally Boy George was going to sing, he didn't turn up so we had Helen Terry instead. The entertainment factor was key. It was organic, collaborative; a happy accident.

My inspirations were David Bowie and Ziggy Stardust. I wanted to do the choreography for a few shows including Rifat Ozbek who I was at college with. Ozbek was always about concept. I did every show with him and Robert Forrest. When he had the white collection idea, he kept it very close to his chest but was looking for very specific types of models. He wanted Tilda Swinton and a guy with long hair and someone who looked like Patti Smith, Yasmin le Bon and Naomi were there, and a woman who looked like an American Indian who had two children called Sun and Moon. I walked in to his studio and looked at the collection. Every single garment was white (even though it was made in colour for the buyers). The set was wide and there was a projection on the back. The girl walked into a big white space and the first thing you saw was a laser on a mirrored ball and a girl standing there in white with little bits of mirror sewn in. It was 1990, the eve of the century, but it was also very clever marketing and became the collection of the season.

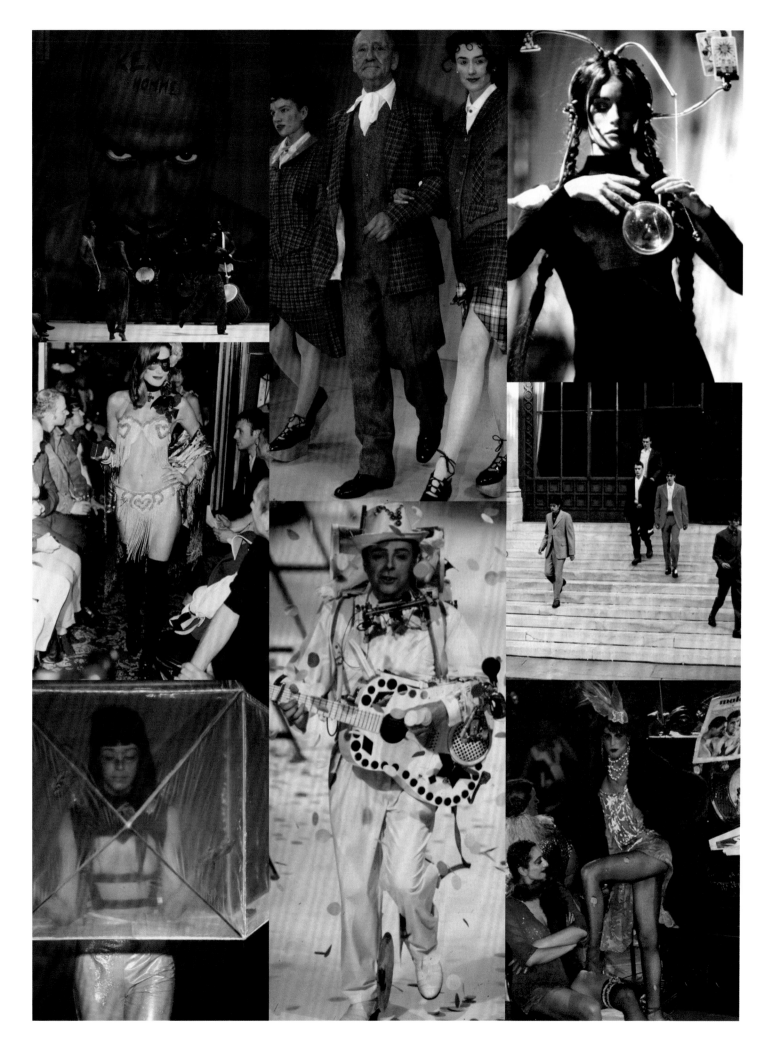

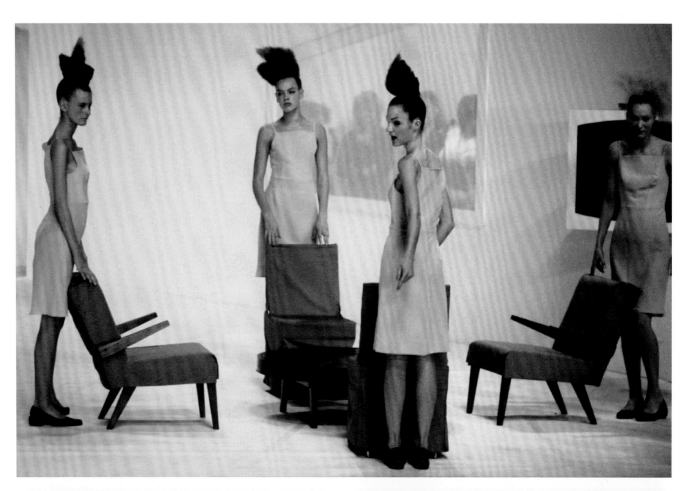

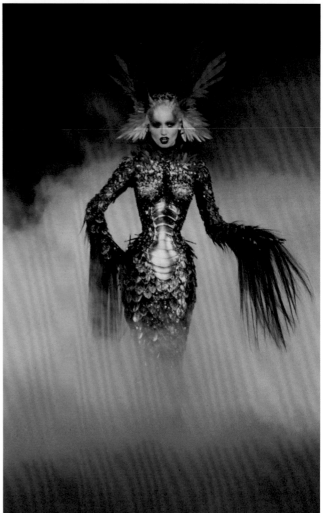

EYEWITNESS

John Walford, Show Producer for
Vivienne Westwood for eight years;
has produced fashion shows globally

I'm a conduit. The designer comes to me to
do a show. If the designer has an idea, I try
and make it happen. If they don't, I will give
them one that will hopefully make them stand
out from the crowd. I always try to open with
a lighting effect or a sound or a theatrical
backdrop. If you get the audience interested
from the beginning, then you have their
attention. I would always speak to the catwalk
photographers before a show and ask, "Are
you happy with the lights? Don't start shouting
at this dark bit because afterwards, there will
be light." If you were good to them, then they
would be good to you and maybe give you an
extra shot for the designer.

We would design the look of the stage,
the casting, music, and choreography and
sort out the lighting. It was really hard work.
Now most producers hand the music over to
a sound designer, which has become a whole
specialist business. The French lead on this.
Now, they all think they are Hans Zimmer.
Stylists have also become more dominant than
ever and sometimes take over. I think they
have become too powerful.

The Westwood shows had a terrific
energy. I remember watching Pagan 5 at the
Duke of York Barracks in 1990; that was the
first year that Vivienne was nominated as
Designer of the Year. That was the one that
had ladies' underpants with penises drawn
on and Joe Corre was walking the models
on leads. There were sixteen models on
the stage, and some were like lap dancers.
When we did Liberty in 93/4, we had all
the star models in our lineup as well as the
Westwood house models Susie Bick and
Sara Stockbridge. It was being filmed as a
minidocumentary by Mike Figgis just before
he did *Leaving Las Vegas*. It was heaving with
way too many people and the Cravat Rouge
lost control. Didier Grumbach (then in charge
of the Chambre Syndicale) said, "This isn't
safe. Pull back the doors and let's fill the two
tents." Vivienne's shows used to be forty-five

minutes long; now shows tend to be about
twelve minutes long. This is partly to do with
budget, partly about keeping the whole thing
moving. Now, it's more about what's selling
and who's buying rather than an idea.

Vivienne really liked to get the character
out of her models. One year she said, "I want
them like school children," so I had them
skipping down the catwalk arm in arm and
the boys play fighting. Before the models went
out, I would give them a thought: something
like "Imagine you are going to the shop to
buy champagne for your boyfriend." The idea
was to get the walk right. There were quite
a few amateurs in the Westwood show and
sometimes we had dancers. Bertie, an elderly
gentleman and a character, would always
ask, "What am I doing?" and I would give
him a scenario. Jibby Beane would have to
know exactly what she was doing. I have done
shows in twenty-eight countries around the
world including China, Vietnam and Nigeria.
In countries where there is no tradition of
catwalk shows, the current European model
has become the aspirational one, the way
that they all want their shows to look. They
misquote Star Trek and boldly go where
someone has gone before.

**Set to impress:
opposite page,
top,** conjuring the
twenty-first century
home at Hussein
Chalayan's minimalist
show, F/W 2000-01;
dramatic elements
offer photographic
opportunities aplenty
that are more likely
to generate media
coverage including
striking silhouettes,
left, and a model
emerging from dry
ice (Thierry Mugler,
S/S 1997). **Right,** Karl
Lagerfeld plants a
fashion kiss to the
entire audience for
Chanel.

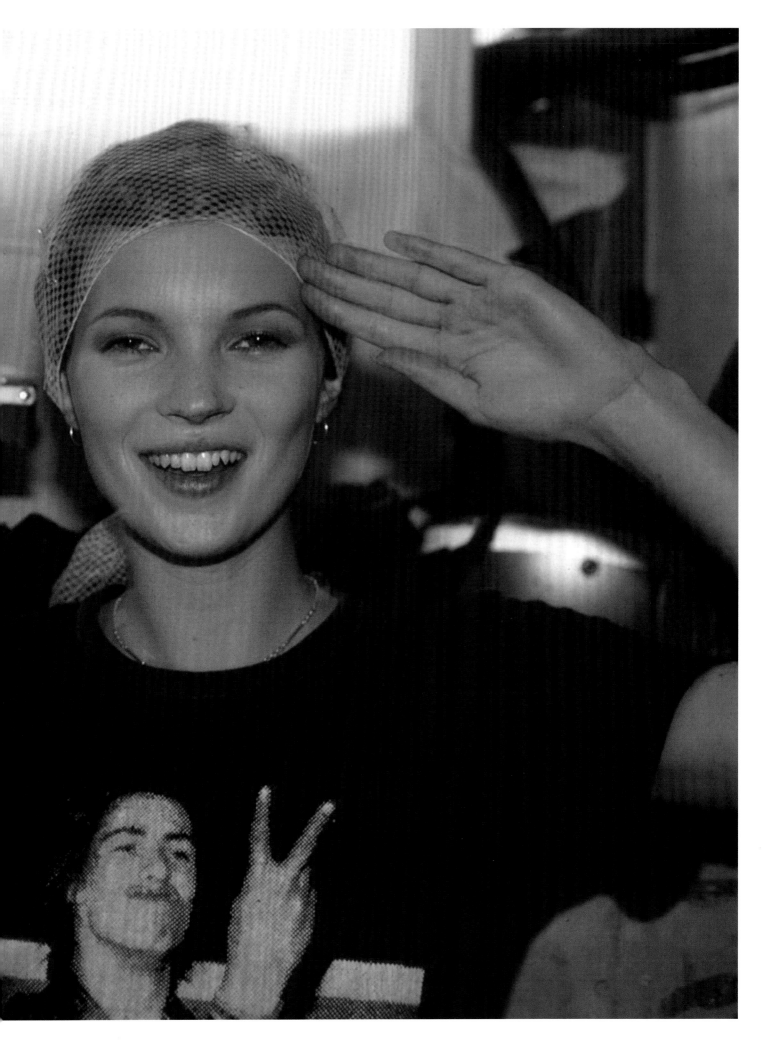

THE NEW MODEL ARMY
WALKING THE WALK

"Those girls could look at a dress and it would talk to them. It would say, Do this in me!"
Antony Price
"Lots of girls are pretty but these were goddesses, extraordinary creatures. They had a magic quality that really worked on camera."
Sam McKnight

Although the professional life of a runway photographer is tough, one of the few perks is surely beauty. What other job casts you into the paths of the world's most beautiful women? How must it feel to kneel before Carla Bruni? To have Cindy Crawford hold your gaze? To get a high-definition focus on some of the best legs in the world? "Of course, they love looking at the women, who wouldn't?" asks Anthea Simms.

Although there is much feminist mileage to be had from a group of (mainly) men pointing their long lenses at their female subjects, there can be no denying that the world's top models and the runway photographers share a dynamic based partly on gender and erotic attraction. Simms notes that "lots of men in fashion are quite camp. By contrast, the runway photographers tend to be fairly straight. You used to get lots of caterwauling, which has died down, although they will occasionally shout out if a model doesn't look up or closes her eyes." She adds: "They used to be a red blooded lot, but now

Faces to launch a thousand frocks: previous page, Shalom Harlow and Kate Moss salute Niall Mcinerney backstage at Chanel F/W 1993–94. **Opposite,** Eva Herzigova glows for the camera in 1992. **Right,** legendary British designer Ozzie Clarke attends to a model backstage at the Bella Freud show in London, October 1995.

Following pages: all eyes on Linda Evangelista, front of house and centerstage for John Galliano in October, 1995, and photographed back-stage the same season by McInerney.

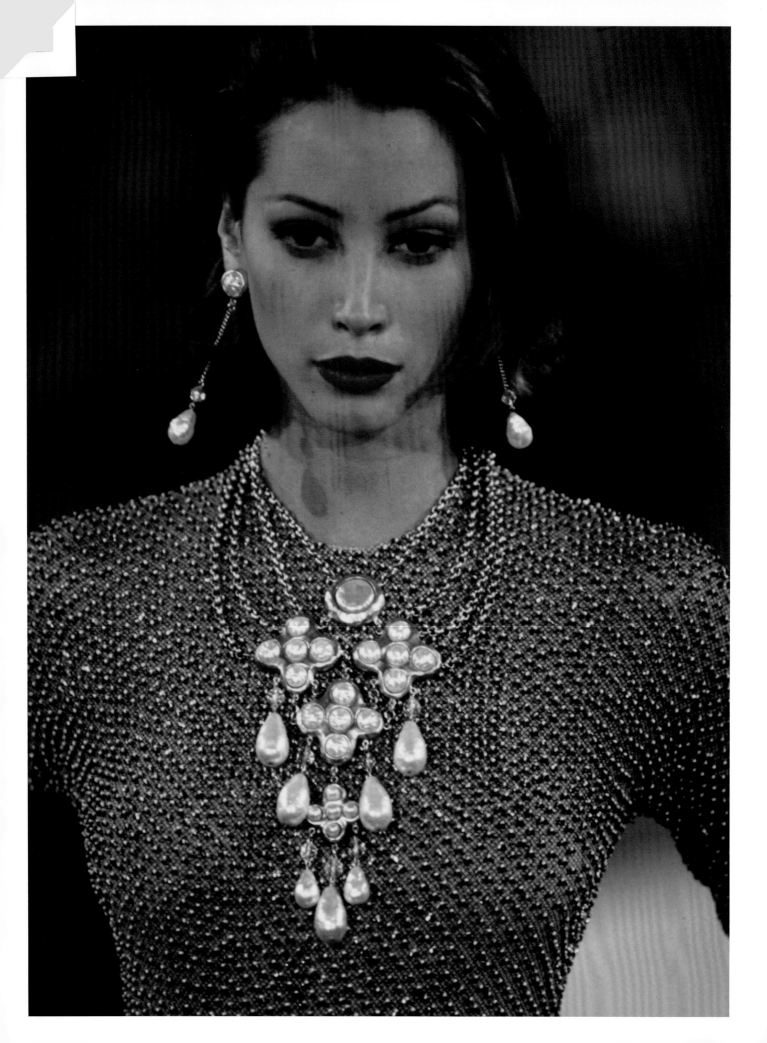

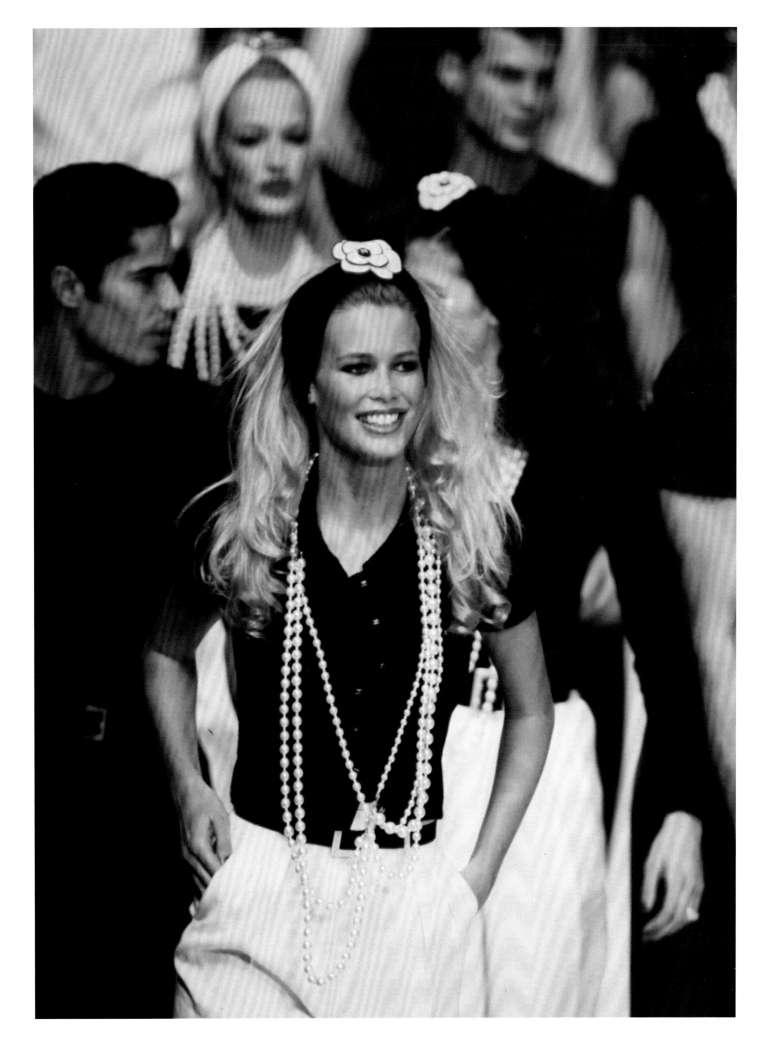

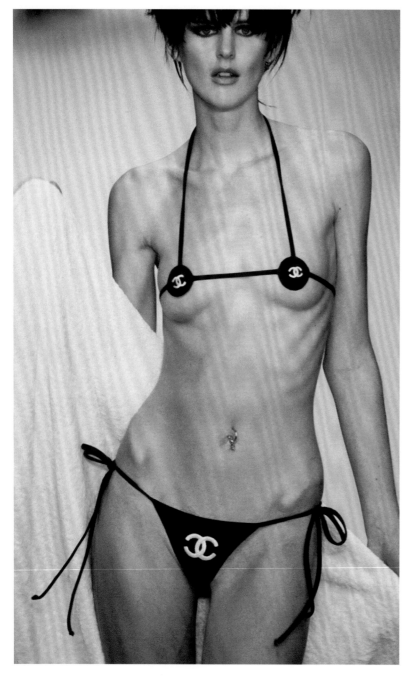

there are no red blood corpuscles left after doing 300 shows."

Runway presentations are shows, and shows need stars. Once, the fashion designers were the undisputed stars, but since the rise of the supermodels in the late 1980s, some designers willingly demoted themselves to the role of dressers. Supermodels now rarely appear on runways, but their legacy remains. There is still a huge importance based on which model opens a show and closes a show. "Designers realized fairly quickly that these girls brought their clothes to life," adds Sam McKnight. "The most important outfits would be reserved for the biggest girls."

When Linda Evangelista said in American *Vogue* in 1990 that she wouldn't get out of bed for less than $10,000, the scene was set for the supermodel phenomenon: highly paid, physical, and aesthetic outliers—freakishly beautiful individuals. "They all started at around the same time and because the business was growing so fast, they all had a lot to do. They were the modern movie stars," maintains McKnight, who admits he misses those "goddesses" he once worked with and built strong ties to. "There were maybe a dozen of them that exploded onto the scene: Helena, Kate, Christy, Linda, Naomi, Yasmeen, Cindy, Nadja, Tatjana, Claudia, Amber, Shalom. You would turn up to do a show and they would all be there, looking gorgeous and ready to work the catwalk. They would get on the runway and own it."

Every era has women that summon that spirit of the age, fashionable faces that somehow tap all the right cultural, aesthetic, and social buttons (Bettina and Kay Kendall in the 1950s, Jean Shrimpton and Twiggy in the 1960s, Pat Cleveland and Marie Helvin in the 1970s, Patti Hansen and Christie Brinkley in the 1980s), but the Supers, as these superstars are also known, were in a different league. Comparing Linda Evangelista with, say, Bettina (once muse to Hubert de Givenchy) is like comparing David Beckham with Stanley Matthews (arguably one of Britain's greatest-ever soccer players). It's not the core talent that is in question but the social currency and cultural capital attached to the new models that redefined their meaning. Supermodels developed serious

Previous pages:
left, Christy Turlington for Donna Karan, F/W 1987–88; and **right,** a coquettish Claudia Schiffer in Chanel, S/S 1999.

So hip, it hurts:
above, a gaunt Stella Tennant models a Chanel micro-bikini in S/S 1998. **Right,** Yasmeen Ghauri backstage at New York collections, April, 1994.

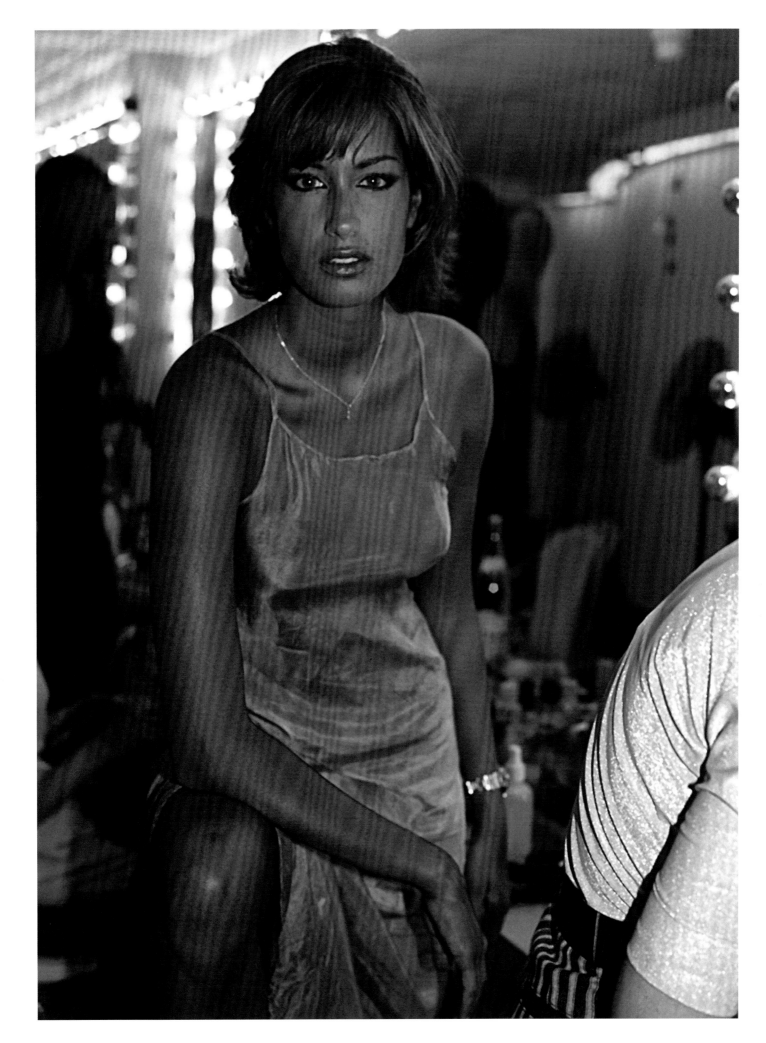

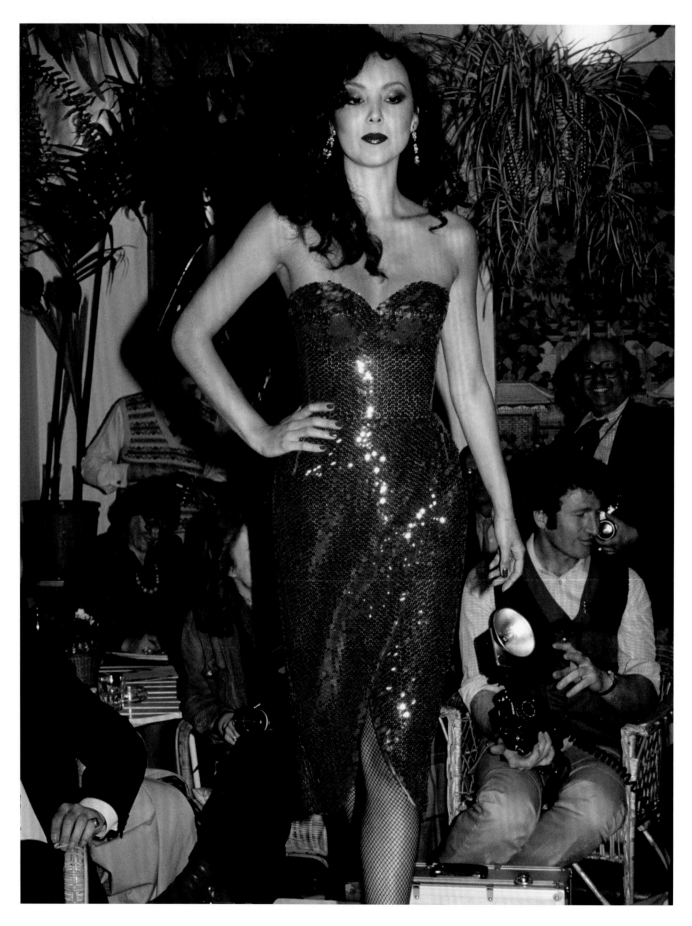

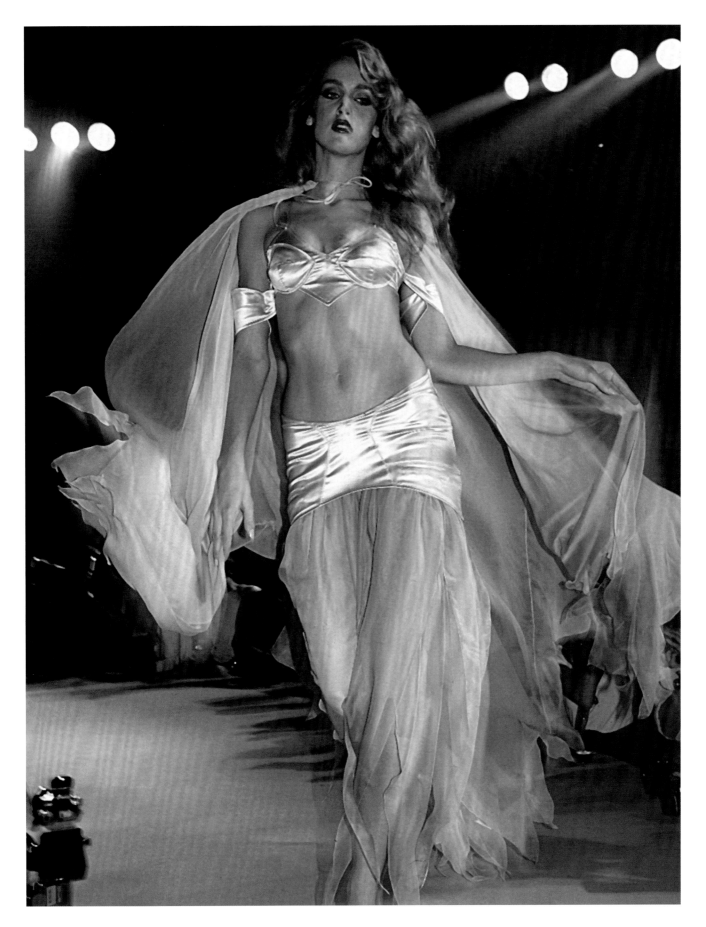

status, commanding huge fees and the adoring gaze of the world. They represented the apex of modeling possibility, soaking up the glossiest editorial including thousands of top magazine covers, not to mention the advertising campaigns, which spanned everything from cosmetics to cars.

Step back just a few years from the age of the supermodel and it was a very different scene on fashion runways. There were showgirls who did only runways and never appeared in editorial, and then there were the girls who got the jobs with fashion photographers and appeared on magazine covers. Models who did shows were trained differently. They could move, walk, and turn. A girl who looked great in front of the camera could not necessarily walk. Now that fashion film is becoming a more common form of fashion communication, models are expected not only to move in front of a camera but also to sometimes act and even speak. In addition to the showgirls who were indigenous to runway, there were also house models—

Original supermodels: previous pages, Marie Helvin and Jerry Hall (Paris, S/S 1980) were the epitome of glamor in the 1970s and 1980s. **Below,** luminous Amber Valetta backstage. **Facing page,** Nadja Auermann models a diamond and emerald necklace during a break at John Galliano's F/W 1994–95 show, also seen **overleaf** on chaise lounge.

women who would present for only one designer such as Ines de la Fressange for Chanel and Maria Selznick for Christian Lacroix. They became more than just house models; they became the muse, embodying the spirit of a designer. "A muse to a designer is like a model might have been to a painter. They are able to trigger the creative process," adds Debbi Mason.

Running parallel to the muse and supermodel story, we saw the emergence of character models or "real" people on the runways in the 1980s and 1990s. Part of Jean Paul Gaultier's aesthetic was to cast interesting models such as Eve Salvail, a shorn and tattoo-headed, often jack-booted beauty. This preference for the idiosyncratic but always stylish individual extended to the fashion press (flattering the vanities of your audience is a strategically sound proposition); the picture of a foppish Hamish Bowles (of American *Vogue*) wearing makeup in Gaultier's spotlight is not easily forgotten.

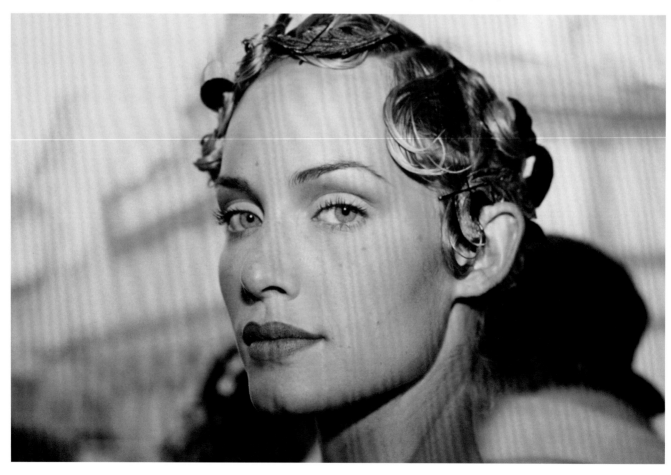

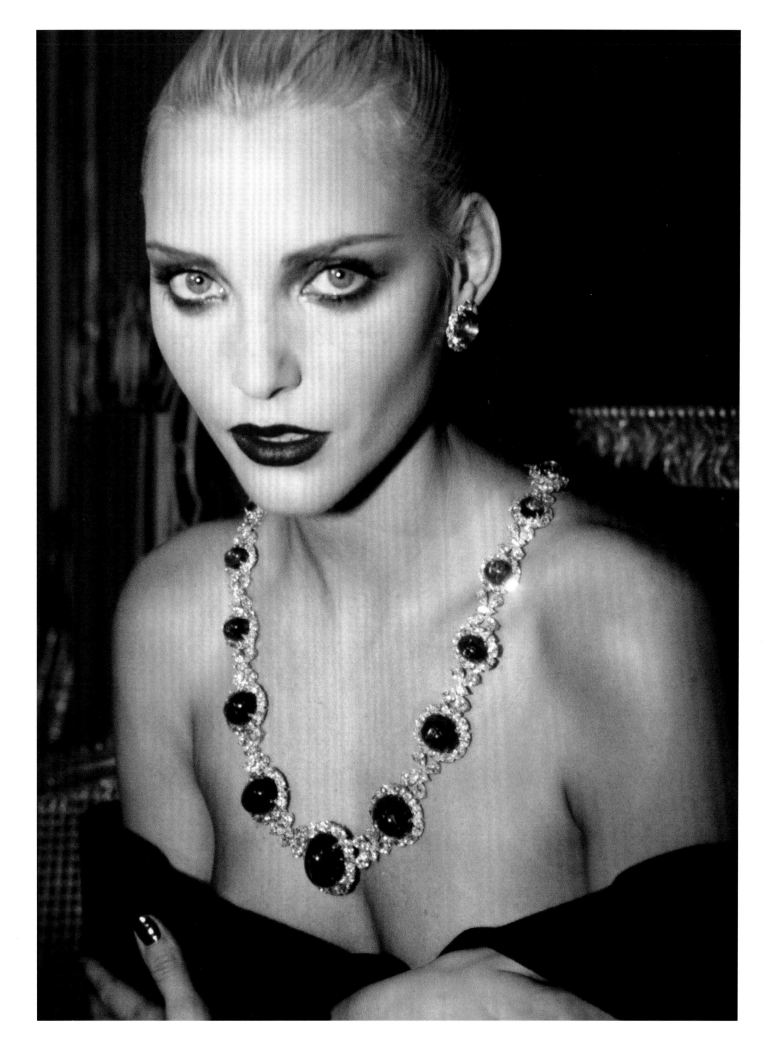

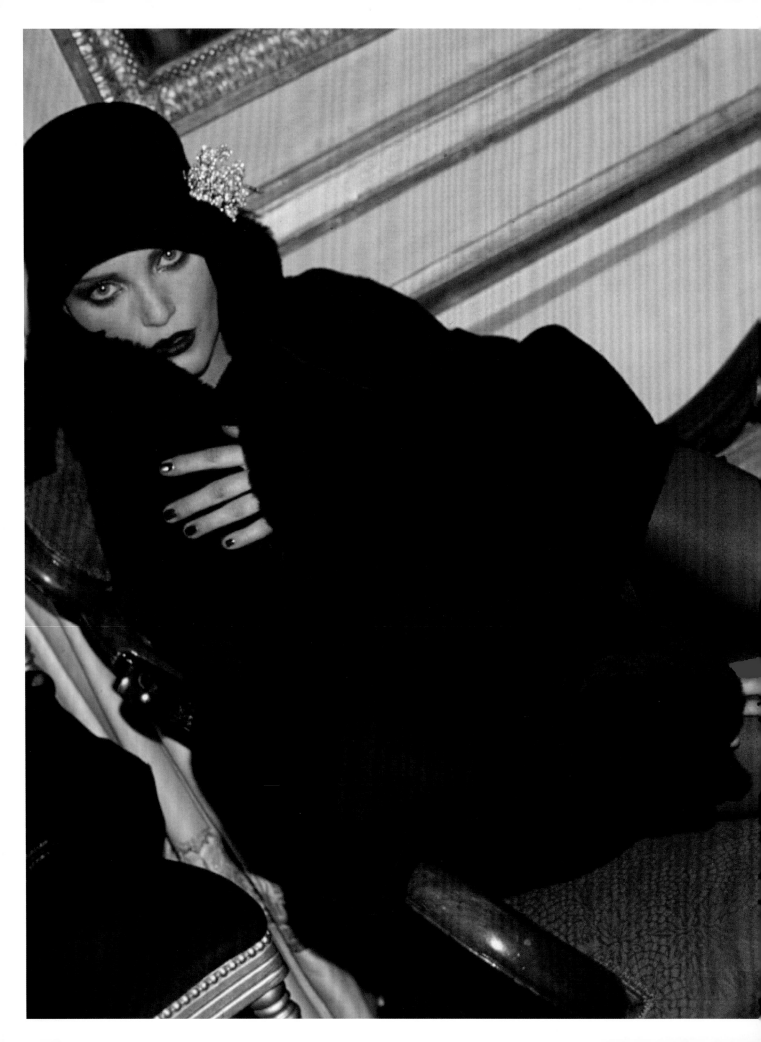

At Comme des Garçons, Rei Kawakubo would draw in iconic individuals from the creative industries who were noted for their ingenuity and intelligence rather than their looks. Architects, sculptors, painters, and performers have all slipped into Japanese tailoring under the instruction of Rei Kawakubo. Seeing Dennis Hopper appear in crumpled linen at a Comme des Garçons menswear show in 1991 was a personal high point. These were clearly clothes cut for the gods. And that is how it works. The carefully chosen models at any runway show become part of the brand language. Whatever their attributes—beauty, character, or personality—these become magically imbued and impregnated into the very garments themselves, making these items more attractive, desirable, and profitable.

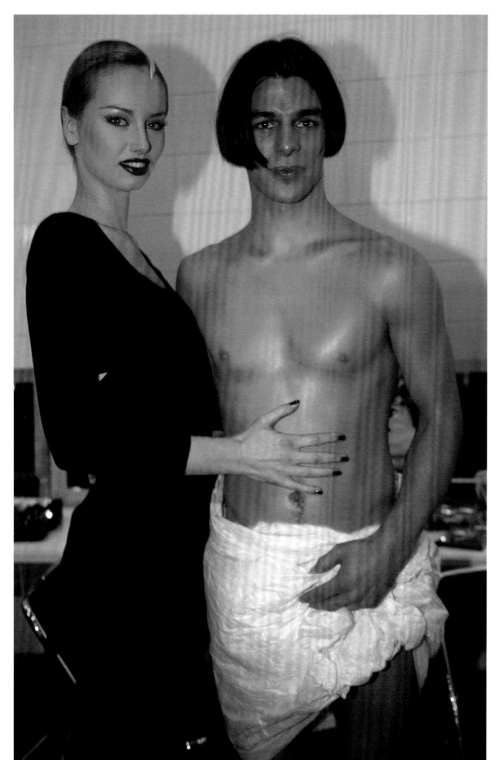

Gaultier's favoured models of the 1980s, Rossy de Palma. The more mature model has graced many runways in the recent past; their presence makes a comment on fashion's obsession with youth; mature model for Comme des Garçons; corset-wearing Mr. Pearl noted for his tiny waist for Alexander McQueen, S/S 1995; model punk and the actor, John Malkovich for Comme des Garçons.

Right page: from **top,** backstage Paris menswear, 1995; Hamish Bowles for Jean Paul Gaultier and with hat boxes. **Below right,** underwater legend Jacques Cousteau for Jean Paul Gaultier.

EYEWITNESS

Sarah Doukas,
Managing Director of Storm Model Agency

Kate Moss is shorter than your average model but has huge presence on stage. The audience is drawn to her. Kate has evolved from simply being a model into an icon. She has inspired generations of photographers and artists such as Mark Quinn and Lucian Freud.

If you want to turn a girl into a brand that works across multiple platforms, then you need to identify and support her interests outside of fashion, her talents and aspirations. We provide 360 degree management for our talent. We take them in, package them in special paper then send them out to the industry when they're ready. Years ago, a model would have been frowned on for wanting to pursue other ambitions: "Why do you want to do acting?" would have been the typical response. Now it's integral to our business that we provide strategic and skilled management. Brands actually request girls with social media skills as this gives them a platform from which to reach the consumer.

Catwalk never used to be so important for a model's career. These days, it's almost impossible to do high-level campaigns and editorial without doing the shows. Treading the catwalk is a casting opportunity. If you want to develop a model at the highest level, it is absolutely vital to get her on the catwalk. The editors want the girl of the moment, the new edgy girls. A month before the shows, the casting directors will turn up to get exclusives. It's vital to have the girls groomed and ready to go. It's really competitive. The editors are all there looking at the new girls to put in the new clothes. There's a lot at stake.

We teach our girls how to catwalk. Some of the girls say, "I can't do it," but most get the hang of it. We say "shoulders back" and show them how to do the turn. A walk is simple, but a girl can put her own twist on it. We tell them, "You will be remembered for it." Some are shy and find the idea terrifying. But over time most get used to it and grow in confidence, and if they are ambitious and understand what catwalk can lead to, they will work hard to do it well.

The requirements are fairly specific for catwalk: 5 foot 11; 5 foot 9 is small for a showgirl, which is where the pressure can come in because a 5 foot 11 girl is likely to have a 36 inch hip, which can be considered too wide for catwalk. These girls are racehorses compared to New Forest ponies. In terms of character, they have to be pretty damn resilient. It can be terrifying at the beginning. I can't imagine how many miles some of them do on the catwalk. It's frantic and relentless. There is all the backstage mania; people doing your makeup, pulling at you, screaming and then the dashing from show to show on motorbikes and if a model gets cancelled for a show, it's hugely stressful for her.

The catwalk season is difficult for them and us. They can be exhausted, exasperated, and grumpy. During catwalk season, we have bookers working through the night, some until 3 a.m. The casting directors can go crazy, screaming and shouting. Sometimes they can be threatening—well she won't get the such and such campaign if she doesn't do this show and the show schedule is insane. Shows are always running over, and if a model does one show, then she can't do the one straight after. It's mayhem: screaming and shouting. You do get hissy fits backstage, with some girls feeling left out because they are not getting as much attention from hair or makeup as much as others.

Catwalk used to be well paid; Milan and New York are now less well paid because the shows are so incredibly expensive to put on. The odd big brand will pay fifteen grand to fly in a girl exclusively. Here we have a basic rate of 250 or 300 a day but there is a sliding scale depending on how popular or high profile a girl is, but no one does it for nothing. Everyone gets something, but it's really pin money. We have to cover all of our overheads, we pay the bookers who work through the night, and we pay the drivers. But catwalk is definite currency for us. We can trade with it and it helps girls get more editorial. We can say to stylists and editors: "Well she did Giles and Vuitton," and they are impressed and are more likely to book them.

Icon and on and on:
Kate Moss for Gucci, F/W 1996–97.

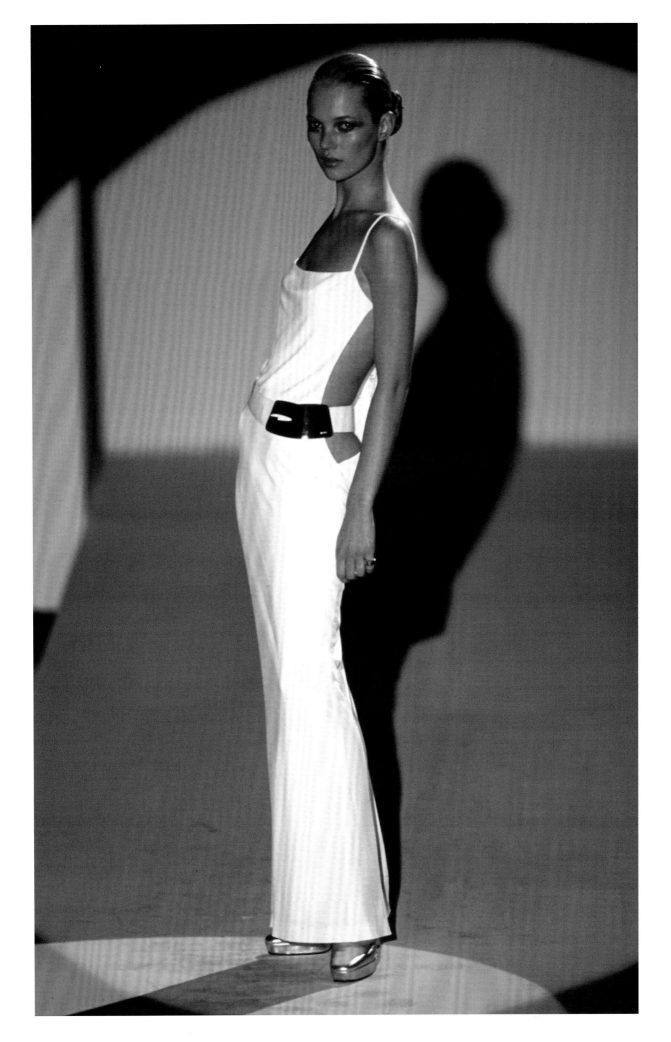

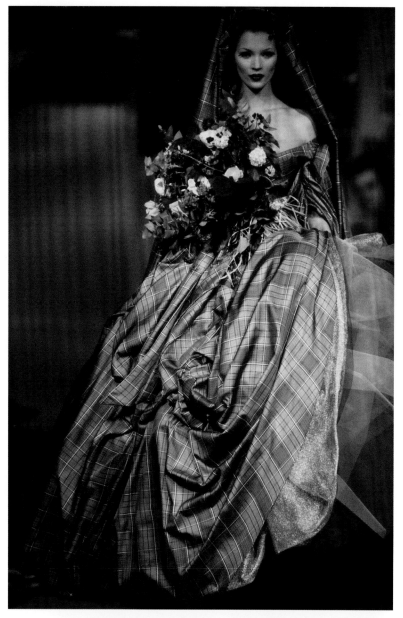

I do worry about lots of young girls together being away for the first time. Some girls are between sixteen and eighteen, and actually, I'm not keen on girls that young doing the show circuit. Are they mature enough to deal with it? Are they mature enough not to drink twelve glasses of champagne and stay out all night? We send chaperones out with our new girls so that there is someone to look after and protect them. I tell them: "Look, you are your own PR. You're not a commodity, you are a person. This is a fantastic opportunity. Be nice to the people you are working with. Remember to say thank you and look people in the eye." They need to eat well, sleep properly. We also educate them about the teams that they might be working with. Someone who has just arrived from abroad might not know who Katie Grand is.

Sometimes, we will dictate to the casting directors. "If you have her, she *must* open the show." It's like being the bride instead of the bridesmaid. The designers know that they will get an enormous amount of press on the back of this. Models have become names and recognizable faces in their own right and can guarantee coverage for a brand.

The buildup to the shows is a combination of dread and excitement. The day that we come back after the New Year, it's full on as the casting directors are straight on the case. We have to make sure that the girls have all their visas in place, that the drivers are on call, that the deals with the hotels are fixed, that the model flats are ready. We talk to lots of food companies that we have deals with for steady supply of healthy snacks and coconut water. The drivers are all here, and it's manic but a lot of fun and actually when it's over, it feels a bit flat.

Above left, Kate Moss in Vivienne Westwood, F/W 1993–94.
Left, Nadège du Bospertus. **Right,** Carla Bruni cuts a swathe on the catwalks before becoming Paris's first lady.

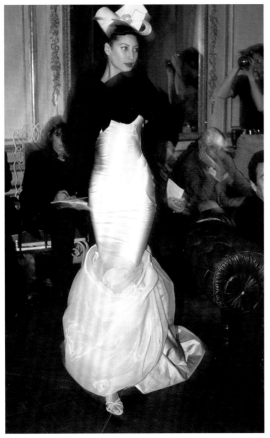

Classic runway: above, Marpessa, the model who made the runway her own with designer Philip Treacy and Linda Evangelista. **Left,** Christy Turlington modeling for John Galliano, F/W 1994–95. **Right,** Marpessa in Chanel, F/W 1986–87.

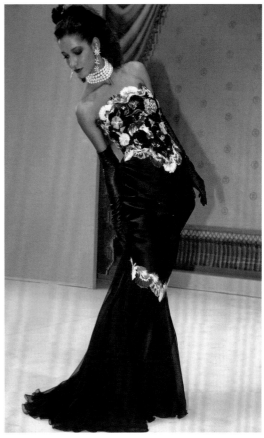

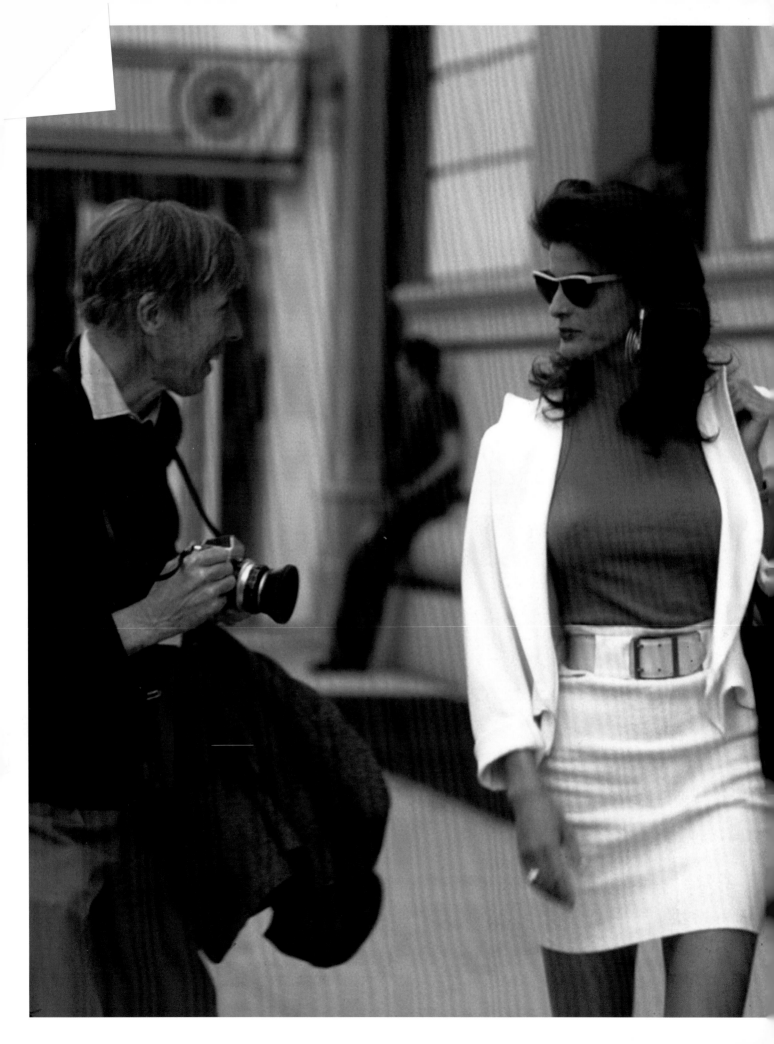

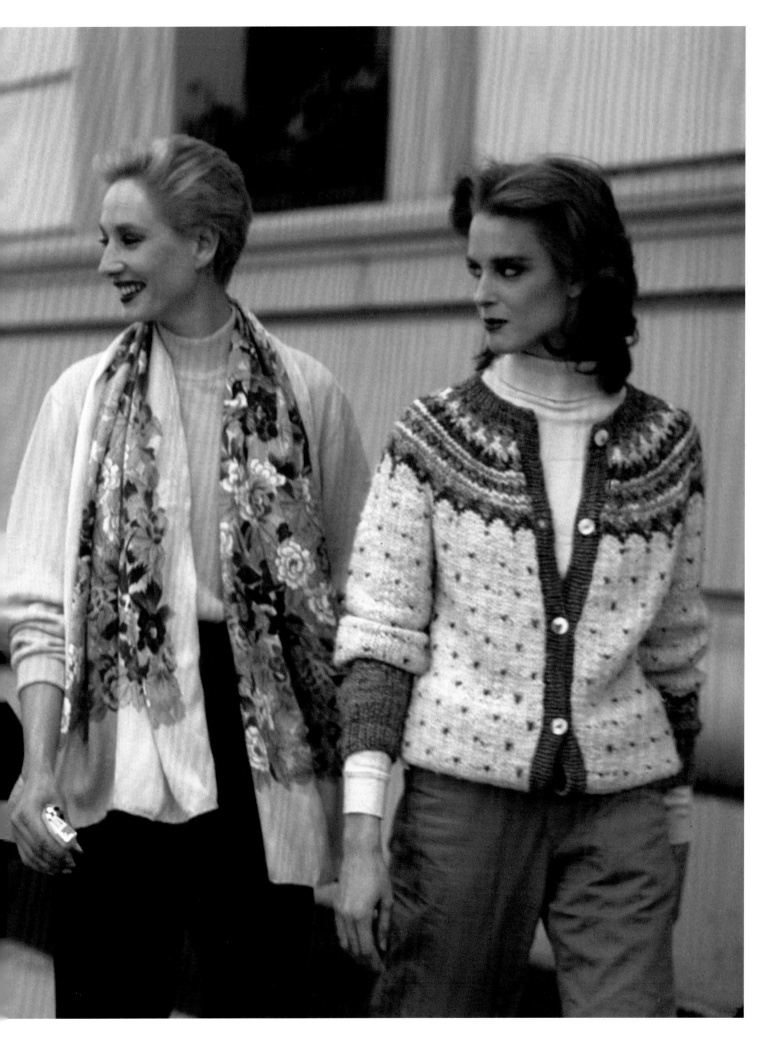

BLAZING STYLE, DYNAMITE CHARISMA
FRONT ROW AND BEYOND

If you want to understand what self-invention is, you just have to look at a fashion show audience. No one is born with a bob. It is something that is acquired and maintained. No one emerges from the womb in brocade trousers and a bow tie. This is a look, carefully considered and skillfully styled. The fashion audience consists of many individuals who have rebuilt themselves out of ordinary life according to the laws of fashion and style. Whatever estate they came from, be it working class, country, or baronial, here everyone is special, and everyone belongs. As part of a unique traveling community that is both inclusive and exclusive, how you dress here really matters. It's not where you came from; it's what you're wearing.

On one level, fashion shows are all about the business and represent the glamorous apex of a powerful industry. Fashion's relationship with the media is vital for the circulation of messages and the manufacture of desire. This is what stimulates consumption and keeps the machine thrumming. On a more human level, a show is an event—a good-looking, seductive occasion that demands an appropriate dress

Watching him, watching them: previous pages, Bill Cunningham, the original street style photographer, is a firm fixture of international runway shows. McInerney catches him at work outside the Pierre Hotel on Fifth Avenue. **Serendipitous style: left,** American *Vogue* editor Anna Wintour and Suzy Menkes, then fashion editor of the *International Herald Tribune* were snapped in identical Versace shirts. **Below,** British fashion patron and style diva, Isabella Blow would bring the party with her in outfits that framed her English eccentricity. **Right,** fashion editor Hilary Alexander hunting out the news and the new

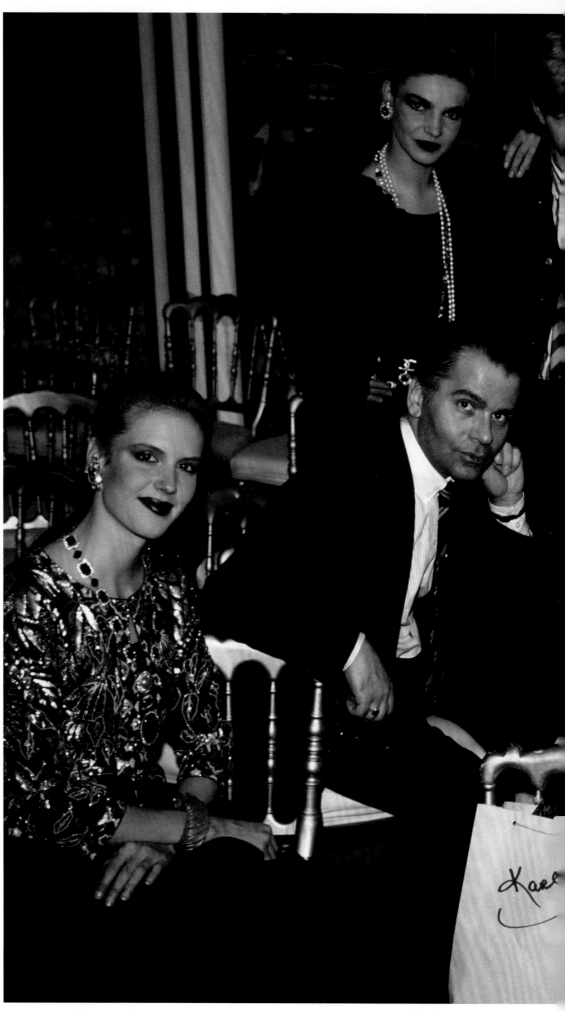

Alternative wedding: life off the runway is just as, if not more, compelling for McInerney, who would turn his camera on the audience whenever opportunity arose. **This page,** Karl Lagerfeld and friends including Anna Piaggi and Andre Leon Talley after the designer's first couture show for Chanel, Rue Cambon, January 1983. **Overleaf: top,** milliner Stephen Jones and Sibylle de Saint Phalle, March 1984. **Below,** Hamish Bowles in conversation with Lucie de la Falaise and photographer, Mario Testino. **Main picture,** Nancy Kissinger and Pat Buckley in matching houndstooth. **Right hand column from top down,** American *Vogue's* Grace Coddington, former fashion director for Bloomingdales Kal Ruttenstein, former *Harper's Bazaar* editor Elizabeth Tilberis, and model Sibylle de Saint Phalle.

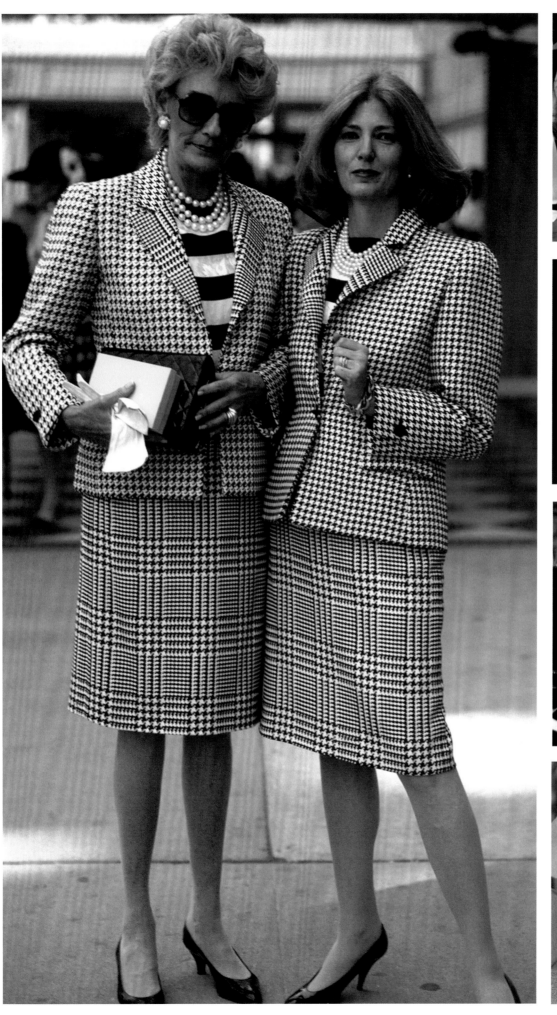

code. No fashion editor would dream of dressing casually to attend an international fashion show. The only jeans you will ever see are the occasional blue denims of runway photographers who require utility, practicality, "and comfortable shoes" (Anthea Simms) for their work. The receipt of a ticket to an Yves Saint Laurent or Prada show requires not only an RSVP but a worthy sartorial response.

The layout of a fashion show is not that different from a sporting event with the action happening in the middle and the audience seated all around. The prime viewing positions are reserved for the VIPs; in football, managers sit in the front row. In fashion, this space is reserved for the most influential opinion formers. Fashion editors and commentators sit to the right of the runway; buyers, to the left. This organization means that everyone can not only look at the clothes but observe each other—across the runway, down the rows, and up the aisles. And observe they do, not necessarily in a judgmental, critical, or imperious way but in a genuinely interested and curious way.

Asking where outfits came from, guessing where they came from, or complimenting some aspect of them is everyday small talk in the world of the fashion show. Were this audience

Let them wear cake: right, club kid and performance artist, Leigh Bowery, could never be ignored, October 1985. **Below,** street style is boulevard chic in 1980s Paris. **Left,** Hardy Aimes, the Queen's dressmaker in Bruton Street, London.

to be surveyed, every single one would claim to dress for themselves. This may be true, but it would not be the whole truth. This audience, like the rest of the world, dresses for acceptance and belonging. In this specific coded environment, the fashion audience dresses to show their contemporaries they have earned their right to be there. Some have devoted their entire lives to this privilege, and it is a statement that can be made in any number of witty, stylish, or elegant ways. At its best, a fashion show is about magic, glamor, and fantasy; therefore, costumes—and masks—are required.

The most important individuals in the room commonly wear their status by donning expensive designer labels and statement jewelry, which may or may not be gifts from designers or PRs. These individuals are ambassadors of the fashion industry, the human personification of a restless, constantly changing world. Yet, they must exude stability and certainty, and this is primarily communicated through their dress. They come to the shows with full awareness that cameras will be pointed at them and that their images will appear on multiple

Facebook sites, blog posts, tweets, newspapers, and magazines. These dictators of chic, at the very least, must convey refined elegance. Ideally, they should be immaculate. Through their choices, they are able to show overt support for a specific designer, although, politically and strategically, they will commonly present a range of sartorial allies, spreading their investments and maintaining diplomatic relations with all.

Behind the fashion generals sits the fashion regiment in well-behaved lines. Whatever part of the fashion map they come from, they can be uniformly recognized and characterized by their fondness for the color black. The shapes of their outfits may change, and the silhouettes will fall in line with contemporary style, but black has been the dominant color for this army of fashion workers for decades. It may not be wildly imaginative, but it's a practical working choice, the international language of chic.

Within this black-clad militia springs the occasional insurgent who refuses to take the easy option. Someone like Anna Piaggi, the legendary fashion editor of Italian *Vogue*, was a visual and sartorial phenomenon. Closer to a walking artwork, she was always an extraordinary sight who understood the power

In crowd: top to bottom, Paloma Picasso, Pierre Berger, Ines de la Fressange, and Andrew Leon Talley; Paris street style in plus fours; the impeccable Manolo Blahnik and his sister Evangeline with friend; the legendary Eleanor Lambert, author of America's best dressed list with British designer John Rocha behind.

of clothes and the joy they might bring. An all-seeing, silent spectacle, she would appear and glow, attracting both photographers and admirers. Isabella Blow was another star of the runway circuit. Neither of these women could be described as beautiful, but they illustrated the transcendent and transformative power of style. Both since deceased, their personal approach to dress was more than refreshing—it provided a visual start, an opportunity to reevaluate what personal style might be. Their male counterparts: Hamish Bowles and Andre Leon Talley, both of American *Vogue*, offer the same bold, unpredictable lessons in menswear. These individuals show fashion at its finest, wittiest, and most individual. Self-invention may be a serious business, but contrary to common cinematic reconstructions of a po-faced fashion audience, it is not without humor.

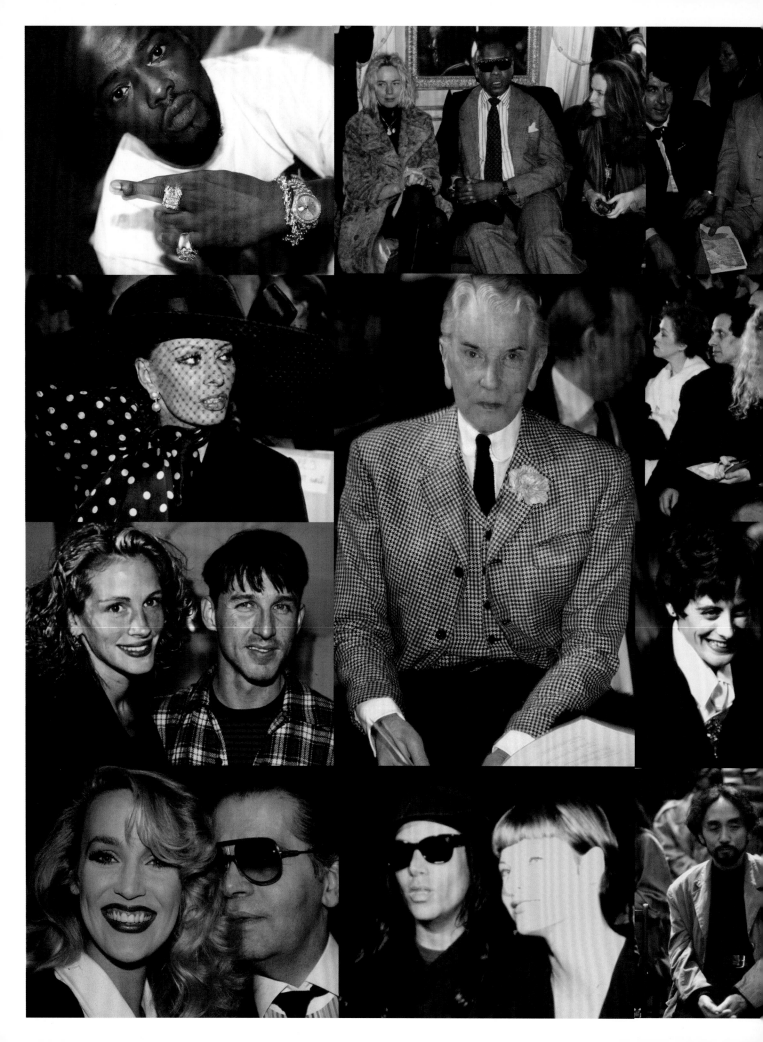

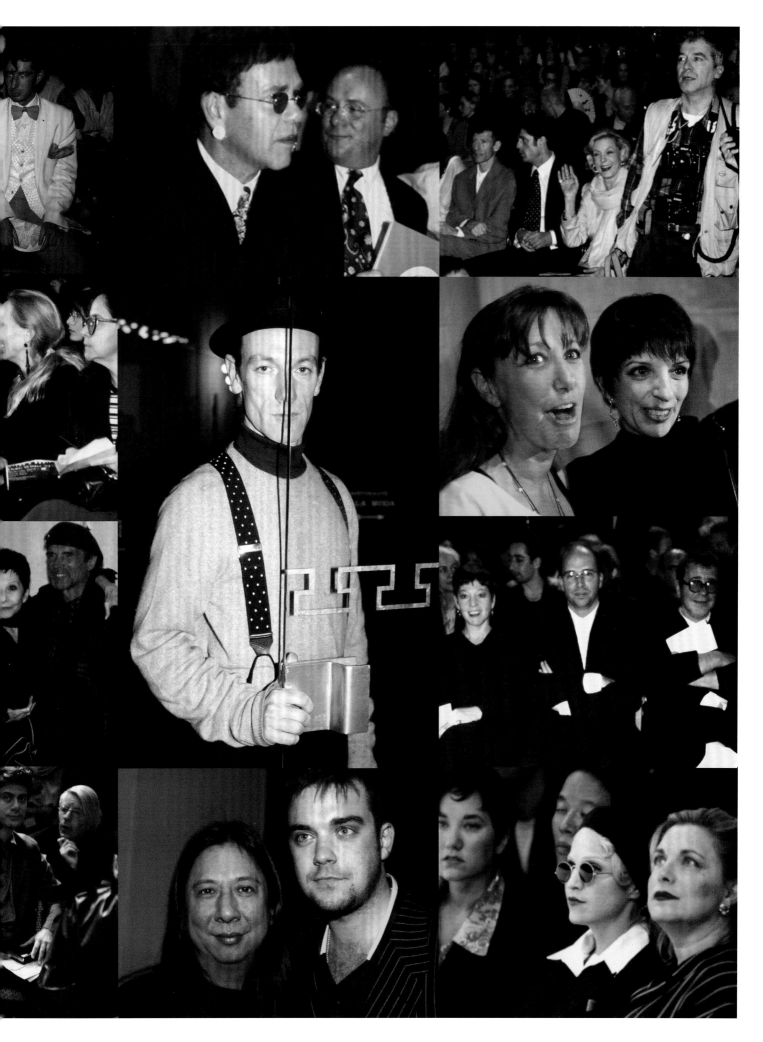

Wall of fame: previous, pages clockwise, left to right, rapper Treach from Naughty by Nature, Andre Leon Talley with friends; Andrew Logan and Duggie Fields; Elton John; Lauren Bacall near Lyle Lovett; Donna Karan with Liza Minelli, Joseph Ettedgui, Madonna, John Rocha, and Robbie Williams, designer, Yohji Yamamoto; photographer, Steven Meisel and Linda Evangelista, Jerry Hall and Karl Lagerfeld; Julia Roberts; Sophia Loren, dandy par excellence Bunny Rogers, Carla Sozzani, and Azzedine Alaïa; **above,** Ines de la Fressange, Zizi Jeanmaire, and Rudolph Nureyev. The original Bufallo Boy, stylist Ray Petri.

Italian Renaissance Woman: this page, McInerney's portrait of Italian fashion editor, Anna Piaggi, captures both her beauty and style. A woman that couldn't be placed in any one look or era, she raised personal style to a fine art. **Seen overleaf** in an array of eclectic outfits orchestrated with elegance and wit, photographed with Yves Saint Laurent and Karl Lagerfeld, with parasol, **top left,** and Chloe keyboard paraphernalia, **bottom left.**

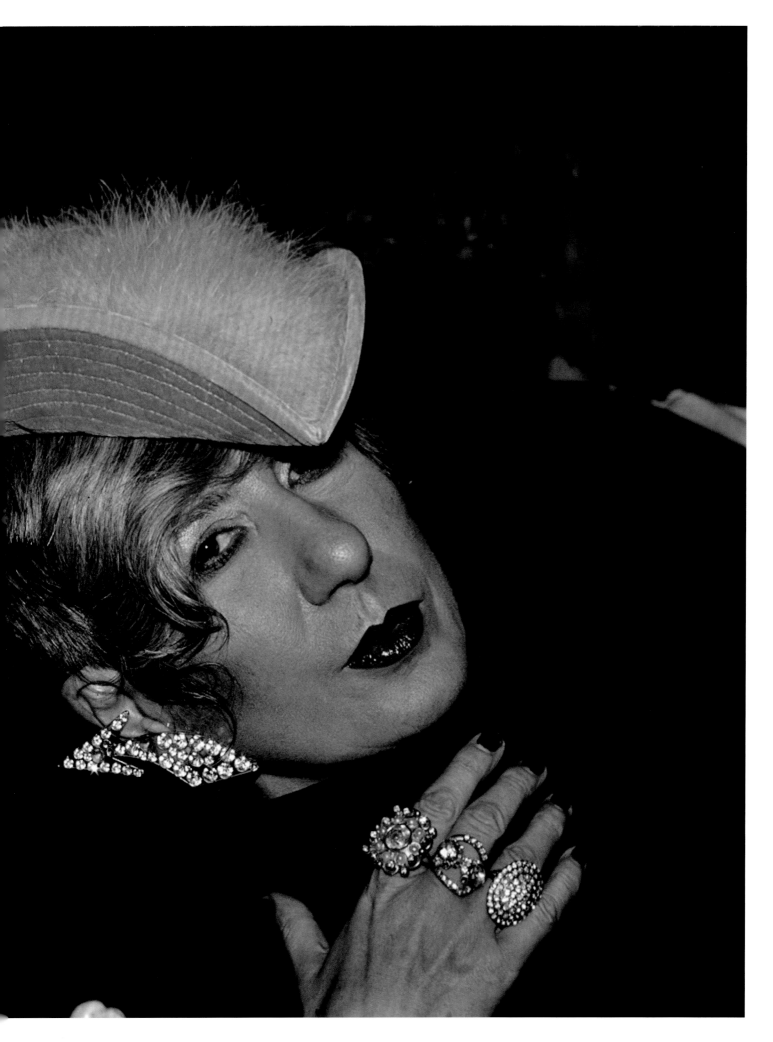

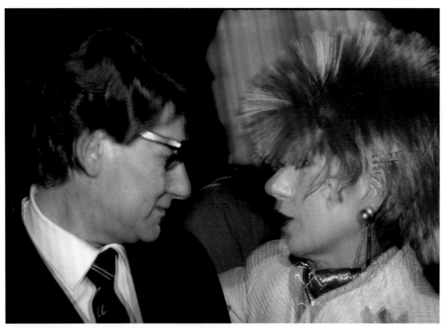

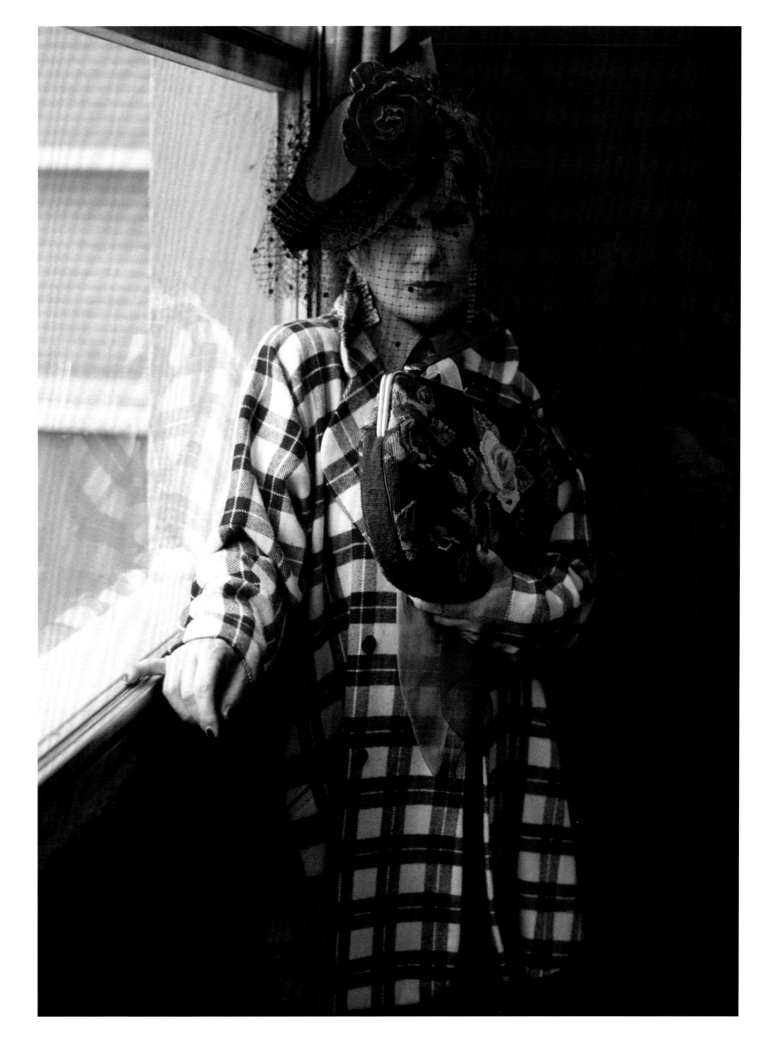

EYEWITNESS

Lynne Franks,
PR and key instigator of London Fashion Week

Being a PR is like being a nanny, mother and grandmother all in one. You are a manager of reputations and orchestrator of events. You promote people that in my case included many fashion designers, and as part of that role, I was also responsible for putting together the seating plan. This involved real skill; it's very easy to put people's noses out of joint with a seating plan. When you organize the press into their seats, who goes where is not based on the circulation of publications but on their influence and positioning. Different shows will be relevant to different audiences, and you need to be aware of that.

For some reason, London Fashion Week would often attract Italian press who suddenly couldn't speak a word of English and would insist on sitting in Suzy's seat. [Suzy Menkes, doyenne of fashion journalism, formerly *International Herald Tribune*, currently *Condé Nast*.] You needed to be very polite but clear and firm. I would constantly get: "Lynne, someone's in my seat. Lynne, the photographers are in the way." Front row seats would go to the *Vogue* Fashion Editors, national

newspaper fashion editors, Suzy Menkes and *WWD* (*Women's Wear Daily*, leading and influential American trade publication). That would make the British trade press cross, but designers were selling to the U.S.

The job of PR would be really difficult when people simply refused to move from their seats. But then, that was also part of the general hysteria and drama of fashion shows. I've been to a fashion show as a guest and people have still come up to me and tell me that someone is in their seat and tell me that they are not happy with their seat, as though I'm responsible for all seating plans for ever after.

In the 1980s, we didn't have celebrity culture in the way that we have now. Celebrities now seem to be everywhere, all the time. It's expected that that they will be in the front row of certain shows, although it was less usual then and something that I deliberately cultivated because I understood the media value. Celebrities were mainly from the music industry or pop stars. The whole point of them was to get pictures in the papers. I would invite people like Boy George, Spandau Ballet and Paula Yates. Now it's her kids in the front row. Madonna would come to the Joseph shows. Katherine Hamnett had some celebrities on the catwalk—like Boy George. The number one celebrity was Princess Diana.

Although I never managed to get her to one of the catwalk shows, she did walk around the British Fashion Week exhibition.

I set up London Fashion Week and the British Fashion Awards and it was great fun, because I was working with my mates who were the designers and producers. There was lots of hanging out with Jasper Conran and Katherine Hamnett. We created our own club, but there was a business motivation too. London at that time really wasn't taken very seriously. It was quite stiff and Madamy. It didn't have the hysteria or excitement of Paris. But this was a new generation with people like Sheridan Barnett, Wendy Dagworthy, Katherine Hamnett, Vivienne Westwood, Joseph and Bodymap. We wanted the world to look at us and put London on the map. Looking back now, I don't know where I got the nerve or chutzpah to do what I did.

I remember walking around with Mikel Rosen in the early 1980s. We said, "Why don't we have the tents all in one venue?" and wondering where we could put the fashion shows, as they were scattered in different studios, showrooms and hotels. I found the money from Mujani [Gloria Vanderbilt Jeans], a client at the time. In fact all of my then clients played a part whether it was with sponsoring shows or giving freebies in goody

Fashionable faces: opposite page and above, left to right, fashion editor Caroline Kellett; Björk below Anna Wintour and Marc Jacobs; the 1980s *Harpers & Queen* team: Iain R. Webb, Catherine Walker, editor Sally O'Sullivan, Hamish Bowles, publisher Liz Kershaw; Andy Warhol above Paula Yates, Bob Geldof, and one of their children; Boy George above Grace Jones.

bags, brands like Harrods, Swatch, Brylcreem. The British Fashion Awards allowed me to produce fun stuff, like having French and Saunders present, way before Dawn French and Jennifer Saunders developed the idea for fashion PR comic satire, *Absolutely Fabulous*.

You knew if a show had been a success depending on how quickly people left their seats or if the audience had a smile on their faces. I would always look at the press the next morning to see what the stories were. Now of course, it's straight onto Twitter with people tweeting about shows instantly. I left London Fashion Week in about 1989 because it had become too political. Then, everyone thought they could be designers, and I had to sit through endless meetings with men smoking big cigars talking about the difference between a designer with a big D and designers with a small d. There was a big push for mass-market brands to be part of London Fashion Week and it stopped being fun. I think the fashion shows have become rather formulaic now and lack spontaneity. We had lots of fun, but we didn't have any money. It may be less fun now but there is more money.

INSIDE THE BUNKER

MAGIC AND MAYHEM BACKSTAGE

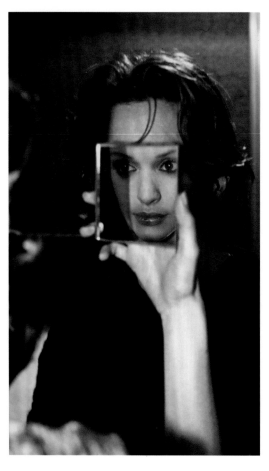

Mirror, mirror: left, as models prepared for their runway moment, the backstage use of mirrors offered Niall McInerney many interesting and witty photo opportunities.
Right, Kaiser confidential: Karl Lagerfeld in a light moment of Polaroid defacement.

As all the invited (and some uninvited) guests take their seats, there is one show the VIPs will miss. Guaranteed to have all the ingredients of a great performance—high emotion, dramatic encounters, unexpected spontaneity, and the transformative power of glamor—backstage is where the real magic happens. Here is where the image makers—the hairdressers, stylists, makeup artists, and models—gather to animate a designer's collection. Without this team of highly skilled professionals, the collection would remain no more than sketches on a page.

The digital revolution and social networking have generated a public appetite for backstage fashion documentation. The rise of online tutorials on "how to get the look" have made stars of its YouTube hosts (often young girls who from the comfort of their bedrooms instruct their followers on how to draw the perfect doe-eye or construct a French plait). Meanwhile, the broadcasting trend in reality TV (including that for the modeling industry), which is set in "real-life" locations,

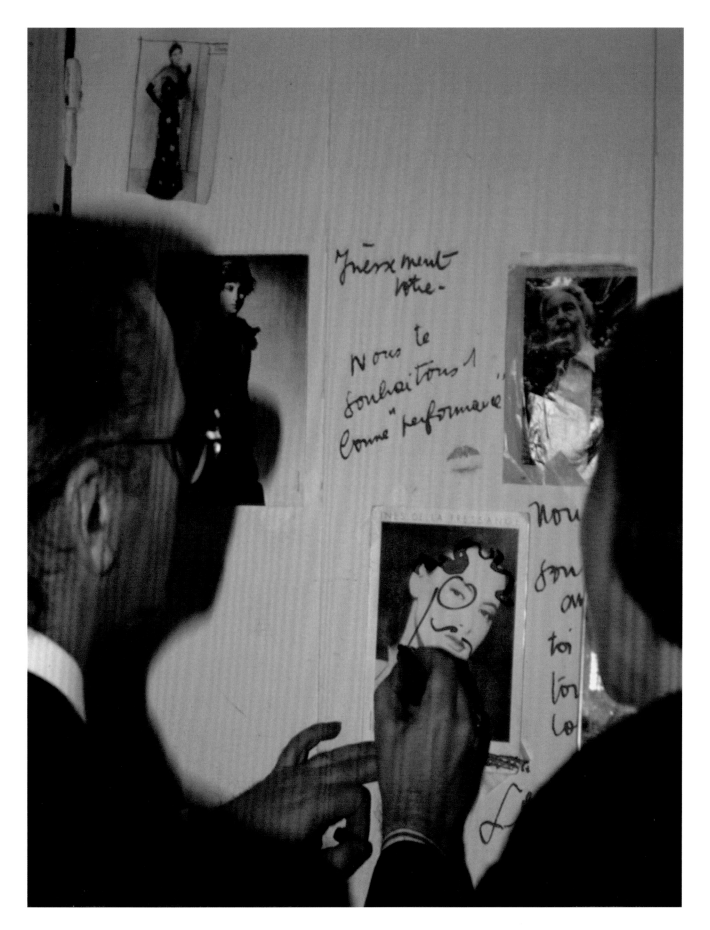

has revealed and stimulated a desire for peering into previously forbidden or private spaces. In the fashion world, which is constructed, staged, and fabulously fake, this desire for authenticity and the unvarnished truth has a compelling currency: "People seem to like looking at a model with her hair half done," reflects leading runway hairstylist Sam McKnight.

Why should images of backstage fashion be so appealing to audiences? Is it because they lay bare the process of glamor? Could it be because imperfection is more accessible and likeable than the flawlessly unreachable? Do audiences respond better to representations they can relate to and identify with? Whatever the reasons, backstage photography and reporting have become a core component of editorial coverage. Trend and news stories around hair and makeup, as well as profiles of

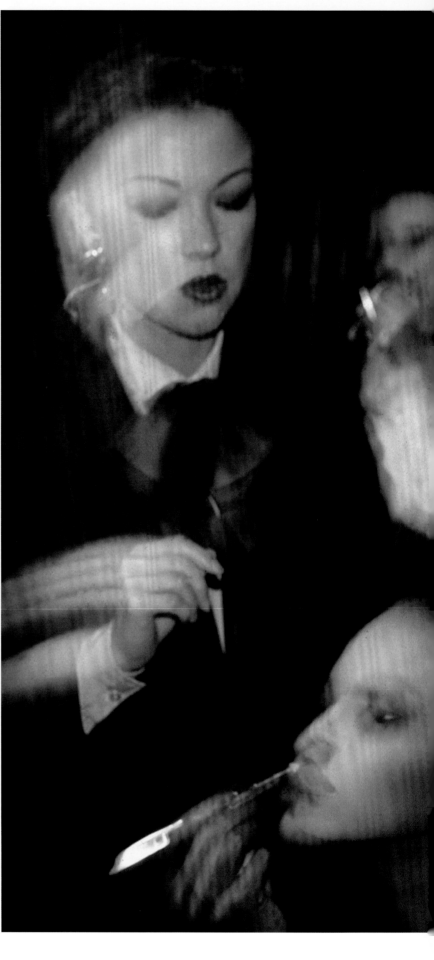

Whirl of activity: main picture left, photographed backstage at Yves Saint Laurent in February, 1985. **Above,** models' hairstyles and looks recorded by Polaroid before the show.

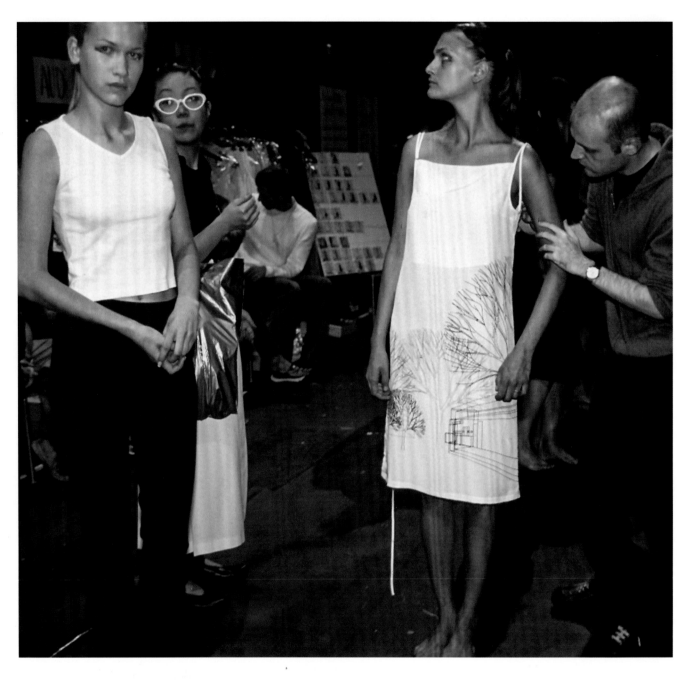

the teams involved, can generate just as much coverage as the designer collections being paraded on the runway outside. Arguably, they are visually and narratively more interesting. In 1951, the great photojournalist and cofounder of the Magnum Agency Robert Capa covered the Jacques Fath couture collections. In addition to capturing model Bettina in the wedding dress finale at the salon show, Capa was just as drawn to the responses of the clients and audience (including Rita Hayworth and her then husband Aga Khan), even going backstage to capture a fitting in progress. This

Last-minute adjustments:

left, designer Hussein Chalayan fitting one of his models backstage for S/S 1998.

was the man who said: "If your pictures aren't good enough, you're not close enough," which could be a motto for great backstage photography today.

Niall McInerney's heroes were the great visual chroniclers and photojournalists such as Henri Cartier-Bresson and Andre Kertesz. Even though he felt "those days were gone," he was still drawn to "the moment of truth." When he headed backstage after a runway show, he was attracted to the palpable, postshow spirit and energy, explaining "It was like after a big theatre show. The performers

would be high as kites with big smiles because it had gone well and all the anxiety was over." Preceding the current backstage trend by more than a decade, McInerney was clearly not motivated by the commissions, as the market hadn't yet been created for this material. "The editors weren't interested. They didn't want to know."

His contemporaries recognized that Niall's backstage work was some of his strongest, with Anthea Simms describing him as "a pioneer. He was one of the first catwalk photographers to go backstage." Mitchell Sams meanwhile was impressed by Niall's social skills that lead to great pictures; his ability to make models relax for the camera: "Through a mixture of nonsense conversation and pure gibberish, he would get them all laughing. He would say to Naomi or Linda: 'Are you going to Southend for your holiday?'" This rapport enabled Niall to construct photographs quickly and encouraged models to be cooperative and compliant. McInerney took a lead from Robert Capa, who said, "Like the people you shoot and let them know it," and what we see are genuine responses to the humorous prompts of a camera-toting raconteur.

Below, notices like these at Husseyin Chalayan F/W 2000–01 collection help models to imbibe the spirit of the collection and assume the right attitude.
Right, makeup guidelines backstage at Helmut Lang.

Even though some of McInerney's work might be described as fly-on-the-wall images, many reveal a complicit interaction with the photographer. Models were asked to hold shoes, slip on some jewels, or salute to the camera. Some of McInerney's photography, although located backstage, bears the characteristics of an impromptu mini-photo shoot. In this section, whether the images are incidental or impelled, what remains is a record of a playful time, a creative space before the fashion machine became so tightly wound. Perhaps now, the girls wouldn't be so relaxed because they would have only eight minutes until the next show. Perhaps they wouldn't be quite as spontaneous because all are so well versed in the language of the selfie. What remains is a compelling visual record of the backstage experience as it once was, its rituals and dynamics.

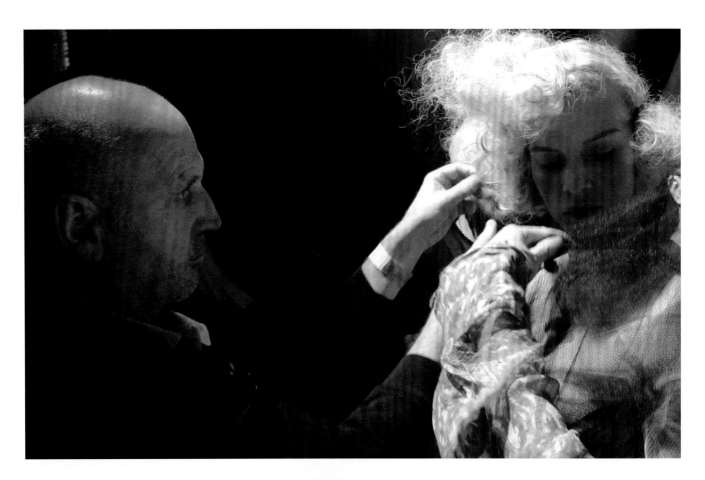

EYEWITNESS

Sam McKnight,
Leading Runway Hairstylist

From the outside, backstage must seem really exciting and buzzy. I suppose if you were watching it on a time-lapse camera it would be like magic; a rabbit being pulled from a hat. What eventually emerges from this chaos and mayhem is a gorgeous creature. From the front, you could never guess what was going on backstage. I've only ever seen one Azzedine Alaïa show from the front that was amazing. I don't like crowds so being at a fashion show is my idea of hell. I prefer to keep a distance.

It's a real frenzied rush to get the girls ready. It starts cheerily in New York, but by Paris, the girls are frazzled. The space makes a big difference. It's the biggest source of stress and frustration. As teams and backstage get bigger and more crowded, the spaces get smaller. If you are cramped, everyone can feel it. If you are using hot tongs and a burly photographer bashes into you, it can be dan-

Mane man:
Sam McKnight, **above,** at work, putting the finishing touches to a Vivienne Westwood show in Paris. Incidental, backstage moments reveal the construction of the dream, the transformation in progress. **Right,** backstage at Chanel reveals the make-up palette of the season.

gerous. I actually burnt Jodie Kidd's forehead once like that backstage. I was unbelievably mortified and had a complete melt down.

There have been some moments like when recently at London Fashion Week, we were meant to be doing a 9 a.m. show when four or five girls turned up with oil in their hair from the last show. There wasn't enough time to wash their hair, so I just pulled out my bag of wigs, which I always have with me. You have to be prepared for every eventuality.

Backstage pictures are now just as important as front of house. Most backstage activity is sponsored by the big hair and makeup brands, and they want their footage. I tweet and Instagram my backstage work and it's massively popular. I get so much publicity from the backstage work. This might be because today's models are less recognizable and therefore less interesting to the general public. What seems to have taken over is How to Get The Look. Everyone wants to see it.

Backstage must feel a bit like a secret world that not everyone has access to. People seem to like looking at pictures with a model's

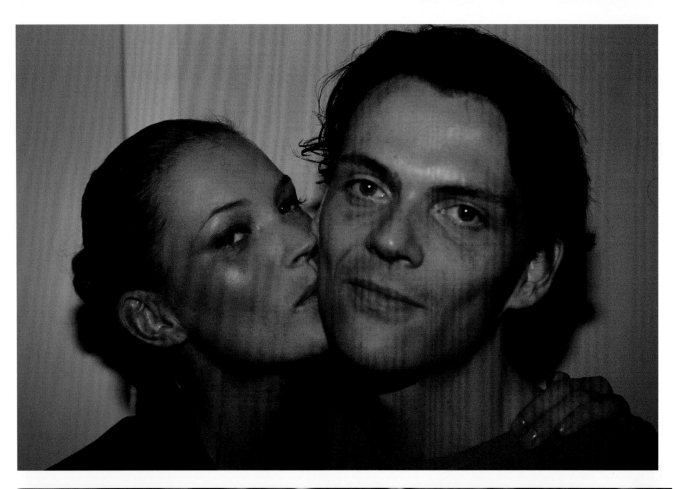

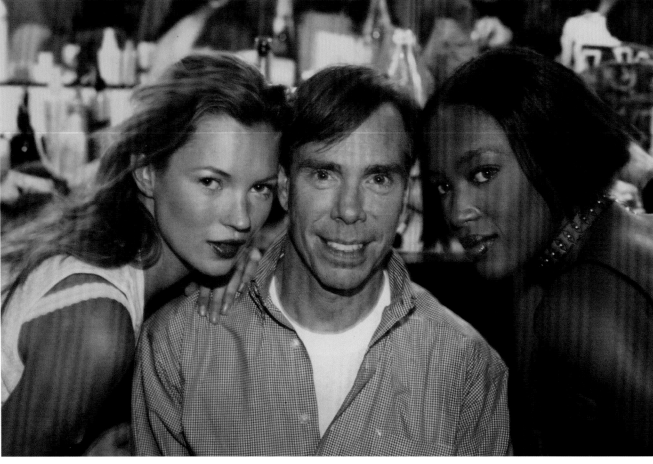

hair half done or pulling a funny face. You might not be able to afford a two thousand pound dress, but you can probably afford the dry shampoo that the model just used. The backstage thing has really taken off with the advent of social media. I think there must be lots of money made from it. These days, backstage is thronging with people. There might be up to twenty-five hairdressers, thirty models and twenty-five make-up artists all crammed in, not to mention the twenty or so beauty journalists, camera people, bloggers and vloggers.

In the days of the supermodels, there was more rivalry between models and who would get the most attention from the main hairdresser or makeup artist. Now, it's more democratic, I spend a lot of my time checking that partings are straight and that all the girls look the same hair-wise although not if the look is messy hair. I will finish everyone off personally. I have to make sure that all of the hairdressers know what we are doing, that we are all on the same page. I manage the whole thing and I have a great team.

How you come up with the look of hair for a show depends on the designer. Sometimes, I will work from a designer's sketchbook or inspiration board. Some designers are exacting and know totally what they want; others have quite random inspirations that you have to take hold of. At Chanel, Karl Lagerfeld is completely focused and will tell you what he wants, but other times he asks you to interpret. Vivienne Westwood has her vision and she will sit with you and go through her ideas with you. If you can follow her train of thought, you realize there is a method to her madness. Sometimes, a look will evolve, and sometimes something you do will click with a designer. You are constantly taking pictures and looking at how different hair looks with the clothes.

I find creating hair looks for shows a really creative process. Hair and makeup can really bring a designer's vision to life in quite a dramatic way. A brand thing has developed in fashion now whereby designers think about sales and who their customer is. There are more people involved in the whole process, and it's more organized and professional than it used to be.

Above, captured here, the animated expression and refreshing spontaneity of model Cecelia Chancellor.

Kiss me Kate: left, above, designer Matthew Williamson gets a peck from model Kate Moss. **Below,** Kate Moss, Tommy Hilfiger, and Naomi Campbell pose backstage at the designer's S/S 1997 show.

Overleaf, male models photographed in June 1995 rest their weary bodies.

Models have to deal with the tension backstage, people coming at them, interviews, hair, makeup. It must be really annoying to have people holding up their phones inches from your face. It's much more intrusive than it used to be. The supers used to make a barricade around themselves and forbid people from getting too close. That seems to have gone, and some of the young girls seem less in control and need more looking after. Lots of girls are pretty, but these girls had a magic quality that really worked on camera. To this day, Kate Moss can get in front of the camera and know how to make it work.

They were heady times. The supermodels were goddesses, extraordinary creatures, and a phenomenon. Modeling started to grow as a profession in the 1960s, and then you had people like Janice Dickinson and Brooke Shields; then in the 1980s when fashion started to expand, the supermodels arrived.

They all started at around the same time, and because the business was growing so fast, they all had a lot to do. They were the modern movie stars. They exploded onto the scene and became the faces of an era. There were maybe a dozen of them: Helena, Kate, Christy, Linda, Naomi, Yasmeen, Cindy, Tatjana. You would turn up to do a show, and they would all be there, looking gorgeous and ready to work the catwalk. They would get on the catwalk and own it. These are people that you spent so much time with backstage over the years. I have really fond memories of the Westwood shows in Paris with Linda modeling. Because they stuck around for longer, you could build relationships. You grew up together.

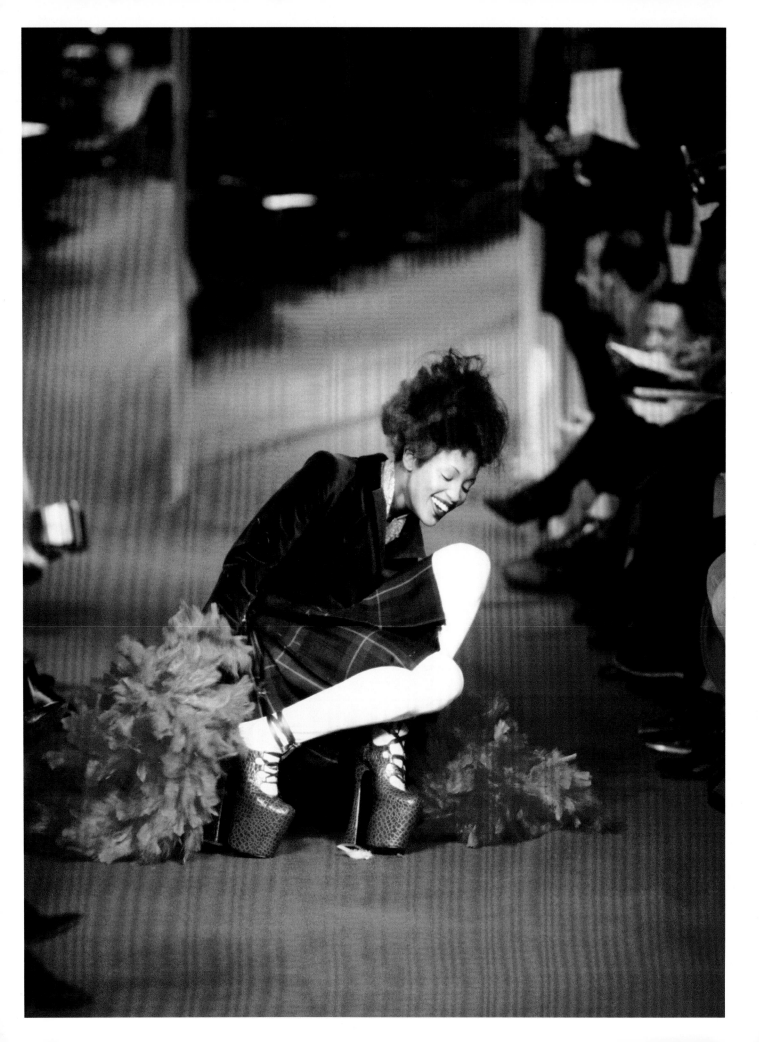

CHAPTER 10
SURPRISE AMBUSH
THE UNEXPECTED AND UNSCHEDULED

A wobble, a twist, and a tumble added up to one of runway photography's most iconic moments. When Naomi Campbell was defeated by her nine-inch heel, five-inch platform Vivienne Westwood purple leather ghille shoes at the S/S 1993 collection in Paris's Le Circle Republicaine on March 17, she couldn't have known it would go down in fashion history. "It put Naomi Campbell, Vivienne Westwood and Paris on a completely different footing," says Sam McKnight, who was watching backstage with Yasmin Le Bon. A photograph that made the national news, it has appeared regularly ever since to illustrate everything from the folly of fashion to an exhibition of footwear. Campbell has talked about the episode on chat shows on both sides of the Atlantic (David Letterman and Jonathan Ross), disclosing that the fall led to lucrative commercial campaigns for an insurance company and a well-known chocolate brand.

Capture it:

Naomi's tumble has become an iconic image of fashion runway and, as Vivienne Westwood's house photographer at the time, Niall McInerney was one of the few runway photographers to capture it.

The mishap also paid dividends for the photographer: "It's the picture that made me rich," says Niall McInerney, who was remunerated every time it was printed in the media.

As the house photographer at Vivienne Westwood, Niall McInerney was one of the few to capture this image. Because the space was relatively small, there were two performances to accommodate numbers, and most of the photographers had been at the first. "It was just luck that I was there," reflects McInerney. Arguably, luck is when talent meets opportunity. An incident such as this requires instant reflexes, a quick fire response no different than that of a news photographer. For this image to have come about, the photographer had to be there in position with camera poised. Ready to frame, compose, and balance the subject, a fast aesthetic and technical judgment was required. McInerney reflects, "Sometimes, you have a feeling a photograph will be good

but you can't be sure until it's processed. It has to be properly exposed at the precise moment."

Visually, this was already a promising show because it was the first to be graced by the supermodels en masse. There was something great about seeing the world's most beautiful women in quirky British design that was both bawdy and beautiful. As fashion editor of the *Sunday Times*, I was in my seat at the top end of the runway when Naomi fell. I remember her walking toward me in her Westwood kilt and fitted jacket. Her bearing and gait were impressive considering the challenges posed by the (then outrageous) footwear (the essence of which has since become almost mainstream). As I watched Naomi sway, I was reminded of a cat I had at the time. I had made the mistake of feeding Tricky a diet of tuna that lacked calcium and interfered with his growing bones. His normally svelte grace was reduced to a bandy-legged lurch. This was what was going through my mind as Naomi, usually feline, was suddenly erratic, out of sync, and all over the show.

The fall was unscripted and unscheduled. No one knew it was coming, and you had to be there to see it. It had the same charge as live TV when the unexpected happens, something between excitement and horror, voyeuristic thrill and empathetic despair. Naomi falling is up there with Tommy Cooper dying on stage, Jarvis Cocker taking umbrage with Michael Jackson at the Brits, and Oliver Reed attempting to kiss Kate Millett. This was real, it was happening, and it was now. It wasn't the first time that a model had tripped and stumbled, and it wouldn't be

Expect the unexpected: above, bloody uprising at McQueen. **Left,** Coke can curlers at McQueen. **Right,** Gaultier dons a wig, F/W 1997-98. **Page right, clockwise from top left,** pregnant pause at McQueen F/W 1994-95; Wild & Lethal Trash F/W 1995-96; from "Cats" to catwalk at Galliano F/W 2000-01; paper play at Galliano F/W 2000-01; Chanel's diddy onesie; Chanel-baiting at Moschino S/S 1987.

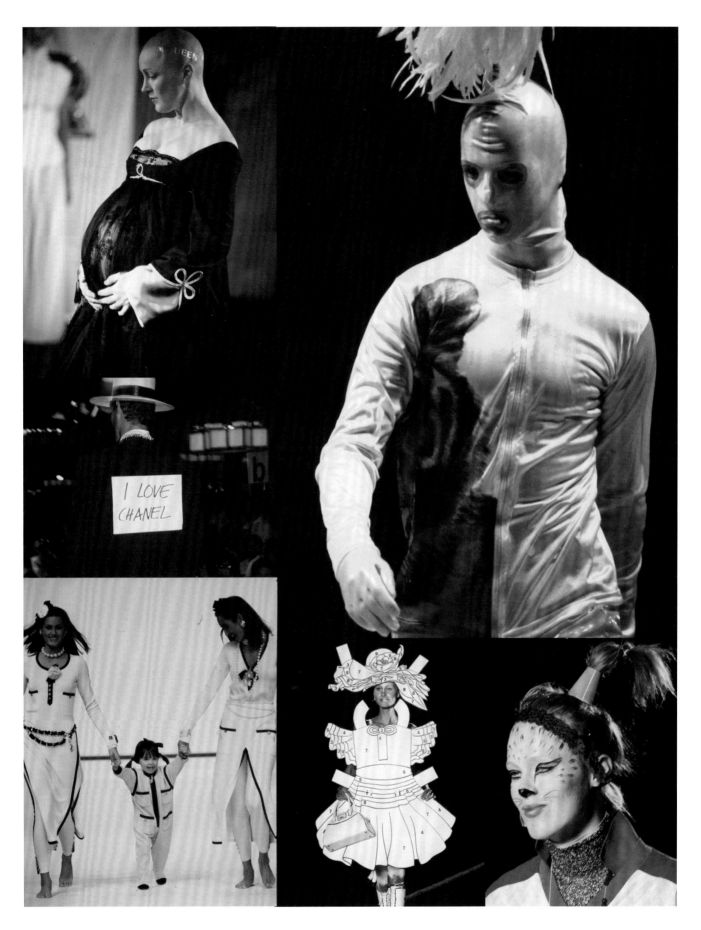

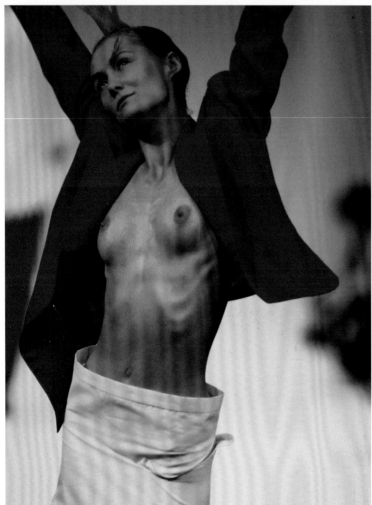

the last. Elizabeth Walker remembers when Janice Dickinson fell off stage at a Valentino show. Walker recalls wryly that "the designer was *not* amused." There have been other unscheduled moments: roofs have fallen in, stages have collapsed, and fur protesters have stormed the runways. But unless it was captured on camera or film, the memories fade and sometimes disappear altogether. Unless an image possesses some deeper cultural resonance or a universal appeal, it will vanish into the annals of indifference.

So why does this particular image strike such a chord? Why does it resonate and why won't it go away? Was it because this very human stumble allowed reality to break through fashion's veneer of perfection? Was it because one of the world's most beautiful women was publicly humiliated? Is it the expression of vulnerability or fallibility? Is it the possibility that perfection does not exist, style is a pose, and pride comes before a fall? It certainly revealed that even in the glossy world of high fashion, excrement happens.

Perhaps the real story is what happened *after* the photograph, *after* the fall. These thirty seconds in the spotlight gave Campbell the opportunity to present herself as a consummate professional. The epitome of grace under pressure, she was able to laugh, pick herself up, and continue with her work. What is more beautiful than spontaneous laughter? She may have been down, but she certainly wasn't out. Niall McInerney was watching from the front, but we have the backstage view from John Walford, show producer. "When Naomi came off stage, she was in good spirits: She said: 'THANK GOD I WAS WEARING KNICKERS.'"

Sex and shoes: Dildo-inspired platform shoes, backstage at Westwood in 1995. Various stages of nudity often find their way onto the runway, **left** (McQueen S/S 1996) and **right** (Alaïa S/S 1992), and are usually calculated and choreographed to gain media exposure.

Here, then gone: top right, Suzy Menkes, Amy Spindler and skeleton friend at McQueen, S/S 1996. **Left,** model in a bag. **Right,** exposure begets exposure (McQueen S/S 1998). **Left,** girl-on-girl corset action at Westwood F/W 1990-91.

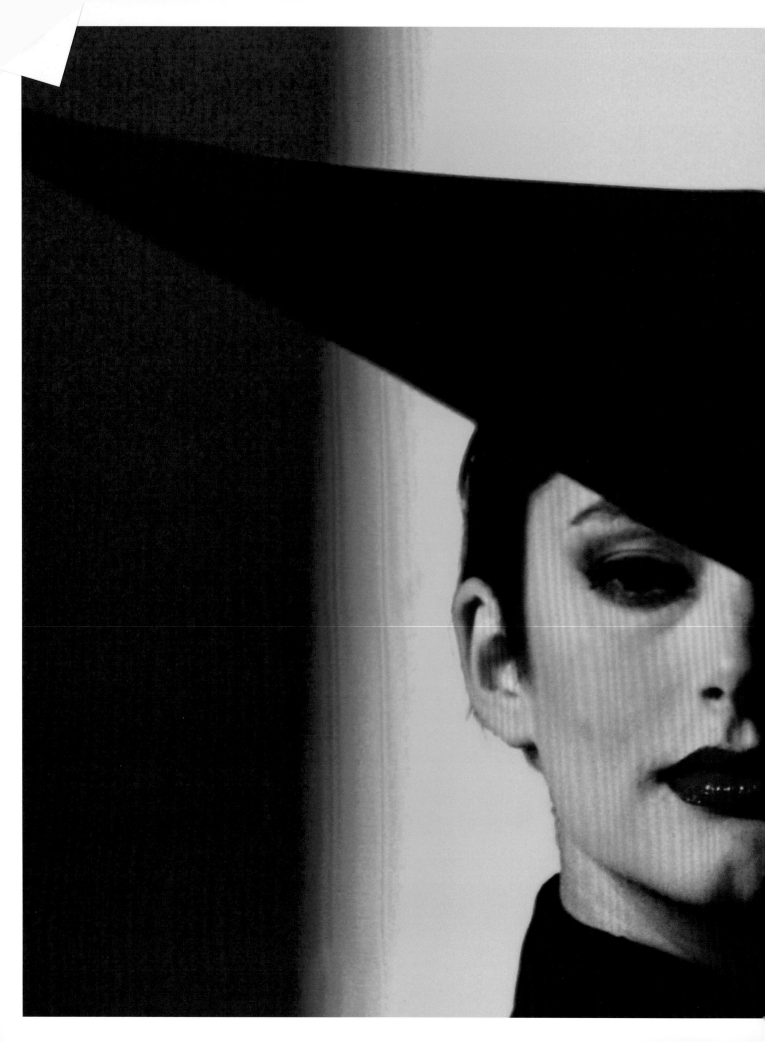

CHAPTER 11
MARCH OF TECHNOLOGY
CHANGING TECH FROM PRODUCTION TO DISSEMINATION

M any of the photographs in this book were taken pre-Internet and pre-digital revolution. Although you can't tell from looking at the image content, they are artifacts from a different time, from another world.

Then, the fashion community operated with slower tools. Although the atmosphere was frenetic and charged, information was transmitted at merely analogue or manual speed. Changing to digital photography has been covered elsewhere in this book; however, Iain R. Webb explains here the impact technology has had on the editor's role: "It meant no more looking through slides; no more taking parcels from America which would be flown back for developing; no more rushing to the photography labs or sitting in hotel rooms making a selection. No more phoning through 1,000 words from New York then realizing it was four in the morning there and the person in the next room had heard every word."

The arrival of digital meant that communication could be instant and immediate. Images, text, thoughts, and

Looking forward, looking back: Hussein Chalayan, F/W 1998–99 creates a futuristic looking collection. **Above,** before the arrival of mobiles, fashion editors would need a landline telephone to file copy and deliver news. **Top left,** Sally Brampton, launch editor of British *Elle*. **Top right,** Denise Dubois, head of the Chambre Syndicale. **Previous,** Philip Treacy hat dappled with lighting effects.

shows could be beamed as they were happening via an accelerating range of communication channels. Even though editors might be sitting at a runway presentation in Milan or New York, they could simultaneously be sorting problems and planning pages with their teams at headquarters. While writing copy directly into their ever-smaller laptops or tablets, they could be concurrently composing posts for their blog (that many were impelled to start by their publishing paymasters who recognized the future was online). They could be tweeting bon mots and using their fabled fashion eye to take arresting shots for Instagram that would earn them more freelance commissions.

This is how it is now, but that is not to say that fashion responded quickly or happily to technology's takeover. For a world whose ethos is *change*, resistance was surprisingly deep and ingrained. Moving to digital photography incurred a considerable expense to photographers. Editors, some who had been knocking around for a while, had to learn new ways of working and operating if they were to survive the new order. And even though digital change meant lots of time was saved (many processing labs went out of business as did some publications), the expectation was

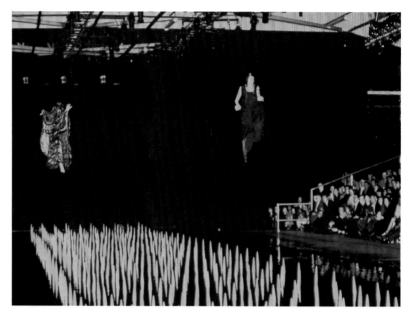

Leading edge runways: the runway itself can be treated as an experimental platform, seen here with fiber optics, **above,** Alexander McQueen S/S 2000, and lit from within, **below left,** Emporio Armani, S/S 1996.

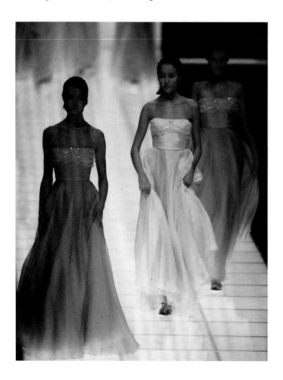

that a wider range of media platforms would be fueled: offline and online, physical and virtual, print and digital. Although the fashion industry is now in the grip of a torrid and passionate affair with technology, the attraction was initially lukewarm or dismissive. In the mid 1990s, a highly regarded fashion editor was quoted in a respected newspaper saying that the Internet wasn't for the fashion industry; it was for anoraks.

The first indication that technology had arrived was subtle and straightforward. The original walkie-talkies were used for military maneuvers and battlefields. Fashion show producers would also use them to communicate with their teams backstage while they were front stage. But the arrival of mobile phones meant everyone had the chance to carry their own walkie-talkie and play dynamic, glamorous types. It was quite cool to have a mobile phone, but it also quickly became about professional sanity. "You can't believe what a difference they made," remembers Elizabeth Walker. "We all wore black. Our cars were all black. We used to spend half our time not being able to find each other. The mobile phone saved so much time."

In a backstage context, John Walford explains how indispensible iPads have become for communicating with models who might not speak English. "I can just draw a quick map that explains to them where they go on the catwalk and in what direction." But it's not just the simple job of basic communication

that the mobile phone made possible. The arrival of smart technology made this piece of hardware every fashion professional's life support machine. It became a device that can be used to take photographs and films, record interviews, summon the Internet, send e-mails, post, tweet, research, purchase, and share. A pocket-sized computer comprising an office, global archive, transportation hub, and messaging system, the smart phone was like a second brain that works faster than the first.

Now the sight of smart phones being held up to capture runway activity is common. This visual documentation is no longer the preserve of runway photographers but is now available to all. Independent or established bloggers are not harnessed by editorial templates and can be more spontaneous, diverse, and fresh in their visual approach. "I think some of the most interesting catwalk photography comes from people that are doing it for the first time. They have crept in and are crouched down somewhere," observes Iain R. Webb. From a production point of view, John Walford explains: "The whole digital thing has changed how you even walk down the catwalk. You must make sure that every photographer can get every single girl individually because when pictures end up on the Internet, they want the single look in the frame."

From the runway photographer's perspective, Anthea Simms adds: "We do have this robotic thing with the girls now, it's like they've been catapulted from a cannon with these glazed, otherworldly expressions. Sometimes, they walk about three inches apart from each other so you have to have the right lens ready for the shot." Simon Chaudoir, former lighting designer for the Alexander McQueen shows and responsible for many dramatic effects, says: "Because shows are now live streamed, the designers can't take risks with lighting because it is being broadcast live on the Internet and people are watching in high definition. You need to be able to see the girls, clothes, and accessories. Lighting used to be more about atmosphere and emotion, now it needs to be flawless and show every inch of the clothes. It's about the instantaneous message." There is an irony here because lighting design has become more

Technology drives fashion forward:
Alexander McQueen, S/S 1998.

sophisticated than ever ("you can have LED lights in water or on a flat disc on the floor, you can do all sorts of things with fiber optics," enthuses show producer Simon Costin).

Meanwhile, digital cameras allow photographers to "push film to the limit. We can deal with smoke, very low lights, multicolored lights; things that you couldn't have managed on the old film," says Mitchell Sams. However, if technology isn't being used so much for its theatrical, visually striking attributes, then it is certainly being used for its communication potential.

Most recently, the communicative power of the smart phone has been harnessed as a key element in runway production. Burberry, a brand that has led on technology innovation, recently presented a fashion campaign on Twitter with their tweetwalk. Burberry took photographs of each outfit and then uploaded them as the show was happening, allowing

consumers to see the new designs at the same time as the fashion professionals in the front row. Luxury label Ken Cole used Vine as a platform and asked all their participants including models and producers to shoot six-second films of the proceedings. These vignettes were then uploaded to give a 360-degree view of the runway production (see *Ken Cole Viewpoints www.drkfuture.com*). Encapsulating the notion of consumers as producers or the new breed of "produser" to use a term coined by media scholar Axel Bruns, opening up to new audiences has subverted traditional hierarchies and power structures. Anyone who is motivated by fashion can reserve a digital front row seat.

Jonathan Chippindale, chief executive and co-founder of the creative technology agency, Holition, produces at least one technically amazing fashion show a year including recently Dunhill, Shanghai, China, which was the largest ever holographic runway display of augmented reality. "The content had a higher resolution than Disney or Pixar and was about the beautification of technology." Before the audience's eyes, a magical presentation of changing seasons complete with singing robins and blooming flowers brought the editor of *Vogue* China to tears and was shared two million times by viewers in twelve days. On one level, it

was flashy visual tricks to entertain a fashion audience and energize a classic brand. On another level, it represented runway shows moving into the realm of everyone's experience. Chippindale is sure that "the democratization of the catwalk is a growing trend. Live streaming is already a standard so that everyone can watch fashion shows as they happen. Eventually the audience will also be able to participate. Pre-digital, brands had all the control. Now equally important is the background noise of other consumers."

In the early 1980s, Antony Price made the bold and some then said unwise move of "letting the public in" to his runway show. Then it meant allowing a TV company to screen it on one channel. Three decades later, fashion shows can appear on your phone, tablet, laptop screen, or TV as they happen wherever you are in the world. Viewers are able to communicate directly with brands by liking, retweeting, posting, sharing, or buying what they like. What has been revealed by technology's surprise hijacking of fashion is its commercial possibilities. Top Shop's Unique Fashion Show used Facebook to live stream a show directly from the runway. It allowed its customers to look, shop, buy, and customize what they saw directly from the runway and receive the product before it hit the shops. Consumers from 133 countries looked at this show live with half a million shares. Before this presentation, the store had been trying to break into China. After this presentation, they were in. Commercially, consumer power has been released via technology and social networking, which has powered a huge boom in the global fashion industry. Even small designers are able to create a web presence and trade without a physical manifestation such as a shop; it's all about clicks and portal rather than bricks and mortar.

There have been casualties on the digital battlefield, and many of these have been runway photographers of which there is a diminishing number. "Digital meant the death of the author," rues runway photographer Andrew Lamb, who continues, "Before, you had to be there, and every one of your slides was unique and belonged to you. Now there are less photographers but everything

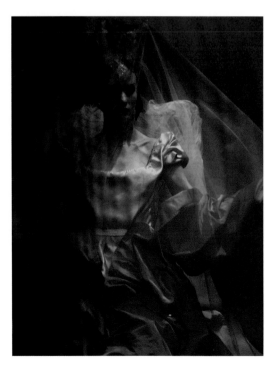

Technicolor queen: lighting can add an additional layer of interest, atmosphere, or meaning to fashion garments and deliver dramatic effects. Christian Lacroix, S/S 1998.

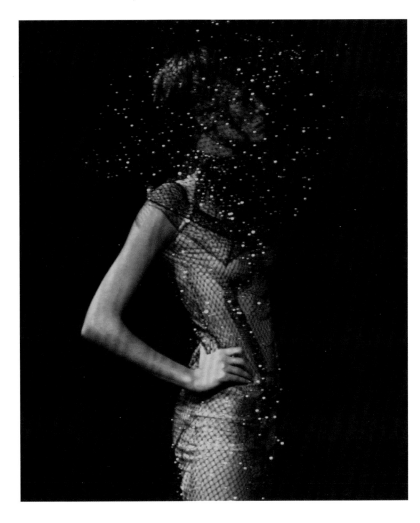

overlaps. At the end of the show, the photographers will swap shots with each other, like the trading of cigarette cards, so that every photographer has every outfit." Mitchell Sams notes that the big digital agencies that have moved in will capture every single outfit from every show and then sell them for next to nothing and press "send" within seconds of a show finishing. "They aren't catwalk photographers, they are general news photographers. Although some clients like *Vogue* still pay for a unique set of images and appreciate quality."

The digital hunger means a runway photographer can no longer be a sole trader but needs to work alongside others: "Your work is now more global than local. It costs to be digital because there is a postproduction team and photo crew that cover all aspects of runway from street to backstage. Hotels, airfares, and travel expenses have to be dealt with in advance and the aftermath is like a

Fashion is change: the changing technologies that defined the visual communication of fashion are caught here. In a pre-Internet world, there were many more runway photographers. The move from analogue to digital runway photography has had a profound effect. The numbers of runway photographers have significantly reduced while the online priorities of live streaming and video become more dominant. Alexander McQueen, S/S 1999.

torrent. The expectation is now that you will be immediate. It's a hairy existence. You have to pay ahead of the season then wait to be paid. This can take months. In many ways, it was simpler when it was just me," reflects Anthea Simms.

The same technology responsible for facilitating online digital direction is what has made fashion film a viable alternative to the runway presentation. Although this is not new (John Maybury directed a film for Rifat Ozbek in 1991), what has changed is the potential reach and leverage of the fashion film. New platforms and audiences have made it a genuine viable alternative for the promotion and dissemination of a new collection. Film director Ruth Hogben has produced for Gareth Pugh some visually striking films that led to valuable news coverage from Suzy Menkes, then of the *International Herald Tribune*. Now that fashion lives a parallel online existence, the expectation from audiences is that they will see a moving image and be "let into" the brand, hence the demand for backstage and insider footage.

Fashion brands are able to offer a wealth of audiovisual material including small films that show us how something is made through the behind-the-scenes films that Sam McKnight referred to. Loved by outsiders, loathed by insiders, behind-the-scene films (BTSs for short) tend to have a polarizing effect on their audiences. Equally potent is the hunger for related celebrity pictures as Anthea Simms notes from the front line: "The groupies are unstoppable; much more frightening than being shoved up against your colleagues taking runway photographs. Initially, the celebrities would back away from the groupies. Now, they will spend twenty minutes doing selfies. It's like a devouring, a bit like a riot but interesting to see." Building and satisfying your online audience has become the mantra for all in this age of the self as brand and interconnectedness.

Many people interviewed in this book talked about the effects of big business on fashion. Some felt it was a dominant and repressive force that had flattened everything out. "In the 1980s, catwalk shows promoted a look that was not corporate for mass

consumption. The clothes themselves could be outlandish, but came from a visionary position. When the brands became introduced, it was less about styling and more about glamor, aspiration and fantasy. It feels like the brand has become bigger than the individual. The designer's ideas are in service to a bigger project. The model is almost now a blank canvas, her body is subservient to the design. The compliant body doesn't disturb anything, it's all about the brand's desire, it is the promotion that takes the energy from the room. As a viewer, it became harder for me to feel emotionally connected to the collections," opines fashion commentator Caryn Franklin, whose initiative All Walks campaigns for greater diversity on the runway.

Big business and the relentless cycle of shows means the laissez-faire spirit that once pervaded the shows resulting in long lunches and enjoyable suppers are now a thing of the past. "Everyone wants everything faster and faster. Once, you would drop off the film at the laboratory, and there would be nothing you could do until it was done, so you could go and have a nice dinner. I remember during the old days of Couture, you could even get a nap in the afternoon. Now that's all gone. Now, there are few dinners. Shows start at 9 a.m. and the last one might not finish until 10 or 11 p.m.," says Chris Moore, the oldest running and longest established runway photographer.

The majority of runway presentations have been homogenized into a presentation formula that keeps the fans of the digital fire alight; however, the huge brands are producing greater and more ostentatious presentations. "How much bigger can they get?" asks Simon Chaudoir, who refers to Ralph Lauren's reconstructed British street onto which the collection was projected and Louis Vuitton's mock steam train that chundered into the Musee des Arts Decoratifs in Paris carrying the world's top models in an extravaganza that allegedly cost fifteen million euros. Profligate displays of luxury leave some viewers uncomfortable. "Some of it has become shockingly opulent," observes Anthea Simms. "Couldn't fashion think of a better way to present and give that money to charity? That would be a newsworthy move. Why don't they

Tools of the trade: for the casual viewer, fashion runway usually exists as an image of a model sporting the season's look. What is not seen, **right,** is the changing, complex technology required to transmit this to a global, diverse, and multi-platform audience. Photographers at various shows and, **center right,** a shot from the Alexander McQueen S/S 1999 show.

make something like that a live event and sell tickets to the public? People would pay to see it."

Simon Costin recently exhibited a show called Impossible Catwalks at the London College of Fashion, University of Arts London and explains that "It was about thinking outside the fashion catwalk box. A fashion show might happen on a street; a graffiti artist could do a look book and models could be entirely street cast. In the future, it might not be necessary to do a show; the information can be absorbed in many different ways. Catwalk is becoming more immersive, multi-sensorial." Jonathan Chippindale from Holition also sounds a warning bell: "Catwalk shows must be about the fashion. Technology has been hyped up, but it often puts a barrier between people and fashion. It should still be about beauty, color, form, structure, silhouette. We must go back to fashion, but it will be somewhere that it can be viewed and shared, where audiences can get involved with it." Anthea Simms wonders if there isn't a smarter way to organize the shows: "Why not run it like the Olympics, so that we can see the whole lot in one city every year? Whatever the future holds, there will always be fashion and it will always be visualized." Niall McInerney feels similarly: "Fashion weeks and fashion collections will never die whatever technology does because they are such an important networking event for people in the business. I remember once at the Hotel Intercontinental in Paris at an Yves Saint Laurent collection over fifteen years ago, the house photographer was setting up with a huge powerful movie camera that was able to produce high definition stills. He said 'You photographers are all finished!' But his camera was so finely tuned and sensitive it had to be very precisely set, and every time a catwalk photographer arrived and dumped their equipment on the podium: 'Doof!' it sent his camera out of register and him ballistic. The photographers are still there now, hanging in. For McInerney who had spent over three decades capturing the runway, the fashion journey was almost over. As technology ramped up in increasingly demanding ways and as online giants started to define the runway experience, Niall knew that it was time to exit, stage right.

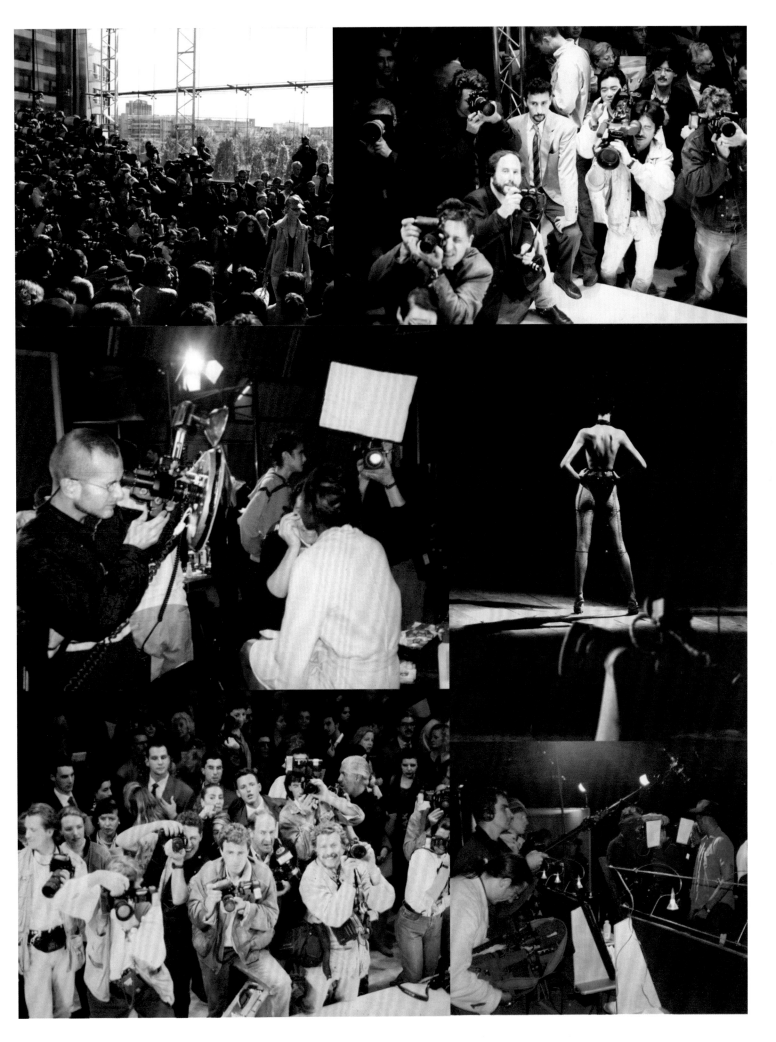

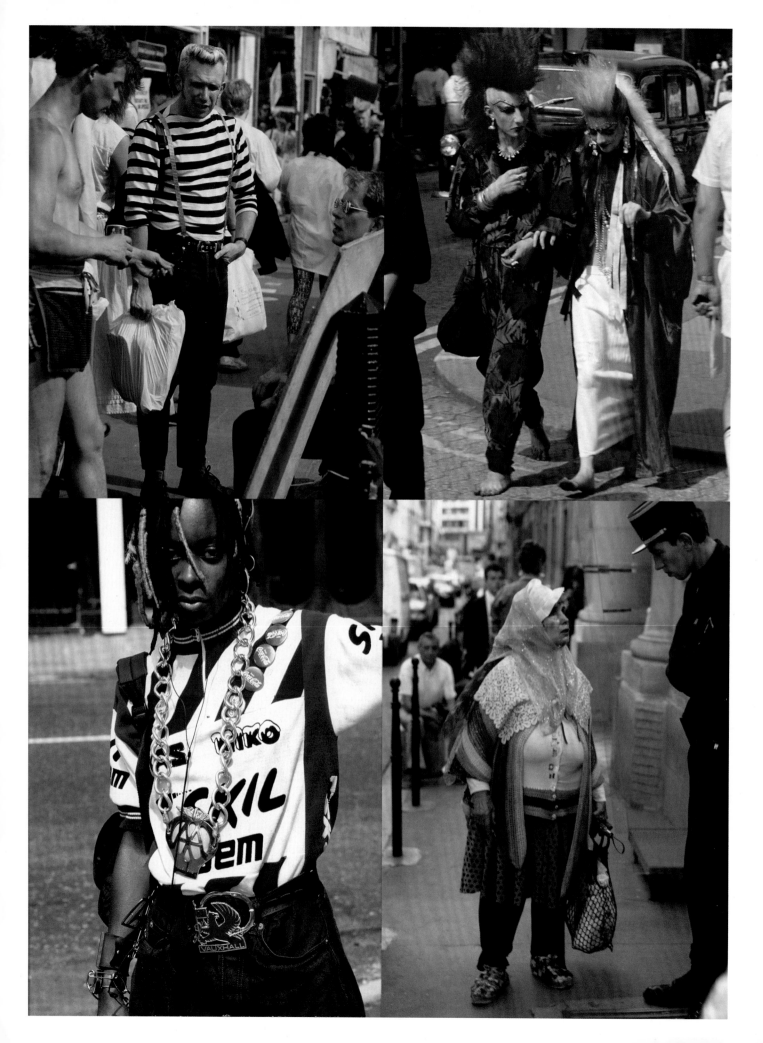

CHAPTER 12
POSTSCRIPT
REFLECTIONS ON FASHION'S BATTLEFIELD

For any new runway photographers who are hoping to enter this most frenetic and ceaseless of battlefields, McInerney offers the following advice: "Rule number one: come back with the pictures. Rule number two: Be persistent. Rule three: Have a positive mindset; believe you can get into a show. Rules four and five: Be there all the time. Be prepared."

From the back of the show tents, the runway photographers would see the stars of their field seated in the front rows, A-list fashion snappers like Mario Testino or Steven Meisel. "You were never invited to do editorial as a catwalk photographer. Very few went on to spread their wings. In many ways, it was lowly." While McInerney's job was primarily to capture the latest looks for his commissioning editors, he also saw runway as an event, a performance, and a stage peopled by dazzling and stylish players. In many of his images, we, as viewers, bear witness to this construction, through its processes being revealed—or are able to be swept up in its atmosphere, to share vicariously in the ambiance or spirit.

The street is a runway: top left, London has been a source of inspiration for designer Jean Paul Gaultier, photographed here in Camden Lock in June 1986. **Right,** punks in London, 1978; hip street style in London, 1986, **left,** and Paris, in the same year, reflect a refreshing diversity of approaches to dress and self-presentation.

Ever ready: above, Paloma Picasso and Jacques de Bascher photographed on the Paris Metro during Paris fashion week in October 1981.

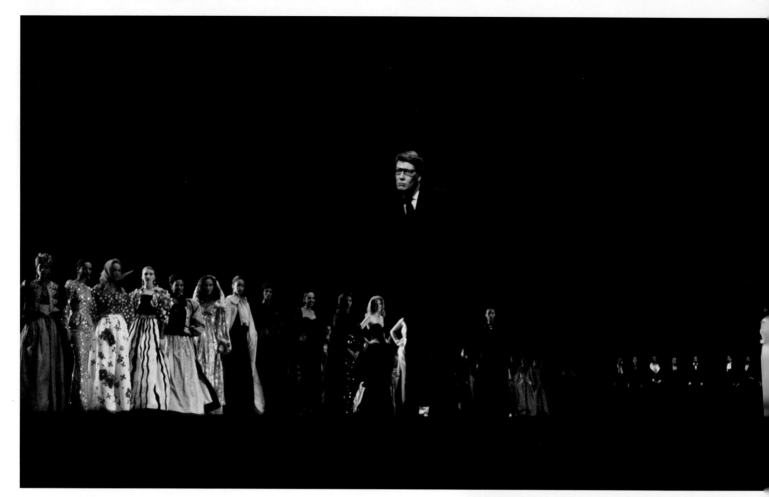

McInerney was one of the first photographers to recognize backstage material as a valuable visual record, decades before it was editorial de rigueur, and his images of street style and fashion's audience capture a different, less self-conscious era. Now, the territories of backstage and street style are densely populated with common chroniclers. Mobile technology means that almost every member of the fashion audience is an active participant of some kind of visual documentation or curation of images. The position of runway photographer may have been humble, but it was, nevertheless, an entrée to a thrilling world.

Niall's memory is composed of photographic images that captured moments. Finding himself in the heart of the action is what comes to his mind, not the weeks, months, potentially years of interminable waiting, waiting, waiting for shows to start, sometimes in the rain. For instance, the chance meeting of a fashion icon on the Paris metro: "Once, I remember going back to my hotel after a day's shooting. Who did I see on the Metro? Paloma Picasso. Of course, I had my

Runway king:

Yves Saint Laurent's thirtieth anniversary at the new Opera House in Paris, 1992, **main picture,** was a dramatic presentation of his greatest sartorial hits; the designer cuts his celebration cake with muse, Catherine Deneuve, and Zizi Jeanmaire.

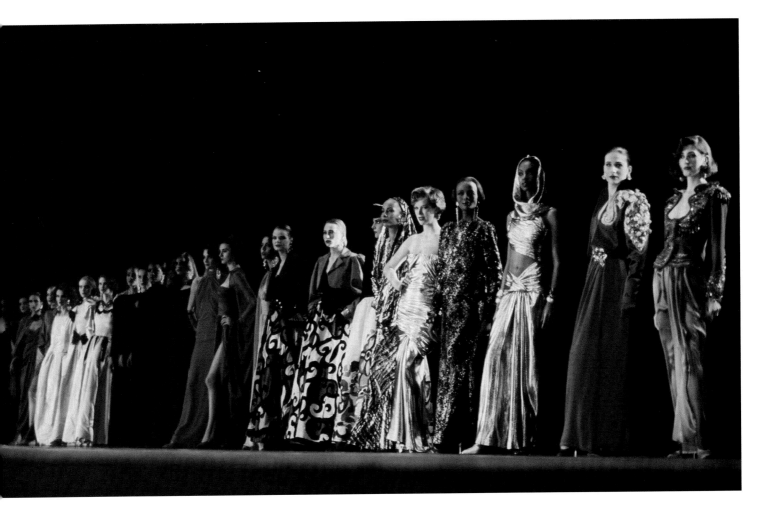

camera ready. She was very gracious. Who would have though that Paloma Picasso would travel on the Metro?"

Even though McInerney wasn't trained in photography, he instinctively recognized that he bore witness to a runway legend at the runway shows of designer Yves Saint Laurent. "His thirtieth-anniversary celebrations at the new Opera House were spectacular. He chose 100 of his favorite outfits. In the theater, the stage was as deep as the auditorium. The curtains opened and all you could see was blackness, then one by one, the models started walking toward you. Afterwards, there was the most incredible party, and Yves cut a cake in the shape of a heart with Catherine Deneuve."

A few years ago, Niall McInerney was wandering down London's Strand when he noticed the signs for London Fashion Week outside Somerset House, so he went in and sat in the courtyard to observe this world that he was once so involved with. "I just wanted to have a look. I noticed that people came there to be photographed and that there were a lot

more photographers. It wasn't like street fashion used to be; it was more like fancy dress or Halloween. Maybe to themselves these characters thought they were fabulous, but it wasn't real style to me. Perhaps they were students thinking 'if I dress up, I'll get photographed, and I'll get into the shows even if I don't have a ticket.'

It was a great to spend time inside this world, to rub shoulders with the rich and famous. It was very attractive, almost addictive. We runway photographers got a huge buzz out of it. You would find yourself in fabulous places like an amazing hotel with rich, sophisticated people and think 'here I am, in high society.' It certainly beat work."

For over thirty years, Niall McInerney has had his camera trained and ready to capture fashion as it was happening. As a witness to many changes, outlined in this book, his photographs leave a record of a time past and yet their immediacy leaps from the page as a record and experience of both fashion's fantasy and reality.

Front line duty:
above, Niall McInerney feigns some shut-eye at Concorde metro station, making the point that it's not all glamor (photographer unknown).

Overleaf, models exit the stage at Azzedine Alaïa, S/S 1992.

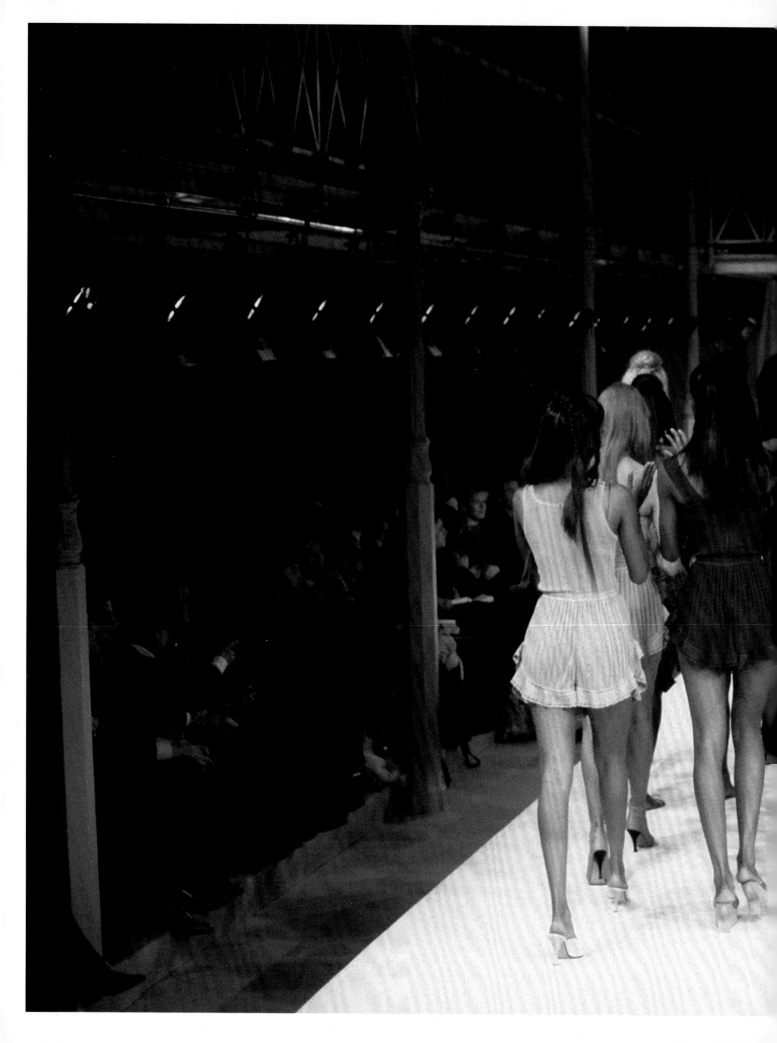

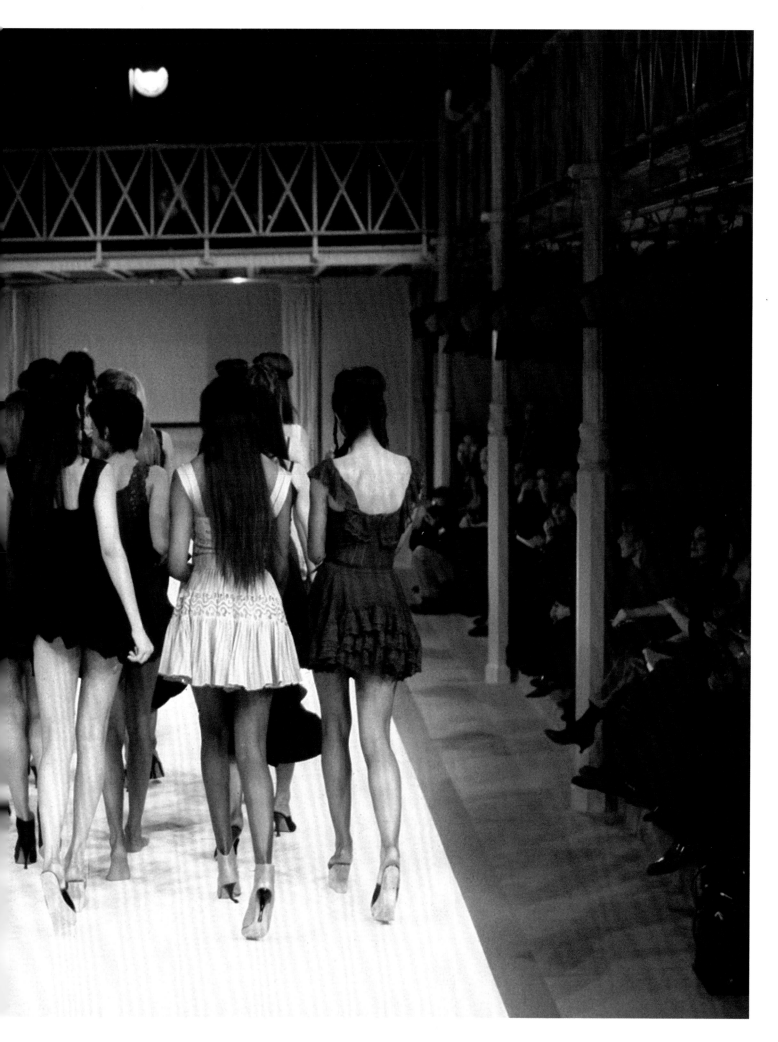

BIOGRAPHIES

Simon Chaudoir

A graduate of St. Martins School of Art (now CSM), Chaudoir has been director of photography for music videos for the likes of the Chemical Brothers and Massive Attack. He now shoots commercials for brands including Valentino, L'Oréal, and Paco Rabanne. As the lighting designer for five memorable Alexander McQueen shows, Chaudoir notes that while in commercials it is possible to reshoot, "you can't do that with a fashion show. It starts, it finishes, it only happens once and everything had better be right. McQueen was my first experience of fashion and I had no idea just how extraordinary these shows were, like operas in a war-zone."

Jonathan Chippindale

Jonathan Chippindale is chief executive of Holition, an innovative agency exploring and expanding the role of technology between luxury and the digital consumer. Chippindale's background in luxury retail included eighteen years with the De Beers Group as a managing director and with Asprey, Garrard and Mappin & Webb in senior marketing roles. He believes that catwalk shows are a chance to explore new sets of ideas, inspirations, and designs that drive brands and labels forward. "Remove the show and you remove the incentive to innovate, which feels counterintuitive to the notion of fashion constantly reinventing itself."

Simon Costin

A set designer who originally studied theater design and history of art at Wimbledon School of Art, Costin staged some of the most spectacular Alexander McQueen shows and brought the excitement of art installation to a fashion context. "McQueen sent me a letter as a student. He wanted to loan some body sculptures for his graduation show. I was only a few years older than him. I lent him 14 body sculptures and we became mates." For Costin, the principles of his craft—the history of design, lighting, and organization of space—can be applied equally to theater, opera, TV, or fashion. Other clients have included Lanvin, Hermes, Maison Margiela, Gucci, Valentino, and YSL. Costin's current passion is British folklore and he is director of Cornwall's Museum of Witchcraft and Magic.

Sarah Doukas

The model agent synonymous with the discovery of some of the world's most iconic and successful faces in fashion, Sarah Doukas started Storm in 1987 in her spare bedroom. Richard Branson was her 50% shareholder and she revolutionized the traditional model industry by offering an international service to her models and their clients. Storm today is one of the most successful model agencies in the world, opening new divisions including Storm Artist Management and Storm Vision.

Caryn Franklin

Broadcaster and print journalist Franklin spent six years at *i-D* magazine and moved to the BBC for over twelve years presenting *The Clothes Show*. She has authored and co-produced numerous fashion programs and documentaries for BBC One, Channel 4, ITV, Discovery, Granada, and UKTV Style and has produced four books. Co-founder of All Walks Beyond the Catwalk, her passion for the politics of image and self-esteem has resulted in current study for an MSc Applied Psychology in Fashion at London College of Fashion.

Lynne Franks

Starting as a shorthand typist in a PR agency at the age of eighteen and setting up her own agency at twenty-one, Lynne Franks was fashion's highest-profile public relations guru throughout the 1980s, when she centralized the then-fledgling London Fashion Week. She launched Gloria Vanderbilt designer jeans in 1979 and later persuaded Vanderbilt's parent company, Mujani, to sponsor a tent outside the Commonwealth Institute in Kensington for British fashion designers. Friends with Dawn French and Jennifer Saunders, Lynne Franks was immortalized by inspiring the character of Edina in the classic British comedy series *Absolutely Fabulous*.

Andrew Lamb

After studying film and drama at Reading University, Andrew Lamb started his photographic career as second assistant to photographer and catwalk king Chris Moore, which initially involved "sweeping the floor and making endless cups of coffee." Lamb's runway photographs went on to appear in the *Telegraph*, *Elle*, and British, French, and American *Vogue*. His most memorable catwalk moment is "the finale of the McQueen show with Shalom Harlow and the robot which 'danced' with her and then sprayed her with paint: bonkers and magical."

Debbi Mason

Former fashion director for British *Elle*, Debbi Mason was known for her unique, eclectic style that translated as stylishly into her pages as it did her own personal image. Originally working as a fashion buyer for Joseph, she went on to work for the *Evening Standard*, *Harpers & Queen*, *Mademoiselle*, and American *Vogue*. Currently artist in residence at Worthing Museum and Art Gallery with partner David Freud, for Mason the collections were about research and learning: "I couldn't help but be in awe and wonder at the miraculous cutting of the Japanese designers. The shows were like a great spectacle that we were all sent off to study."

Sam McKnight

One of the world's leading hairstylists, Sam McKnight's first catwalk shows were for Yuki and the Emanuels. He was there at the beginnings of London Fashion Week, styling hair for the Katherine Hamnett shows alongside makeup artists such as Linda Cantello and Mary Greenwell, and remains a key player in creating hair directions for Chanel, Vivienne Westwood, Balmain, and Fendi. Over the decades, he has worked closely with Patrick Demarchelier, Nick Knight, and Mario Testino and has been responsible for some seminal hairstyles, including Princess Diana's short, slicked-back style and Agyness Deyn's bleached blonde crop.

Chris Moore

The first and longest-serving catwalk photographer on the fashion circuit, Chris Moore was honored in 2014 by the British Fashion Council with a Special Recognition Award. Born in Byker, Newcastle-upon-Tyne, in 1934, he started as an apprentice in a city print firm for two years and in 1953 went to work at Vogue Studios, where he assisted many of the great photographers, including Cecil Beaton. In 1999, he co-founded fashion resource catwalking.com and in 2012 was awarded an honorary doctorate by the London College of Fashion.

Brenda Polan

Brenda Polan works as a freelance journalist. She was fashion editor and then women's editor of the *Guardian* in the 1980s, fashion

editor of *The Independent on Sunday*, associate editor of *Tatler*, style director of *You* magazine and *The Mail on Sunday*, and style editor of the *Daily Mail* in the 1990s. She has written for many other publications, including the *Financial Times*, the *Independent*, *Harpers Bazaar*, and *Elle*, to name a few. In addition to television and radio work, Polan served on the Design Council Awards Committee and the Press Committee of British Fashion Council and chaired the London Fashion Group.

Antony Price

Fashion designer Antony Price was the original high priest of high glamor. Best known for his work with the music industry, famously dressing Roxy Music and the Rolling Stones, he recently celebrated his seventieth birthday. He graduated from the Royal College of Art in 1968, going on to design menswear for Stirling Cooper and setting up Che Guevara. His first fashion show in 1980 brought a waft of sophistication to the UK, and Alexander McQueen and John Galliano, fashion students at the time, attended his shows.

Mikel Rosen

International fashion consultant and stylist Mikel Rosen is best known for his memorable catwalk productions in the 1980s, notably for Bodymap and Rifat Ozbek. Rosen started his career as a fashion designer in Milan and Paris but preferred putting on the show to making the garments. This led to show production requests from other designers and Rosen becoming one of the early founders of London Fashion Week. "The adrenalin was fantastic: calling models, lights, sound projection, set changes—in the hope it all happens at the same time!"

Mitchell Sams

Current runway photographer for *British Vogue*, former runway photographer for *Marie Claire*, and one of the funniest men in fashion, Mitchell Sams started out as a hairdresser before moving into photography assisting. Lured by the promise of international travel, he was an assistant to Michel Arnaud for many years, eventually graduating to a runway photographer in his own right. A genuine fan of fashion, Sams also works for Tom Ford, John Galliano, and i-D. "I've always loved taking pictures of lovely clothes and feel that designers like Galliano, McQueen and Margiela were about real talent, quality and beauty."

Kathryn Samuel

Former fashion editor of the *Daily Telegraph* (1985–1996), Samuel also worked at the *Daily Mail*, *Evening Standard*, and *Now* news magazine, where she was one of the first editors to work directly with Niall McInerney. She recalls, "On our first collections together I was seven months pregnant—he couldn't have been more of a gent—and, incidentally, took superb catwalk pictures. Catwalk photographers might not have the fashion eye of editors but they must be able to see picture potential and Niall could do that. He quickly became established as one of the best."

Anthea Simms

One of the rare breed of female catwalk photographers, Anthea Simms originally trained for a career in illustration but switched to photography while she lived in New York and recalls her first show shoot taking pictures of a Betsey Johnson show in a church where the models kneeled. She currently freelances for *Elle UK* and *Flare Canada* and has been

a catwalk and street photographer for over thirty years. "The shows really reflect change above and beyond fashion. I love to cover the RTW, Menswear and Haute Couture Collections because it allows the opportunity to experience and document these changes over time."

John Walford

John Walford has produced fashion shows in twenty-nine different countries for individual designers, notably Vivienne Westwood, Hussein Chalayan, Manish Arora, and Romeo Gigli, and for organizations such as the British Fashion Council, Shanghai Fashion Week, and Singapore Fashion Festival. As a firm supporter of emerging talent, Walford was also a founder of Graduate Fashion Week and Fashion Scout. "When I started, fashion shows were not accessible to the public until months later, now they are instantly available online. What's not changed is the designer's desire to be seen as cutting edge with hair, make-up and music."

Elizabeth Walker

With training in graphic design, Elizabeth Walker joined *Harpers & Queen* as assistant art editor in 1972 and remained for twenty years, eventually transitioning to fashion editor. During this time, Anna Wintour worked as assistant fashion director; Amanda Harlech and Hamish Bowles worked as fashion assistants after starting their careers on the *Harpers* student issue; and Niall McInerney covered catwalk. Walker's exacting eye and refined sense of style have won her many fans over the years, and the collections have always been a cornerstone of her professional life, which included

sixteen years at British *Marie Claire*. "The fashion moment is a myth. It's all about evolution and reaction."

Iain R. Webb

Iain R. Webb studied fashion design at St. Martins School of Art (1977–1980). During his career he has been fashion editor/director of the *Evening Standard*, *Harpers & Queen*, the *Times*, and *Elle*. Currently fashion features editor-at-large of *Ponystep*, he has authored several books, his latest entitled *Invitation Strictly Personal*. He lives in Bath, UK, where he consults for the Fashion Museum and muses over his life in frocks on his blog, hopeandglitter.wordpress.com, and his Instagram site, hopeandglitter. He is also currently a fashion lecturer at Central Saint Martins and The Royal College of Art.

INDEX

Note: Photographs and associated captions are indicated with a p following the page number.